THE BRITISH ARCHAEOLOGICAL ASSOCIATION

CONFERENCE TRANSACTIONS
For the year 1980

VI

MEDIEVAL ART
AND ARCHITECTURE
at Winchester Cathedral

1983

*Copies of these may be obtained direct from W. S. Maney and Son Limited,
Hudson Road, Leeds LS9 7DL*

ISBN Hardback 0 907307 07 8
Paperback 0 907307 06 X

PRINTED IN GREAT BRITAIN BY W. S. MANEY AND SON LIMITED

HUDSON ROAD, LEEDS LS9 7DL

CONTENTS

LIST OF ABBREVIATIONS AND SHORTENED TITLES

in use throughout the volume. See also individual contributions

Archaeol. J.	*Archaeological Journal*
BAA CT	*British Archaeological Association Conference Transactions*
B/E	N. Pevsner *et. al.*, ed., *The Buildings of England* (Harmondsworth various dates)
JBAA	*Journal of the British Archaeological Association*
P.H.F.C.A.S.	*Proceedings of the Hampshire Field Club and Archaeological Society*
RCHM	Royal Commission on Historic Monuments
VCH	Victoria County History
Willis (1846)	R. Willis, 'The Architectural History of Winchester Cathedral', Proceedings of the Archaeological Institute, September 1845 (1846); reprinted in idem, *Architectural History of some English Cathedrals*, 1, Chicheley Press (1972)
WCR	*Winchester Cathedral Record*

Preface

The publication of this volume, the sixth in the series of British Archaeological Association Conference Transactions, would not have been possible without financial assistance from the British Academy and the Juno Trust. On behalf of the Association we would like to thank them for their generosity.

We are grateful to the general editor of the Victoria County History for allowing us to reprint the ground plan of Winchester as a frontispiece to this volume. We have also taken the opportunity to include three photographs of the crypt, otherwise scarcely available in print, as an introduction to the plates section. These are reproduced by courtesy of Frank Woodman. The cover design is by George Carter.

It is with regret that we record the deaths, since the Conference took place, of Canon Fred Bussby and Wilfrid Carpenter Turner. The extent to which students of the Cathedral and its history are indebted to them is evidenced by the number of times their help and expertise is acknowledged in these pages.

T. A. HESLOP
V. A. SEKULES
Hon. Editors

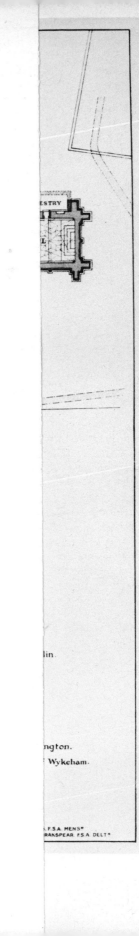

ESTRY

L

lin.

ngton.

Wykeham.

. F.S.A. MENS*
RANSPEAR. F.S.A. DELT*

The Romanesque Cathedral of Winchester: Patron and Design in the Eleventh Century

By Richard Gem

The Romanesque cathedral of Winchester is one of the most remarkable buildings of its age in England, and in Europe, on account not only of its immense scale but also of the diversity of influences contributing to its design. For these reasons it raises important questions as to the role of patron and mason in 11th-century building projects, and helps to throw light upon the contribution of each to the development of Romanesque architecture at a key moment.

BISHOP WALKELIN

The documentary sources are unanimous in attributing the initiative in the rebuilding of the cathedral to Bishop Walkelin: he may be seen, therefore, to have been the principal patron. The Domesday Survey shows that the endowments of the see of Winchester were divided between the Bishop's personal estates and those specifically set aside 'for the support of the monks'; while earlier charters indicate that the origins of this division go back well before the Conquest. What is not evident, however, is how financial responsibility for different aspects of the cathedral's life were apportioned. For the purpose of the building operations there must have been an administrative and professional structure presumably under the bishop's guidance, but the arrangement of this remains unknown. Officials would have been variously responsible for the routine administration of the finance, for the direction of labour and for the procurement of supplies; and these office holders are likely to have been clerics. Besides these (and perhaps in some cases holding a degree of administrative authority also), would be the master masons, carpenters, glaziers, plumbers, smiths, painters and so forth. Those professionally engaged in the building trade at the relevant period in Winchester are anonymous,[1] but on the clerical side an amount of biographical information is available.

Following the deposition of Bishop Stigand in 1070 from the see of Winchester, Walkelin, who was a royal chaplain at the time, was immediately appointed by the king in his place and was ordained by the papal legate. William of Malmesbury says that Walkelin had been commended by Archbishop of Maurilius of Rouen,[2] which suggests that he may have been one of that Archbishop's chaplains or a canon of the cathedral of Rouen. That the family was a Rouenais one is further suggested by the fact that Walkelin's brother, Simeon, was a monk of St Ouen in Rouen.[3]

Walkelin by conviction seems to have belonged to that group of contemporary bishops — which included Archbishop John of Rouen (Maurilius' successor), Archbishop Thomas of York (appointed in 1070), Bishop Osmund of Salisbury (appointed in 1078) and others — who were interested in the proper organisation of their cathedral chapters along canonical lines. He considered the English system of monastic chapters as anomalous, and planned to replace the monks in his own church with canons. The king agreed to the change, but Walkelin was stopped by the intervention of Pope Alexander II and of Archbishop Lanfranc, and he had to reconcile himself to the monastic *status quo*.[4] That he was unlikely to have been anti-monastic as such, however, is suggested by the fact that his own patron, Maurilius, had been a monk, and also by the fact that he was remembered later at

Winchester (in the tradition represented by the *Annales Wintoniae*)[5] for his devotion to the monks and love of the convent — this may have been an exaggeration but is unlikely to be totally untrue. Perhaps the system was made easier to accept by his appointing as prior of the convent his own brother, Simeon: though in 1081 or 1082 Simeon was promoted to the abbacy of Ely and left Winchester.

Simeon was replaced as prior by a monk from the convent who seems to have been a man of exceptional qualities: Godfrey, a native of Cambrai. William of Malmesbury was warm in his praises of Godfrey's virtues as a religious and also as a man of letters.[6] He reformed the body of customs governing the monastic life at Winchester, including a revision of the divine office, and established generous norms for regulating hospitality to visitors: these customs continued to be followed after Godfrey's death in 1107.

Walkelin's own involvement in the life of the community, other than his building activities, is not recorded. But he certainly played a fairly active role in affairs of state and in 1097 acted as one of the regents of the kingdom. That he enjoyed this political role is suggested by the story that, having offended William I on one occasion, Walkelin offered to resign his bishopric so long as could retain office as one of the king's clerks.[7] This might indicate a man of rather secular ambition: but the *Annales Wintoniae* again paint the other side of the picture, eulogising him as a man of piety, asceticism and sanctity.[8] The truth is probably that he was very much a man of his age, committed wholeheartedly to the affairs of both church and state, and seeing no conflict between them, an outlook still just possible before the Hildebrandine polarisation was complete.

CHRONOLOGY

The foundations of the new cathedral were laid in 1079:[9] in 1086 quantities of timber were acquired,[10] possibly for the roofs; and in April 1093 the monks moved into the partially completed building.[11] The demolition of the old church was begun in July 1093,[12] and this alone would have made it possible to lay out the north side of the nave, from the fifth pier west of the crossing up to the main west front. There would have been no obstacle, however, to laying out the south side of the nave before 1093. A confused tradition may preserve some recollection of Walkelin's having completed the original crossing tower[13] and when he died in 1098 he was buried by the steps in the nave in front of the pulpitum.[14] The greater part of the church may have been finished by about 1098 or shortly thereafter, although it is arguable that the completion of some parts of the superstructure was interrupted by the collapse of the crossing tower in 1107.[15]

THE GENERAL SCHEME

The building comprised a square central crossing, containing the choir, over which rose a lantern tower; east of the crossing projected a presbytery terminating in an apse, while to north and south of the crossing were transepts projecting an approximately similar depth to the presbytery — the whole formed a quasi-centralised scheme. Circumscribed about the presbytery were aisles, with galleries over, and an ambulatory which was rectangular in external plan and which led to an extended eastern apsidal chapel. The whole building east of the crossing was elevated over a crypt. The transepts also had a circuit of aisles with galleries over, and above the outer corners of the transepts four minor towers were intended.

To the west of the crossing was a long nave of twelve bays, with aisles and galleries, stretching back to a western massif. The latter appears to have provided either for a pair of

towers flanking two further bays of the nave, or for a single west tower with flanking transverse arms.

THE SCALE OF THE BUILDING

On the strictest interpretation of the evidence it cannot be conclusively proved that the scale of the whole church was determined from the moment of the opening of the works: the actual construction progressed only in stages, and all the foundations cannot have been laid out in a single campaign because of obstructions standing in the way. However, it seems highly likely that there was from the start at least an intention to build the church to the dimensions as finally completed; while some of the main lines determining those dimensions could have been laid out on site where obstructions did not occur.

If the whole building was indeed planned as early as 1079 then Winchester was to be one of the largest, if not the single largest Romanesque church in Europe; rivalling and surpassing such great churches as Mainz and Speyer Cathedrals, St Rémi de Reims and Santiago de Compostela, buildings which themselves constituted some of the largest erected in western Europe since classical Antiquity. In Romanesque terms Winchester was only rivalled (slightly later) by Cluny and possibly by St Paul's Cathedral in London.

The truly enormous scale of Winchester requires an explanation, not solely in terms of mensuration and applied geometry on the part of the master masons, nor in terms of functional requirements, but in terms of the motives of the patron responsible for it. Such motives are very difficult to determine in the absence of documentary evidence, but some clue to them may be provided by the fact that the general scale of Winchester bears a comparison with the Vatican basilica of St Peter built by the Emperor Constantine and itself planned to an exceptional scale to rival the basilica of Trajan.

At St Peter's (following Krautheimer's measurements)[16] the total internal length of the main volume, from the entry to the apse up to the internal face of the west wall, was 109.4 m, or 110.8 m to the external face of the same wall. At Winchester the comparable measurement from the entry to the eastern arm (i.e. the west face of the east wall of the crossing) up to the probable position of the internal face of the west wall of the nave was 107.3 m, or 109.2 m if the thickness of the east wall of the crossing is included; if the probable thickness of the west wall of the nave is included also (but not any of its buttresses) this then comes to 111.4 m.[17] Again, at St Peter's the width of the central nave was 25.2 m between the centres of the columns and would have been rather more (say 26.4 m) if the full widths of the nave walls were included. At Winchester the equivalent measurements are only 13.1 and 14.9 m: however, the total internal width of the nave and aisles is 26.0 m. Finally, at St Peter's the internal length of the transept (excluding the outer *porticus* was 63.9 m, or 66.4 m if the thickness of the walls between the transept and *porticus* is included. At Winchester the equivalent measurement is physically difficult to determine because of the presence of the choir in the crossing: however, the total internal length of the transept is approximately 63.2 m, or 63.9 m if measured to the back face rather than the front face of the arcaded wall dado.

Eric Fernie has already suggested[18] with regard to Ely that the great length of the more important Anglo-Norman churches indicates in general terms an attempt to emulate the size of the largest Early Christian basilicas of Rome: but he tends to see the more specific similarities between individual buildings as being explicable in terms of coincidences arising from the survival of a particular tradition of mensuration from Late Antiquity into the Middle Ages. He is probably right in his implied rejection of the idea that it was the master masons of 11th- and 12th-century England who were specifically copying the dimensions of

Early Christian churches in Rome; and right also in supposing that similar systems of mensuration are likely to have led to coincidences in actual buildings. But, this being the case, the way in which the Anglo-Norman churches emulated the Early Christian ones, if indeed they did, needs clarifying: in what did the emulation consist?

The most likely explanation, in the case of Winchester here under discussion, is that the patron knew of the exceptional scale of St Peter's and that in order to emulate it, for whatever reason, gave the master mason certain measurements, obtained by himself, to use as the basis for working out his detailed plan. (How in practice the plan was worked out by the mason is not of immediate concern here: presumably, however, it was by a method consistent with that demonstrated by Fernie already for Ely and, in this volume, for Winchester itself.) That patrons did in fact indulge in this sort of 'copying' exercise in the 11th century is shown by documentary evidence. For example, Krautheimer has pointed to the case of the church built in 1036 in Paderborn, in connexion with which Bishop Meinwerk sent Abbot Wino to Jerusalem to measure the Holy Sepulchre[19] though the actual form of the Busdorfkirche in Paderborn would hardly lead a modern critic to suppose that it stood very close to the Jerusalem prototype. A similar incorporation of measurements from the Holy Sepulchre took place in a church built at Cambrai in 1063–64;[20] and such an interest in this type of iconography at Cambrai at this date may be relevant to Winchester when it is remembered that Prior Godfrey came from there sometime before his promotion in 1082–83.

For the use of St Peter's in Rome, rather than the Holy Sepulchre, as an architectural model there is evidence from the Carolingian period (represented by Fulda) onwards. A case only slightly later in date than Winchester, it may be argued, is provided by Cluny where the monastery from its foundation had been placed under the special protection of SS Peter and Paul and of the Roman pontiff, and which in the 11th century was closely bound up with the papal reform movement. The scale of the great new church begun at Cluny in 1088[21] again appears to emulate the scale of the Vatican basilica, and it seems likely that this is a piece of deliberate 'copying' on the part of the monastic patrons, prompted by the particular traditions and role of the abbey. Winchester did not have quite the same 'Roman' context as Cluny, though its church was likewise dedicated to the Prince of the Apostles. It is necessary, therefore, to look further for a sufficient explanation why the patron should have sought to emulate St Peter's in the Vatican. That explanation, however, can only be arrived at after an examination of other features of the Winchester design; for Walkelin's church shows a wide diversity of sources that must be subsumed in one overall explanation of the patron's brief to his masons.

THE EASTERN CHAPELS

One feature of the 1079 design that probably derives from an immediately local source is the main eastern chapel reached from the ambulatory. This chapel, although it had an apsidal termination, differs from a standard Romanesque radiating chapel in that the apse was preceded by a straight 'nave', which was of three bays at crypt level. The main upper chapel was destroyed in the early 13th century when it was replaced by the present Lady chapel, but it may be assumed to have had the same general plan as the crypt level. The similarity is obvious between this chapel and that which lay to the east of the high altar in the pre-Conquest cathedral, built c. 980–94, and in both cases also the chapel has been argued to have served the cult of the Virgin,[22] which was thus assured continuity between the old cathedral and the new.

The case of the east chapel is a reminder that a basic requirement of the new cathedral was to serve a particular liturgical purpose. Liturgical considerations must have formed the central reference point of the patron's brief, and it is only features of the building for which an explanation in strictly liturgical-functional terms is not sufficient that the art historian should examine against iconographic and stylistic explanatory models.

One feature that does not appear particularly functional, and which again may show an ultimate derivation from Anglo-Saxon sources, is the rectangular form of the ambulatory chapels flanking the entrance to the Lady chapel. The form is attained only at the expense of a considerable irregularity in the plan of the chapels themselves and of the pentagonal bays preceding them. It is a deviation again from more normal Romanesque canons, but perhaps betrays a similar interest in rectangular forms to the rectangular presbytery and east chapel at Rochester Cathedral (begun *c.* 1077), or the rectangular transept chapels at Lincoln Minster (begun in the early or mid 1070s). While the rectangular east end was certainly a feature of Romanesque architecture in the Low Countries, and this group of Anglo-Norman buildings could have been aware of this, it is also true that the rectangular form had been standard in England already before the Conquest; for example at Stow Minster — though not in the Old Minster at Winchester as it stood in Walkelin's day. No particular motive on the part of the patron can be discerned in the adoption of this plan at Winchester in 1079, and it may have been determined solely by the master mason, though his motive for doing so cannot be deduced from the surviving evidence.

THE CRYPT, AMBULATORY AND GALLERY OF THE EAST ARM

Whatever the influences may have been on the form of the eastern chapels, there can be no doubt that the general *parti* of the eastern arm derives from orthodox Anglo-Norman sources, and not from Germany or the Low Countries where the tradition of rectangular east arms bears resemblance to Winchester only in *plan*. At Winchester the extensive crypt is truly an internal, not an external, feature and repeats the plan of the church at the main aisle level and probably at the gallery level. Furthermore, at all levels the central vessel was fully open to, and integrated with, the aisles and ambulatory; while the aisles and galleries were open also westward to the transepts.

The immediate source for Winchester, it may be argued, lies in the *parti* exemplified at St Augustine's Abbey, Canterbury;[23] despite what might appear at first sight to be marked differences. At Canterbury the central chamber of the crypt was divided into three aisles for vaulting purposes, while the ambulatory had rectangular bays that were wider north and south than east and west. At Winchester the central chamber had only a central row of columns, while the ambulatory bays were elongated east and west. On further analysis, however, this difference may be seen to be more apparent than real. At St Augustine's the piers in the periphery of the main chamber were quite slender and closely set, so that the only way to obtain roughly square bays for vaulting was to divide the central chamber into three aisles. At Winchester the main piers of the crypt were much more massive and more widely spaced (in order to accommodate a different arrangement of piers in the presbytery above). This not only gave the ambulatory bays different proportions, but made it difficult to vault the central chamber in the same way as Canterbury — i.e. in three aisles, with one column opposite each pier — without producing bays of awkward proportions. Winchester chose to retain the principle of one column opposite each pier, and sacrificed the three-aisled arrangement in favour of a single central row of columns. What might have appeared as a typological difference between Winchester and Canterbury thus may be seen as a structural necessity resulting from an intended difference in the design of the presbytery above. This

suggests that a mason familiar with the construction of the crypt of St Augustine's (or a similar building) was presented with a brief to integrate a crypt into a church with a presbytery specifically different in design.

THE ALTERNATING PIERS OF THE PRESBYTERY

That there was at Winchester a deliberate departure from the precedent of such buildings as St Augustine's in the design of the pier system of the presbytery seems demonstrably the case. The Canterbury presbytery can be reconstructed with a system of uniform columnar piers: at Winchester Carpenter Turner has shown that there was an alternation, reflected in the fact that the continuous stylobate wall on which the piers stood had provision only at each alternate pier for a respond towards the aisles.[24] Taken on its own this evidence would reveal no more than that the piers were alternately compound and simple. But if the evidence is taken in conjunction with Ely (a building arguably deriving its plan from Winchester), there can be little doubt that the simple piers were columnar and the compound piers were composed of rectangular elements with attached half-columnar shafts.[25]

There is only one possible source in England, it would seem, for this alternation of compound and columnar piers: Westminster Abbey,[26] where work began possibly about 1050 and must have been nearing completion or recently completed about the time Winchester was begun. Westminster as far as is known was a building quite different in the *parti* of its eastern arm from Winchester, but the alternation of piers in the nave must have been one of the most memorable individual features of its design. Westminster, however, belonged to the Early Romanesque thin-walled tradition, and its alternating system had no real context in the tradition to which the main structure of Winchester belonged (i.e. the High Romanesque thick-walled tradition of St Etienne at Caen). This suggests that the adoption of the feature in the later building reflected not the structural logic of the master mason but the desire of the patron.

That a medieval patron might take a very direct interest in the design of the principle supports within a church is shown in Abbot Suger's own commentary upon his works at St Denis,[27] and it is not surprising that Walkelin should have concerned himself with this aspect of the design of Winchester. The reason that he chose Westminster as a model most probably lies in the royal connexions of both churches — this will be considered further below. It is possible that the mason also had some familiarity with the works at Westminster (either through travelling on his own initiative or because he was sent there by Walkelin) for, as Peers pointed out, the capitals of the crypt columns at Winchester are of similar form to those in the dormitory undercroft at Westminster.[28]

THE TRANSEPT PLAN AND ELEVATION

If the presbytery piers derived from Westminster they are something of an isolated borrowing, for the general arrangement of the elevation as seen in the transepts (little is known of the upper parts of the presbytery elevation) belongs firmly within a developing but orthodox Anglo-Norman High Romanesque tradition.[29] The form of the transept piers at the aisle and gallery levels follows closely the type of compound pier established at St Etienne in Caen; the large subdivided gallery openings are comparable to Cerisy-la-Forêt (apparently slightly later in date than Winchester, but standing purely within the Norman tradition); the clerestory wall passage — despite its stepped arcades — attaches to the tradition of the thick-wall technique as formulated at St Etienne. Thus the 'grammar' of the

construction may be seen to be orthodox Anglo-Norman: but not so the statement made with it.

The continuous circuit of aisles and galleries around three sides of each transept is without known Anglo-Norman precedent: yet it does attach to a tradition that recurs in several major buildings in different parts of Romanesque Europe. In an Early Romanesque context in France the tradition is exemplified by the probably early 11th-century design, known only in plan, of Orleans Cathedral (followed later in the century by St Aignan, Orleans); also by the church of St Rémi in Rheims, dedicated in 1049. In Flanders the aisled transept, again known only in plan, occurred at the abbey of St Bertin (*c.* 1045–46 to 1081, and remodelled *c.* 1090 to 1105: it is not clear when the transept plan was established). In Lower Lorraine the probably related buildings of Stavelot (dedicated in 1040) and St Maria in Kapitol at Cologne (dedications in 1049 and 1065) had aisled transept plans but, in the latter case at least, there were no galleries. The Cologne church is notable for the apsidal form of the transepts, which suggests an imitation of the 6th-century church of the Nativity in Bethlehem. In Italy also an Early Christian prototype may lie behind the design of Pisa Cathedral (begun in 1063) where the transepts are aisled and galleried. These examples all belong to the early stages in the formulation of a theme that in France and Spain was to find its mature Romanesque statement in the so-called Pilgrimage group of churches, with which, broadly speaking, Winchester is contemporary (though the chronology of the Pilgrimage group is controversial).

The Winchester transepts are four bays deep, as at St Martial at Limoges (or St Aignan and Orleans Cathedral). The aisles return across the ends of the transepts, as at St Martin at Tours, St Sernin at Toulouse and Santiago de Compostela (or St Rémi and Stavelot). The central pier of the north end and south end aisles is columnar rather than compound, as at Tours (or St Aignan and St Rémi). The gallery openings are subdivided, as at Toulouse, Compostela and Ste Foi at Conques (or St Rémi, on the east side). The north and south transept façades are carried up not over the inner arcades, but in the plane of the outer walls of the end aisles, as at Tours (or as in the unaisled transepts of St Etienne, Caen). The transepts had clerestories and open wooden roofs, apparently unlike any of the Pilgrimage churches, but as at St Rémi. Nor were there eastern apsidal chapels beyond the aisles, such as existed in all the Pilgrimage churches; but in this respect comparison may be made with Stavelot.

If the Winchester transept bears a number of resemblances in particular to that at Tours, it should not be overlooked that Tours itself has been claimed as showing Norman influence.[30] There is no reason, therefore, to postulate a direct dependance of Winchester on Tours (which seems unlikely anyway on chronological grounds — if, that is, Tours was begun only following the fire of 1096),[31] nor a direct dependence on any other of the Pilgrimage churches. What may be deduced from the comparisons is that Early Romanesque experiment with the aisled and galleried transept formula gave rise to mature statements of the type which were parallel in the Pilgrimage group and in the Anglo-Norman tradition at Winchester. Yet, the fact that Winchester was designed at almost precisely the same moment as St Sernin (begun *c.* 1077–82) and Santiago (begun in 1078) cannot but leave a lingering suspicion that Walkelin had some inkling of the ambitious projects being planned there.

THE GROUPING OF TOWERS

Possibly the most striking feature of Walkelin's cathedral is the provision made for a remarkable group of towers to rise over the building. Chief among these was that over the

crossing: the original tower collapsed in 1107 and was then rebuilt as it survives today. The remaining towers were either not completed originally or do not survive. The evidence for four of the towers (one pair over the north-east and north-west bays of the north transept aisles, flanking the north transept gable; the other pair in a corresponding position on the south side of the building) was examined by Willis.[32] He pointed out that the towers seemed to have been an afterthought, but provision for them was made while work was in progress. Whether they had ever been completed, or had been completed and subsequently dismantled, he was uncertain. It may well be that they were never completed, perhaps as a result of the collapse of the crossing tower in 1107 and a loss of confidence.

A third pair of towers Willis believed rose over the rectangular chapels opening off the ambulatory;[33] that is, in a position analogous to the transept façade towers. That this was really so, however, is unlikely in view of the fact that the surviving chapels at crypt level would have provided no support for the south-west angle of the north tower, nor for the north-west angle of the south tower. Peers, on the other hand, in his plan of the Romanesque crypt[34] showed a pair of massive abutments between the lateral and central crypt chapels which could have carried minor towers — though he himself followed Willis's theory. Peers's abutments appear to be entirely hypothetical, but they are not implausible. In the 13th-century rebuilding of the east arm the north-east and south-east chapels rose up above the level of their vaults in a way suggestive of low towers, and this possibly recalls the memory of an earlier pair of eastern towers of some form.

The provisions at the west end of the nave of the church also pose problems. Although the evidence had often been interpreted as providing for a twin-towered façade, Peers considered that there was much more likely a single west tower terminating the nave and flanked by shallow western transepts.[35] The plan of the west end shown by Peers, however, is not accurate when compared with the recent excavation of the northern part of the west front by Biddle and Kjølbye-Biddle.[36] The plan indicated by the latter work would permit a reconstruction which at foundation level provided in plan a square central unit, flanked on north and south by rectangular units projecting beyond the line of the aisles, but not as deep in a north and south direction as east and west. This would certainly allow for a great central west tower flanked by two short transverse arms: but equally it would allow for two smaller rectangular towers projecting beyond the line of the aisles and flanking a central space that continued the nave up to the gable wall. This critical problem cannot be solved without further evidence; but the implications of either solution may be assessed.

Twin west towers would clearly relate Winchester to a standard Anglo-Norman tradition, as for example at Canterbury Cathedral. For a single west tower with flanking arms the most obvious source would be the westwork of the Old Minster at Winchester itself, built c. 971–94. Twin towers might be the more expected; but a single tower would provide a source for the later appearance of this type at Ely.

However some of these problems are resolved, it is clear that the overall external massing of the cathedral was intended to be a dramatic composition with a cluster of towers rising skyward and breaking the long horizontal emphasis that is so apparent today. The scale of investment necessary to realise this project would have been considerable and makes it inconceivable that the moving will behind it was other than Walkelin's; but the sources for the actual design are diverse and may reflect the contributory ideas of more than one person. As a starting point, the two great churches in the middle of Anglo-Saxon Winchester[37] must already have provided a group of two or more lofty towers as a precedent for a dramatic composition. None the less, the particular grouping of towers in Walkelin's building (with the possible exception of a single west tower) is not Anglo-Saxon. The crossing tower, at least as rebuilt following 1107, is an orthodox Anglo-Norman form, as would be also twin

west towers. The minor towers are rather more difficult to parallel. Turrets indeed occur in Normandy flanking the apse of La Trinité at Caen and of Cerisy-la-Forêt, and turrets flanking the east chapel at Winchester might be a related phenomenon — being displaced because of their assimilation into an ambulatory plan. Turrets also occur in Anglo-Norman architecture flanking the gable façades of transepts, as at St Alban's Abbey (begun *c.* 1077 and with a substantial part complete within ten years); but nowhere else are these translated into full towers. However, the Norman tradition of turrets flanking the apse does itself relate to an earlier and wider tradition of fully developed towers in a similar context (e.g. in the 10th century at St Maximin, Trier; in the 11th century at Speyer Cathedral or at Notre-Dame at Morienval), and Héliot felt able to invoke these Norman turrets as a precedent for the towers flanking the transept apses of Tournai Cathedral in the 12th century.[38] Héliot is perhaps mistaken in seeing such a source for Tournai (though he is right in drawing a parallel), because it is quite likely that the transept façade flanked by towers had already developed in Lower Lorraine. At St Trond (rebuilt between 1055 and 1082) there seem to have been twin towers flanking the transept façades,[39] and here they clearly relate to an indigenous tradition of towers flanking the sanctuary in the angles formed between the sanctuary and the transepts. The transepts at St Trond, however, following the Mosan tradition, were lower than the nave and there was no crossing or central tower: in this respect it was quite different from Tournai or Winchester.

A precise Mosan, Scaldien or other Lotharingian or Flemish source cannot be pointed to for the Winchester transept towers, but it may well be that the patron or designer was familiar with the effect of grouped towers that was certainly more characteristic of these areas than of Normandy itself — and in this connexion it is appropriate to recall that the learned Prior Godfrey of Winchester came from Cambrai. None the less, Winchester is not in isolation in an Anglo-Norman context in showing an interest in the principle of grouped towers. Canterbury Cathedral by the early or mid 12th century must have provided quite as dramatic, if a rather different silhouette: a crossing tower, twin west towers, minor towers attached to the west side of the east transepts, and another pair of towers rising over the radiating chapels of the ambulatory.[40] Winchester and Canterbury perhaps were inspired by a common vision of the Sion amidst whose numerous towers the Psalmist urged his people to seek their God.[41]

PATRON, MASONS AND DESIGN

In tracing the genesis of the Winchester design it has been shown already above that it is necessary to distinguish the roles of the patron and of the master mason or masons. Wherever it is possible to examine the actual 'grammar' of the architecture at Winchester — the masonry technique, the system of construction, and individual forms — it appears to stand firmly in the Anglo-Norman tradition established already at Canterbury. However, the statements made with this grammar are quite a different matter: they reflect a wide-ranging interest in formulae that are as much outside the Anglo-Norman tradition as they are within it. This divergence cannot be explained simply in terms of a master mason who was a widely travelled man and who collected ideas that caught his imagination and incorporated them into his own work. The divergent features are not merely stylistic but involve the fundamental brief for the design with all its financial implications. The only satisfactory explanatory model involves a master mason (or masons) who stands within a particular technical tradition where he has received his training, and a patron with wide ranging interests who is responsible for formulating the brief. The point of synthesis and creation comes where the master mason has to translate the brief into reality.

B*

The formulation of the brief at Winchester — the intention that was to determine the form of the building — must be attributed firmly to the patron, Bishop Walkelin; though Walkelin may very well have discussed the project with others and have been influenced, for instance, by Prior Godfrey. But what was the overall conception in Walkelin's mind?

In trying to understand the design of Winchester it is instructive to make a comparison with Lanfranc's Canterbury. The guiding principle behind Christ Church was one of decency but of moderation: Lanfranc's new cathedral was certainly a large building by pre-Conquest standards (it compared with St Etienne, Caen), but it was not ostentatiously so; it breathed something of the discipline of Le-Bec. At Walkelin's church on the other hand everything was immoderate — though not without unity.

Winchester was eclectic, but it was consistent in wanting to incorporate into one huge scheme all the most elaborate features of the new High Romanesque architecture of Europe. Furthermore, behind the choice of features there may be discerned clear intentions. In the first place there was the adoption of certain features from the pre-Conquest cathedral, and these must have emphasised the essential continuity of the church with a tradition stretching back to the 7th century; a tradition to which Walkelin had become the heir. The Bishop must have been aware that an essential feature of Winchester's Anglo-Saxon tradition had been its intimate association with the West Saxon monarchy that might enable it to be regarded in some sense as the 'capital' of England. It was a royal association the current reality of which was demonstrated by William the Conqueror's construction of his new palace adjacent to the cathedral c. 1070.[42] But a fundamental shift in the focus of royal power was in progress, initiated already under Edward the Confessor, which was substituting Westminster for Winchester. Symbolic of Westminster's rising fortunes must have been the great new abbey church there, and it is hardly surprising that there should be found at Winchester features of the Westminster design emulated and surpassed. The emulation of Westminster shows in the borrowing of the system of alternating piers: the surpassing shows in the adoption otherwise of more up to date currents of design, of a greater diversity of parts, and of an altogether larger scale.

The most elaborate Anglo-Norman building projects had an eastern arm with an extensive crypt, ambulatory, and radiating chapels: so, therefore, should Winchester. The most elaborate Romanesque churches in other parts of France, however, had not only an eastern arm with ambulatory, but also a circuit of aisles and galleries around the transepts: Winchester should, therefore, introduce this *parti* to Anglo-Norman architecture. Anglo-Norman great churches had crossing towers and western towers, while churches elsewhere in Europe had eastern towers and transept towers: Winchester should have them all.

In this competitive spirit the rivalry with Westminster that may have been the starting point was left behind and new horizons were opened up. St Peter's new cathedral in Winchester should make a worthy comparison with the place of the Apostle's burial in Rome. The mother church of the diocese should be a tangible embodiment even of the New Jerusalem, the Psalmist's many-towered Sion. Secular rivalry and pride were thus transcended in an overall conception which, while still reflecting both the political and ecclesiastical pretensions of the Anglo-Norman state, yet would have attained — had it ever been fully realised — to a sublimity that must have made it one of the most telling expressions of the high medieval religious ideal.

REFERENCES

1. Though in 1086 one Hugh *caementarius* held land from Bishop Walkelin (VCH, Hampshire, I, 463–64). For the 12th century, however, see: F. Barlow, M. Biddle, O. von Feilitzen, D. J. Keen, *Winchester in the Early Middle Ages* (Oxford 1976), 433 et passim.

2. William of Malmesbury, *De Gestis Pontificum Anglorum*, ed. N.E.S.A. Hamilton, Rolls Series, LII (1870), 172.

3. Rudbourne (*Historia Maior Wintoniensis*, ed. H. Wharton, *Anglia Sacra* (London 1691), I, 255) adds, for what it is worth, that Walkelin was a blood relative of King William, and that he had studied in Paris.

4. William of Malmesbury, op. cit., 71–72; Eadmer, *Historia Novorum in Anglia*, ed. M. Rule, Rolls Series, LXXXI (1884), 18–19.

5. H. R. Luard (ed.), *Annales Monastici*, Rolls Series, XXXVI (1865), II, 39.

6. William of Malmesbury, op. cit., 72–73.

7. Luard, op. cit., 35.

8. Ibid., 39.

9. *Annales Ecclesiae Wintoniensis*, ed. Wharton, op. cit., 294.

10. Luard, op. cit., 34–35.

11. *Annales Ecclesiae Wintoniensis*, ed. Wharton, op. cit., 295.

12. Ibid.

13. Rudbourne, op. cit., 256; John of Exeter, *cit.* Willis (1846), 18.

14. Rudbourne, op. cit., 256.

15. Luard, op. cit., 43.

16. R. Krautheimer, S. Corbett, A. K. Frazer, *Corpus Basilicarum Christianarum Romae* (Vatican 1977), V.

17. It is difficult to be precise as to the Winchester measurements — as for different reasons it is at St Peter's — since the equivalent of two bays at the west end of the nave no longer survives. I should like to thank very much Mrs Corinne Bennett, Surveyor to the Fabric, and her colleagues for the help kindly given to me in measuring Winchester.

18. E. Fernie, 'Observations on the Norman plan of Ely Cathedral', *BAA CT*, II (1979), 4.

19. R. Krautheimer, 'Introduction to an "iconography of medieval architecture"', *Studies in Early Christian, Medieval and Renaissance Art* (London 1971), 117.

20. Ibid., 124.

21. For Cluny in general see: K. J. Conant, *Cluny: les églises et la maison du chef d'ordre* (Medieval Academy of America 1968).

22. M. Biddle, *Excavations near Winchester Cathedral, 1961–1968* (Winchester 1969), 70.

23. For a discussion of Canterbury see: Richard Gem, 'The significance of the 11th-century rebuilding of Christ Church and St Augustine's', *BAA CT*, V (1982).

24. I am most grateful to Mr Wilfrid Carpenter Turner for discussing his findings in the presbytery with me.

25. At Ely the piers of the south transept are of this form; the presbytery piers were presumably similar to these except that the minor piers had attached shafts (for which evidence survives) on their face towards the presbytery.

26. Richard Gem, 'The Romanesque rebuilding of Westminster Abbey', *Proceedings of the Battle Conference*, III (1980), 33–60.

27. E. Panofsky (ed.), *Abbot Suger on the Abbey Church of St Denis and its Art Treasures* (Princeton 1979), 91 *et seq*.

28. C. R. Peers in, *VCH*, Hampshire (London 1912), V, 52.

29. Cf. J. Bony, 'La Technique normande du mur épais', *Bulletin Monumental*, XCVIII (1939), 173 *et seq*. Bony was able to locate Winchester in the orthodox Norman tradition, despite its departure therefrom in the form of its clerestory wall-passage arcades. The innovation in the wall-passage arcade is difficult to discuss without knowing precisely what happened at Canterbury Cathedral. Ely, which is closely related to Winchester, Bony called purely orthodox — which is certainly true of the general structure, but not of the decorative forms.

30. C. Lelong, 'Le Transept de Saint-Martin de Tours', *Bulletin Monumental*, CXXXIII (1975), 127.

31. Lelong's excavations (loc. cit.) have shown clearly that the aisled transept (standing until the Revolution) was a rebuilding on earlier foundations. The rebuilding is not referred to in the documentary sources, but the fire of 1096 seems a likely occasion — though a slightly earlier start to the works might be argued on stylistic grounds.

32. Willis (1846), 25 *et seq*.

33. Ibid., 38.

34. Peers, loc. cit., facing 52.

35. Ibid., 52 and plan facing 50.

36. M. Biddle, 'Excavations at Winchester, 1969', *Antiquaries Journal*, L (1970), Fig. 12 facing 316.

37. Barlow *et al.*, op. cit., 306 *et seq*.

38. P. Héliot, 'Les Parties romanes de la cathédrale de Tournai' *Revue Belge d'Archéologie et d'Histoire de l'Art*, 1956.

39. L. F. Genicot, *Les églises mosanes du XI^e^ siècle* (Louvain 1972), 27 *et seq.*

40. The main towers are shown on Prior Wibert's waterworks drawings; the transept towers survive.

41. Psalm XLVII (Vulgate):

> 'Circumdate Sion, et complectimini eam;
> narrate in turribus eius.
> Ponite corda vestra in virtute eius,
> et distribuite domos eius, ut enarretis in progenie altera.
> Quoniam hic est Deus, Deus noster in aeternum, et in
> saeculum saeculi;
> ipse reget nos in saecula.'

42. Barlow *et al.*, op. cit., 292 *et seq.*

The Grid system and the Design of the Norman Cathedral

By Eric Fernie

Ever since Hippodamus of Miletus or one of his Ionian forerunners first applied it to the layout of a town in the middle of the first millenium B.C., the grid of squares has been a constant feature of architectural design and, perhaps even more, of architectural history. Over the last twenty years it has in particular gained acceptance as one of the hallmarks of architectural planning between the 8th century A.D. and the 12th, in contrast to the more sophisticated proportional systems claimed for the Gothic period, such as root-two, root-three and the golden section. Among examples cited to support this view have been the palace chapel at Aachen of the late 8th century, the St Gall plan of the early 9th, St Michael's at Hildesheim of the early 11th, and the cathedral at Winchester in the late 11th.

Paul Frankl's eloquent characterisation of the architecture of this period in terms of its rectangularity and frontality has undoubtedly proved a useful perception, as much for the understanding of the Gothic as for the Romanesque, while Walter Horn's 'square schematism' is a suggestive extension of the original idea. These formulations are however often and

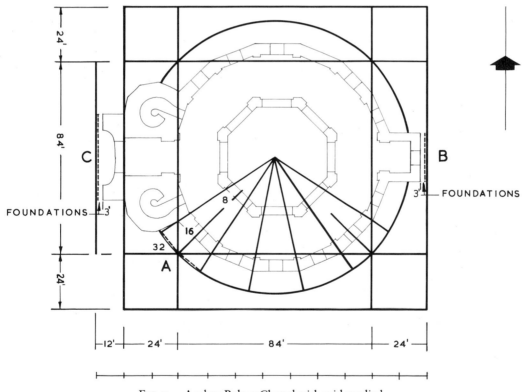

FIG. 1. Aachen Palace Chapel with grid applied.
After Hugot, 1965, Fig. 7

FIG. 2. St Gall, ideal plan with grid applied, detail.
Horn, *Art Bulletin*, 1966, Fig. 14

easily confused with the grid of squares, and the supposed presence of grids in the four examples quoted above turns out on investigation to be at least unlikely if not impossible, as I shall briefly attempt to show before embarking on a more detailed examination of Winchester.[1]

Hugot applies a grid of 84 ft squares to the layout of Charlemagne's palace at Aachen. The chapel sits centrally in one of these and has its main dimensions explained by subdivisions and extensions of the large square in modules of 12 ft (Fig. 1). The analysis is untenable on two grounds. Firstly, neither the intersections nor the lines of the grid correspond at any point with the angles or the sides of either the main octagon or the sixteen-sided outer wall. These shapes are only related to the grid via the device of a further thirty-two sided figure lying outside them (point A). Secondly, the sanctuary to the east and the entrance block to the west can only be made to fit the grid by using their foundations rather than their standing walls (points B and C).[2]

Horn's analysis of the St Gall plan posits a grid of squares underlying the whole design. I have discussed this subject elsewhere, so that here it will suffice to say that while the nave and transepts of the church contain some squares there is a complete lack of correspondence between the grid and all the monastic buildings, pathways and boundaries, making it difficult to see how its use advances our understanding of the plan (Fig. 2).[3]

St Michael's at Hildesheim is one of the clearest examples of what is meant by square schematism. It has at each end a square crossing flanked by two square transept arms, while the nave consists of three similar squares marked by piers alternating with pairs of columns.

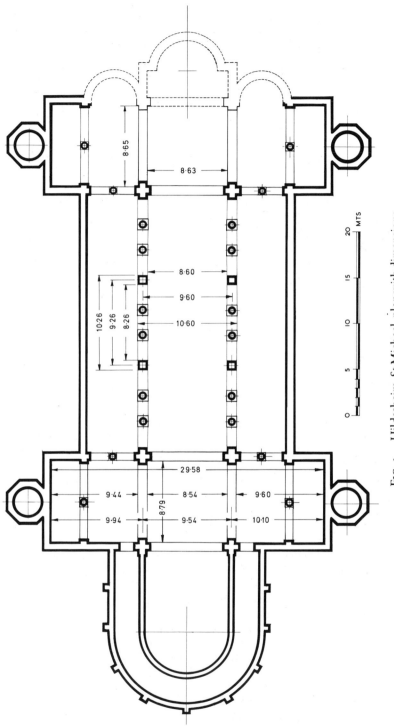

FIG. 3. Hildesheim, St Michael, plan with dimensions

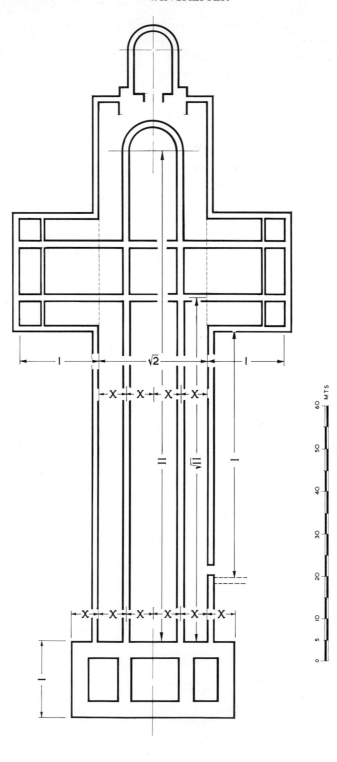

FIG. 4. Winchester Cathedral, proportions

R CATHEDRAL

KELIN'S BUILDING

IER AT PRESBYTERY LEVEL

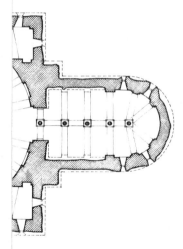

(CRYPT) LEVEL

L E G E N D

T EXCAVATED

STRUCTED (RW)=WILLIS 1846

It is therefore reasonable to see it in terms of squares and even to infer the existence of a planning grid.[4] Examination of the dimensions as opposed to the appearances, however, reveals that while the two crossings are square, the shapes into which the transepts and the nave are divided are rectangles, not squares, whether one measures to the interior, the exterior or the centre of the wall, or to a mixture of the three (Fig. 3).[5] It has been argued that this is the result of faulty workmanship,[6] but the rectangles are bounded by accurate right angles, the apparent discrepancies are entirely consistent, and the building as a whole is not incompetently laid out. The result is that, while there may be a square schematism in the plan (in the loose sense in which a rectangular chancel can be described as a square east end), apart from the crossings there are no squares proper and there is certainly no grid.[7]

François Bucher includes Walkelin's cathedral at Winchester among those buildings which he describes as additive, that is built up from a series of blocks or units added one to the other and lacking any irrational numbers in their proportions, unlike Gothic buildings.[8] Once again the dimensions disprove the existence of any such regular units and on the contrary reveal the presence of irrational proportions.

The closest the design comes to exhibiting a unit or module is in the width of the nave and aisles, as the centres of the arcade walls and the centre of the nave divide the total internal width of 85 ft 4 in (26 m) into four equal units of 21 ft 4 in (6.50 m) (Figs. 4 & 5).[9] For this to form part of a grid or a modular system the east-west length of the nave bay would need to be the same, but this is in fact 22 ft 2 in (6.75 m). It is not possible to argue that the discrepancy of ten inches (.25 m) is due to negligence, because it occurs so consistently and because both lengths are closely related to other dimensions on the plan, as follows. The bays in the presbytery are considerably shorter than those in the nave, and it is no surprise to find that their 15 ft 8½ in (4.79 m) length relates to 22 ft 2½ in (6.77 m) as one to the square root of two. Winchester therefore exhibits the same irrational proportion as characterises the plans of Ely, Canterbury, Norwich and other Anglo-Norman buildings. On the north-south axis, the 85 ft 4 in (26 m) width of the nave and aisles divided by root-two equals the 60 ft 4 in (18.39 m) which is the salient length of the transept arm.[10] The western massif contains similar elements arranged so as to produce a different layout. Its external depth from east to west is a few inches over 60 ft (18.29 m +) relating it to the width of the nave and aisles as one: root-two, as in the transept, while its north-south length is the 85 ft 4 in (26 m) width of nave and aisles extended to each side by one more of the units of 21 ft 4 in (6.50 m).[11]

The major dimensions of the east-west axis exhibit the formula which occurs in many major Anglo-Norman buildings and indeed in the church on the St Gall plan, in that the length of the nave multiplied by root-two equals the length of the nave plus the distance to the chord of the apse.[12] The cloister occupies eight and a half bays of the twelve-bay nave. Since the position of its western wall is known only from the remains of the door in the tenth bay of the south aisle, no specific length is available, but as eight and a half is to twelve as one: root-two, it is likely that the cloister, the nave and the length to the chord are related as one: root-two: two (see Roman numerals in Fig. 4).

The piers of Walkelin's building only remain in anything like complete form in the transept. The faces under the soffits of the arches consist of a larger central half-shaft flanked by two smaller ones, the three parts relating as one: root-two: one. In the nave only one pier, the second in the north arcade, has survived the later re-facing in anything like measurable form. The south face of this pier has a core which relates to the main pilaster as root-two: one (Fig. 6).[13]

The same sorts of relationship therefore exist on three different scales, the faces of the piers, the sizes of the aisle bays and the overall lengths of the major elements (Fig. 4). The

c

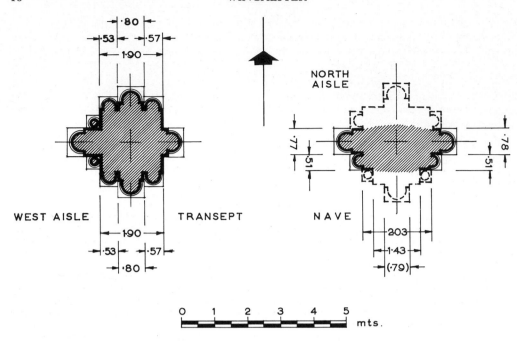

DETAIL OF TRANSEPT PIER 2 DETAIL OF NAVE PIER 2

FIG. 6. Winchester Cathedral, plan of piers

proportion also occurs in the elevation as the height of the arcade and tribune storeys is about 55 ft (*c.* 16.80 m) and that of the whole including the clearstorey about 77 ft (*c.* 23.50 m), relating as one: root-two in whole numbers. These lengths are very different from any of those in the ground plan and also relate as whole numbers instead of geometrically. At Ely the elevation is similarly divorced from the ground plan and, what is perhaps of greater interest, the layout of the nave and aisles is determined by the two lengths of 55 ft and 77 ft.

If it exists at all then, the square schematism of Winchester Cathedral is aesthetic rather than geometrical. No grid of squares underlies the design and, far from it being devoid of irrational numbers, its whole composition is based on an incommensurate ratio. Thus, while in many ways Gothic buildings may be more sophisticated than their Romanesque predecessors, this does not appear to be one of them. Indeed, it is ironic that the only surviving medieval drawing of a church plan unequivocally based on a grid, the *glize desquarie* on folio 14v of Villard de Honnecourt's sketchbook, should occur in a Gothic context.

ACKNOWLEDGEMENTS

I would like to record my gratitude to Don Johnson for drawing all the plans except Fig. 2 for this article, and to the Leverhulme Trust for generous assistance with travel costs.

REFERENCES

1. P. Frankl, *Gothic Architecture* (Harmondsworth 1962), 10–14; W. Horn, *The Plan of St Gall* (1979), I, 212–38. Both these publications represent considered statements of ideas formulated over a number of years. E. Sunderland *Journal of the Society of Architectural Historians*, 18 (1959), 98 on finding more rectangles than squares in Burgundian Romanesque buildings, cast doubt on the idea of square schematism 'currently gaining popularity in descriptions of the Romanesque style'.

2. L. Hugot, 'Die Pfalz Karls des Grossen in Aachen', *Karl der Grosse* (1965), III, 542 and 556–61, and Figs 2 and 7. The length of the sanctuary in Hugot's plan should be contrasted with that of F. Kreusch, ibid, 466 and facing 474. The feet in Hugot's grid are 1 ft 1 in (.333 m) long.

3. Horn, op. cit., I, 76–104; E. Fernie, 'The Proportions of the St Gall Plan' *Art Bulletin*, LX (1978), 583–89, and a review of Horn in the *Burlington Magazine*, CXXIV (1982), 97–99.

4. H. Beseler and H. Roggenkamp, *Die Michaeliskirche in Hildesheim* (Berlin 1954), 130–34; N. Pevsner, *Outline of European Architecture* (Harmondsworth 1958), 57; Horn, op. cit. 237.

5. See Beseler and Roggenkamp, op. cit., 132–35 for all dimensions. The crossings are about 28 ft (*c.* 8.60 m) square internally. The central bay of the nave measures (1) between the inner faces of the piers 28 ft 2½ in × 27 ft 1 in (8.60 × 8.26 m), (2) between the centres 31 ft 6 in × 30 ft 4½ in (9.60 × 9.26 m) and (3) between the outer faces 34 ft 9 in × 33 ft 8 in (10.60 × 10.26 m). The western transept is 97 ft (29.58 m) long internally which is three times 32 ft 4 in (9.86 m), while the north arm, the crossing and the south arm are (1) between inner faces 31 ft, 28 ft and 31 ft 6 in (9.44, 8.54, 9.60 m) and (2) to the centres of the crossing walls 32 ft 7 in, 31 ft 4 in and 33 ft 2 in (9.94, 9.54, 10.10 m).

6. Beseler and Roggenkamp, op. cit., 123–37 passim; Pevsner, loc. cit.

7. The same criticism can be levelled at the present author's original analysis of Norwich Cathedral, 'The Ground Plan of Norwich Cathedral and the Square Root of Two', *JBAA*, CXXIX (1976), 77–78, as well as Fig. 2 and note 2 where the application of a grid requires special pleading to accommodate variations in the lengths of the aisle bays. These variations can be explained more satisfactorily in terms of the effects of the overall proportions on the nave and eastern arm.

8. F. Bucher, 'Design in Gothic Architecture', *Journal of the Society of Architectural Historians*, XXVII (1968), 51.

9. The interior faces of the aisle walls are almost entirely lost in the nave, but they survive in the presbytery in the form of strips of metal marking the remains excavated between 1968 and 1970 by the then cathedral architect. I am indebted to Mr Carpenter Turner for informing me in correspondence that although some of the floor markings are reconstructions rather than reflections of the evidence, the lines representing the inner faces of the aisle walls were established from the excavated faces of their plinths.

10. The north arm is 60 ft 4 in (18.35 m) long and the south 61 ft 8 in (18.80 m). Since the north arm is free-standing it is marginally more likely to have been correctly laid out.

11. Willis (1845), records 60 ft (18.29 m) for the width of the western massif as it was available to him from the excavations of Owen Carter. Mrs Kjølbe-Biddle has kindly informed me that the excavations of the late 1960s revealed a length of 61 ft 8 in (18.80 m) from the chamfered block at the north-east corner to the western face of the robber trench at the north-west corner. Willis's drawing of an exposed corner (p. 65) shows it with two chamfered plinths one above the other, each about three inches (7.5 cm) deep, which would set the wall surface (to which all our other measurements in the building have been taken) six inches (15 cm) back at either end, and leave a total of 60 ft 8 in (18.50 m), including an allowance for the robbing itself.

 The western massif is the only part of the building where the external dimensions appear to be the significant ones. Choosing to adopt internal or external measures at will to suit one's purpose renders any proposed system of proportions suspect, but there are parallels (at St Etienne in Caen and at the Cathedral in Lincoln) for the application of internal measurements externally to entrance blocks, where in any case one might perhaps expect to find them.

12. The nave is about 266 ft (*c.* 81 m) long and the nave plus the distance to the chord about 376 ft (*c.* 114.60 m). For other Anglo-Norman examples see E. Fernie, 'Observations on the Norman Plan of Ely Cathedral', *Medieval Art and Architecture at Ely Cathedral, BAA CT* (1979), 1–4, and 'St Anselm's Crypt', *Medieval Art and Architecture at Canterbury before 1220, BAA CT* (1982), 34–36.

13. The transept piers have, on the faces under the soffits of the arches, a central element which varies little from the width of 2 ft 7 in or 2 ft 7½ in (.79–80 m). The flanking elements vary from 1 ft 8½ in to 1 ft 11 in (.52–.58 m) and average 1 ft 9½ in (.55 m), giving an average total wall thickness of just under 6 ft 3 in (1.90 m). 6 ft 3 in (1.90 m) divided as one: root-two: one equals 1 ft 10 in, 2 ft 7 in and 1 ft 10 in (.56, .79, .56 m). The core of the nave pier is 6 ft 8 in (2.03 m) long from east to west, while the pilaster is 4 ft 8⅓ in (1.43 m) wide and 6 ft 8 in divided by root-two equals 4 ft 8½ in (1.435 m).

Collaborative Enterprise in Romanesque Manuscript Illumination and the Artists of the Winchester Bible

By Larry Ayres

To a level not found in other artistic periods, Winchester's voice was raised in two central epochs of medieval manuscript illumination, the Anglo-Saxon and the Romanesque. It was in these periods that Winchester manuscript painting helped shape the front-lines of the artistic forces of medieval Europe. For Anglo-Saxon art, Winchester provided book illumination with an artistic signature which has come to be regarded as the major insular contribution to the stylistic regionalism of the late 10th and early 11th centuries,[1] an era to which art historians have traditionally applied nomenclatures on the basis of national, imperial, or political considerations, as Anglo-Saxon, Ottonian, or Mozarabic. In Ottonian art around the year 1000, for example, Reichenau and Cologne step forth as Continental 'Winchesters', because illuminated manuscripts from these centres also carry distinct and influential regional profiles.[2] But where do these significant continental houses of book illumination from around 1000 stand in relation to Romanesque manuscript painting a century later? What of the significance of Reichenau and Cologne, of Trier and Echternach for Romanesque illumination of the late 11th and the 12th centuries? Regrettably, their Romanesque reputations pale in comparison to their former pre-eminence.[3] There remains only one centre on continental soil which stands on a par with Winchester in constancy of development and in quality of production in the movement from the earlier regionalisms to the High Romanesque solutions of the 12th century and then beyond. That centre was Salzburg, but even then, Salzburg was a late joiner to the Ottonian scene and its early life has none of the vociferous self-definition found in the Anglo-Saxon 'Winchester School' from the days of its infancy.[4]

During this span of centuries between 980 and 1180, Winchester's only serious rival — and this rivalry also goes beyond things artistic — her only peer in combining constancy of artistic excellence with a position near the mainstream of manuscript illumination was another insular lion, Canterbury.[5] It may seem bold to be making assumptions on behalf of Winchester given that we have what must be only a small fraction of her artistic output from the Romanesque period. But for the survival of the Winchester Bible such a claim would be out of the question for the Romanesque period. However, this great manuscript offers not only glimpses of mainline traditions in Romanesque painting, but it also contains miniatures whose styles look ahead to Gothic naturalism.[6] The Winchester Bible reveals uniformly high performances from all its illuminators and demonstrates that Winchester maintained a vigorous and cosmopolitan artistic environment as exemplified in this book decorated by masters representing highly different stylistic persuasions and sources.

I would like to identify briefly the stylistic orientations of the illuminators of the Winchester Bible before going on to specifics of workshop collaboration. As has been demonstrated by Charles Rufus Morey and Walter Oakeshott, at least two artists who executed miniatures for the Winchester Bible also participated in the embellishment of the famed Terence manuscript bearing a St Albans anathema and now belonging to the collections of the Bodleian Library (MS Auct. F. 2.13).[7] The first of these masters, the Apocrypha Master, best known in the Bible for his painted initials to Hosea (Pl. IIA), Joel,

and Ezra and the frontispiece drawings to Judith and Maccabees, is an exponent of what I have called in a previous study the 'Angevin style'.[8] This artistic current originated and gained a strong foothold in regions which are today French soil but which in the 12th century belonged to the island kingdom of Henry II. Spirited figures are rendered as rather flattened linear designs or colour-silhouettes. Highlights or light patterns usually adhere to the edges of forms in abstract configurations rather than being distributed or modulated in more gradual, naturalistic fashion across the surfaces of figures. The Continental ancestry of this artistic denomination can be shown by comparison with fresco cycles and illuminated manuscripts from the west and south-west of France, works such as paintings from the crypt vault of Saint-Savin-sur-Gartempe and the Baptistry at Poitiers, and miniatures executed at Angers, Limoges, and other centres in the region.[9] The square jaws of figures, the laminated ridges of the torsos, the abrupt movements, the abstract approach to the treatment of highlights and even the palette — a curious burnt yellow or orange, bright blue and purple often lightened with white lines — these features of the Apocrypha Master have antecedents in the Angevin realm.

One of the Apocrypha Master's collaborators in the St Albans Terence and at Winchester belongs to an entirely different stylistic orientation. The identity of this master was first recognised by Walter Oakeshott who named him the Master of the Leaping Figures on the basis of his inspired and animated figural compositions, as for example, those historiated initials prefacing the Fourth Book of Kings and the Fifty-First Psalm (Pl. IIB).[10] The Master of the Leaping Figures's formal outlook can be associated with a Romanesque mode known throughout Western Europe in the 12th century, and found earlier in England in the Bury Bible and the Psalter of Henry of Blois.[11] This style, as seen in his miniatures at Ps. 51, was labelled the 'damp-fold style' by Wilhelm Koehler who was first to draw the distinction between it and the trend represented by the Angevin style in Romanesque art.[12] In contrast to the Angevin outlook of the Apocrypha Master, the 'damp-fold style' adapts three-dimensional values to curvilinear designs, thereby creating abstract lattice-like effects which are nevertheless still shaped by, or cognisant of, plastic or sculptural considerations. Underlying the 'damp-fold idiom' of Romanesque painting was a familiarity with Byzantine art or Byzantinising principles which was lacking in the Angevin phase. In this context, it should also be kept in mind that Magister Hugo in the Bury Bible and the Master of the Leaping Figures at Winchester were not Byzantine artists manqués. Byzantine artistic canons embodied both naturalistic and hieratic values, and Romanesque painters acknowledged such models in their own efforts to harmonise form with ornamental structure. The 'damp-fold style' acknowledges this process.[13] Interestingly enough, in the hands of the Master of the Leaping Figures with his bright and vociferous colouring, it seems to take on a new lease on life.

Byzantine art, but in a different mould, was an essential component in the artistic heritage of three other illuminators of the Winchester Bible: the Genesis Master (Pl. IIIA), the Morgan Master (Pl. IIIC) and the Isaiah Master (Pl. IIIB).[14] But these artists valued it primarily for its leverage in cultivating greater naturalism of expression, and it is also clear that they were aware of a particular stream in Byzantine development, the Late Comnenian style which emanated westward from Constantinople in the second half of the 12th century and asserted its influence in regions both north and south of the Alps.[15] Its expressive leanings and dramatic movements have been characterised as 'dynamic' and 'baroque.' At Winchester, this is most evident in the facial renderings which bear special debts to such Byzantine models.[16] The Genesis Master's work seems most in step with this Late Comnenian turbulence as, for example, exemplified in the mosaics of Monreale, but he also liberates his style here and there from adherence to the cloisonné patterning of Byzantine

drapery. The Morgan Master carries this process a step further, as he adopts a more classicising formal bias in which the figural definition seems more independent of earlier models be they Eastern or Western. Whereas the supple garments give little indication of Byzantine pedigree, the Morgan Master's facial renderings betray clear debts to Greek physiognomic formulas, heavily shaded complexions fostered by green underpainting and expressions endowed with an intensity often at odds with the calmer, classicising forms to which they are attached. This contrast was to a considerable degree alleviated in the miniature by the Isaiah Master, who composed with a more muted palette. These Byzantinising phases at Winchester also had continental cousins so that, in the last quarter of the 12th century, art in Winchester was again linked to pan-European concerns.[17]

With this brief survey in mind, I would like to turn to the illuminated leaf, a detached folio from the Winchester Bible designed to preface the Books of the Kings and now belonging to the Pierpont Morgan Library in New York City (MS M. 619).[18] The verso (Pl. IVA) of this leaf, which depicts scenes from the life of David, has been taken as a hallmark of the Morgan Master's finished work. Here his partiality for introducing bright red into the colour scheme is noticeable in a world which is otherwise dominated by blue and pastel shades of pink, grey or beige. The faces of Saul and Samuel in this work however reveal that in facial portrayals the Morgan Master is still taking his cue from his Byzantinising sources. This same dependence on Byzantine physiognomy is also a keynote of the miniatures which he executed on the other side of the Morgan Leaf which is devoted to the history of Samuel as recorded in the First Book of Kings (Pl. IVB). This is clearly seen in the scene which shows the dedication of the young Samuel to the Lord's service as Hannah presents him to Eli, but apart from the facial types in this scene, the chromatic atmosphere is strikingly different from the Morgan Master's work on the verso of the same folio, enough so as to invite further investigation of the matter.

Walter Oakeshott was among the first to observe that in the Samuel cycle of the recto, the Morgan Master is guided by designs of the Apocrypha Master and he indeed finished painting the compositions of another illuminator. If we take a closer look at the amphora carrier who stands behind Hannah in the scene — and incidentally the iconography of the figure has an earlier parallel in the initial at I Kings of the Stavelot Bible (Pl. VA), a Romanesque manuscript to which we shall return anon[19] — the amphora carrier's demeanor bears a clear resemblance to the style of figures by the Apocrypha Master on other pages of the Winchester Bible (cf. Pl. IIA), not only in the external features of designs such as the arcs of ridged folds, but there is also an attempt here to emulate the burnt-yellow colouring so characteristic for the Apocrypha Master.[20] It seems as if the Morgan Master, in finishing this design by the other miniaturist, has also adapted his palette to that of the Apocrypha Master's illuminations, but the facial rendering nevertheless belongs to the Morgan Master's own outlook. In the adjacent figures of Hannah we see a different process at work, for here the Morgan Master reverts to a softer pastel pink tone of the kind found elsewhere in his own work but not in that of the Apocrypha Master. In using a colour more in keeping with his own style, the Morgan Master apparently does not feel as obliged to follow that other artist's drawings so rigorously, and we can see in the treatment of the garment across Hannah's right knee that the Morgan Master has taken little notice of the hook-like convention of the Apocrypha Master's underdrawing. The same can be said of his portrayal of Hannah's prayer located in the lower left corner of the leaf. Here the Morgan Master uses a flaxen yellow known in his other work and disregards entirely the underdrawing for a more plastic expression, whereas in the figure of Eli anointing Saul at the far right, we see a Romanesque fashioning of folds in a brighter coin with the characteristic orange edging, an approach to value modelling which looks to the past.

A similar attitude can be discerned in the miniature to Zephaniah in the Winchester Bible, a miniature in all probability designed by the Apocrypha Master, but painted by the Genesis Master whose Byzantinisms are readily apparent in the facial types (Pl. IIID).[21] In this depiction of the prophecy of the Day of the Lord, in the figure directly beneath the Lord's right, we see two pictorial systems at work. In the bright yellow cloak we recognise the Apocrypha Master's approach to colouring and the same hook-like folds, but on the long tunic in blue we meet remnants of *cloisonné* folds gleaned from the Genesis Master's Byzantine sources. In the treatment of the Lord's left shoulder we see a further quotation from the Apocrypha Master's technique in the web of orange highlights which stick to the contours as in 'Angevin' production. The adjacent figure who wears a violet tunic shows the same laminated frame in the treatment of arm and torso that characterises the Apocrypha Master, even though this miniature was painted by the Genesis Master.

These observations regarding collaborative enterprise in Romanesque illumination touch on a question that is not new to Bible illustration. For example, the giant Bible now in the British Library (Additional MSS 28106–7) which was written and decorated at Stavelot Abbey between 1093 and 1097 also exhibits the same phenomenon of different talents focused on the same miniature.[22] In the beautiful initial at I Kings (Pl. VA), Usener saw the hand of another artist at work in painting initials by the immaculate draughtsman he dubbed the Pentateuch Master. Furthermore he suggests that one of the scribes of the Stavelot Bible, Goderannus, embellished designs by other illuminators. But perhaps a closer analogy to the Winchester issue can be seen in the miniatures of a Gospel Book produced at the Saxon house of Helmarshausen in the late 12th century, a manuscript which was adorned by three illuminators of different stylistic orientation. For the light it may throw upon the workshop practices at Winchester, I would like to review aspects of book illumination at the Benedictine abbey of Helmarshausen in the last quarter of the 12th century and, in particular, treat the artistic relationship of two of the three masters of the Helmarshausen Gospel Book now at Trier.

Sometime between 1168 and 1189 Herimann, a monk of Helmarshausen, executed as scribe and presumably as illuminator a splendid Gospel Book for the Guelph Duke (Pls VB, VIA; formerly Gmunden, Schloss Cumberland), a manuscript which unfortunately disappeared from public view during the Second War.[23] The British Library owns a somewhat earlier product of Herimann's workshop, the Psalter of Henry the Lion (Pl. VIB; Lansdowne MS 381 I), a book so-called because representations of Duke Henry (1129–95) and his wife, Matilda, the English princess, were included in the Crucifixion miniature of its pictorial cycle.[24] The marriage of Henry, Duke of Saxony, to the daughter of Henry II of England was celebrated in 1168, and for this reason, it has traditionally been assumed that the psalter dated from about 1168 or shortly thereafter and the stylistically later Guelph Gospels from about 1175. Recent investigations on the Psalter and the Gospels of Henry the Lion now propose somewhat later dates in the 1180s as more appropriate for these volumes, sometime in the period after Henry's downfall in 1180 but before Matilda's death in 1189.[25] Common in miniatures of the Helmarshausen school in the time of Herimann were intense, opaque colours, which still resound in spite of flaking in some areas, vermiculated backgrounds in gold and silver, and an almost *horror vacui* approach to constructing ornamental layers of pigment.[26] The sacrifices made in the name of surface pattern are clearly indicated in the portrayal of the Resurrection from the psalter's pictorial cycle (Pl. VIB). This stylistic outlook is substantially if not totally maintained in the later Guelph Gospels (Pl. VB, VIA), a book which contains dedication and coronation miniatures depicting Henry and Matilda and which was in all likelihood presented to St Blasius at Brunswick on the occasion of the dedication of the altar to St Mary in 1188.[27]

The next illuminated book to emerge from the Helmarshausen scriptorium was another Gospel Book whose decorative programme shows both conservative and progressive tendencies side by side. This manuscript now belongs to Trier Cathedral (Pl. VIIA, B, VIIIA; Domschatz MS 67; Dombibliothek MS 142),[28] and according to Ekkehard Krüger in his recent study of the scriptorium of Helmarshausen in the time of Henry the Lion, the Trier volume was written by the same scribe who wrote the Guelph Gospels of the Duke, namely Herimann.[29] Herimann's hand is also evident in the majority of ornamental initials of the volume. But the miniatures of the Trier Gospels show that new artistic forces were also affecting Helmarshausen in the form of illuminators who were much more cognisant of contemporary Byzantinising trends. Most relevant for our purposes is the artist of the Last Judgment miniature in the Trier Gospels, an artist fully conversant with the attitudes of Late Comnenian Byzantine principles but at the same time translating them in accord with Western naturalistic tendencies of the last quarter of the 12th century (Pl. VIIA). His Byzantinising facial composures show that we are dealing with a miniaturist in the Morgan Master's league, but the Saxon master never went as far as the Winchester illuminator in translating his Byzantine borrowings into classicising figurative structure.

This Byzantinising painter whom we shall call the Judgment Master undertook to execute in paint miniatures designed by Herimann or a close follower in the Trier Gospels. This is particularly evident when comparing the Last Judgment miniature (Pl. VIIA) before the opening of John's Gospel with the frontispiece to that of Mark (Pl. VIIB). The faces of the figures in both works bear the imprint of the Judgment Master's style or influence, whereas the bodies of the figures in the miniature at Mark conform to Romanesque canons as known in Herimann's *oeuvre*. The Judgment scene represents the Judgment Master's vision in totality. In comparison the Baptismal figures seem flat when contrasted to the more bulky and agile forms found in the Judgment scene. Comparisons of details of garments from each miniature show that the pictorial topography of the Baptism scene has been superseded by a more fluid and continuous approach to modelling which is based less on impasto contrasts. To place the Baptism scenes of the Trier Gospels (Pl. VIIB) and Guelph Gospels (Pl. VIA) side by side shows the endurance of Herimann's ideas in the later manuscript, but they are being subjected to new sets of rules as well, especially in the facial renderings.

Now this process of artistic collaboration at Helmarshausen has been scrutinised carefully by art historians.[30] Georg Swarzenski in his study of the house in the time of Henry the Lion saw the miniature campaign of the Trier Gospels as a collective undertaking.[31] Swarzenski perceived a younger artist, the Judgment Master, completing the designs of Herimann as a new master of high artistic range who entered the school from a different and progressive artistic heritage. Karl Usener, on the other hand, saw an exchange of artistic language, a dialogue between Herimann and the Judgment Master, taking place in the Trier Gospels.[32] He felt that miniatures such as the Baptism from the Trier Gospels (Pl. VIIB) displayed two talents in communication with Herimann updating his pictorial outlook to that of the new Byzantinising intrusion. In favour of Usener's stance are the vermiculated gold backgrounds of the Baptism miniature, but when viewing the facing page, the ornamental text page opening the Gospel of Mark (Pl. VIIIA), I doubt that Herimann could have bridged such a wide gap and could have poured such a powerful image of the Evangelist Mark into this golden initial framework which is certainly Herimann's. In the final analysis, it appears that the figurative or pictorial work of this passage of the volume was assigned to the Judgment Master, working from Herimann's designs and at times making the requisite modifications with the facility of an 'alter ego'.[33] Herimann's primary contribution to the Trier volume was the forest of golden initials which he created throughout the book and which were a carry-over from his earlier Helmarshausen

tradition. Chronological objections to the phenomenon of workshop simultaneity at Helmarshausen — with conservative and avant-garde masters of different stylistic persuasions and training working side by side, or with one artist assisting in finishing the designs of a colleague — need no longer stand as a barrier to the notion of a collective process in light of recent arguments favouring a date in the 1180s for the Guelph Gospels.[34] To recapitulate, the detached leaf from the Trier Gospels now in the Cleveland Museum of Art (Pl. VIIIB) contains a miniature designed by Herimann, but its painted execution shows the Byzantinising heads of the Judgment Master who accommodated his figural painting otherwise to the flatter, less modulated colour-schemes of Herimann's tradition. The situation seems analogous to the Morgan Leaf whereby one artist is attempting to adapt aspects of his rendering in paint to the design and colour co-ordinates of another. What effected such alliance other than the presence of both illuminators in the scriptorium simultaneously?

The breathtaking miniature at II Kings in the Winchester Bible presents us once again with this dilemma of evaluating colour values in relation to other features of an artist's style (Pl. IXA, B).[35] The narrative of the letter begins depicting Saul's suicide on Mt Gilboa as the Israelites do battle with the Amalekites. Midway in the stem of the letter an Amalekite offers Saul's bracelet and sword to David who rends his garment in a gesture of inconsolable grief. Now the faces of these figures surely acknowledge the presence of the Morgan Master and may be assigned to him or an assistant (Oakeshott's Amalekite Master) because of their Byzantinising complexions. The heated battle shows a brilliant palette at work and an expression of 'damp fold' conventions as the initial was evidently designed by the Master of the Leaping Figures and, with the exception of the faces, the illuminator attempted to remain faithful in painting the initial to the stylistic bias of the Master of the Leaping Figures. At the base of the initial, the Amalekite at David's order receives his due in a miniature which is a *tour-de-force* of medieval book illumination (Pl. IXB). If, however, we compare the decapitated Amalekite at II Kings with the figure of Doeg slaying the priests (Pl. IIB), we can see that the Morgan Master or his assistant (the Amalekite Master) attempts at II Kings to retain the bright colour scheme of the Master of the Leaping Figures as he finishes the painted work of the design, but, on the other hand, the more modern master has little sympathy for the sharp light patterns sponsored by the Romanesque fascination with surface values. Or was such impasto definition built from *appliquéd* layers now beyond the aesthetic reach of the Morgan Master's generation? One notes the change in tonal outlook when this same master paints the miniature at III Kings where he in turn composes in a calmer classicising pictorial language more his own.

For the art historian, the question of simultaneity, of a large atelier of diverse masters, each embodying artistic excellence but also belonging to different stylistic generations, seated side by side and illustrating gatherings of the self same book, may involve chronological obstacles. It would be difficult to date the Morgan Master's style in the Winchester Bible much before the mid-1170s at the earliest, and yet can the date of the miniatures of the Apocrypha Master and Master of the Leaping Figures be advanced to such a late period, even in terms of their representing a brilliant sunset of two Romanesque modes, the 'Angevin' and the 'damp-fold' idioms? But, on the other hand, these miniatures are paintings and must presumably obey its laws, which point in several instances to a dialogue between masters or at the very least an acknowledgement of another's approach in design and execution. Indeed how integral is colour to the structure of pictorial style? Is there more to this than a later generation of Byzantinising illuminators tipping their hats to two mainstay styles of Romanesque painting? Did the novelty of the new Byzantinising intrusion, surely the wave of the future, bring about at Winchester in the late 1170s or early 1180s a situation analogous to that found at Helmarshausen in the Trier Gospels? These

parallels at Helmarshausen can only widen Boase's boundaries of the 'Channel School' in the art of north-west Europe during the period.[36]

In conclusion, the pan-European picture holds relevance for the decorative program of the Winchester Bible to a degree not known for the earlier 'Winchester School' of the Anglo-Saxon period. But this is not surprising in view of the historical dimension of England's new alignments with the Continent in the post-Conquest era. The Winchester Bible miniatures are significant because they acknowledge these new Continental and Mediterranean links and sources without sacrificing any of the vitality known in insular book illumination since Hiberno-Saxon times.

ACKNOWLEDGEMENTS

The author wishes to thank the Alexander von Humboldt Stiftung for a travel grant which enabled him to attend the Winchester Conference of the British Archaeological Association.

REFERENCES

1. F. Wormald, *English Drawings of the Tenth and Eleventh Centuries* (London 1953); idem, 'L'Angleterre', in *Le siècle de l'An Mil (950–1050)* (Paris 1973), 227 ff.; E. Temple, *Anglo-Saxon Manuscripts, 900–1066* (London 1976), esp. 17 ff.

2. H. Jantzen, *Ottonische Kunst* (Munich 1947); F. Mütherich, 'L'art ottonien' in *Le siècle de l'An Mil (950–1050)* (Paris 1973), 87 ff.

3. C. Nordenfalk, 'Romanesque Book Illumination', in *Romanesque Painting from the Eleventh to the Thirteenth Century* (Geneva 1958), 143.

4. For a review of Salzburg production, see O. Demus, 'Kunstgeschichtliche Analyse', in *Das Antiphonar von St Peter (Kommentarband)* (Graz 1974), 263 ff. Another continental candidate for this role would be Regensburg.

5. C. R. Dodwell, *The Canterbury School of Illumination, 1066–1200* (Cambridge 1954).

6. O. Pächt, 'A Cycle of English Paintings in Spain', *Burlington Magazine*, CIII (1961), 166–75; L. M. Ayres, 'The Work of the Morgan Master at Winchester and English Painting of the Early Gothic Period', *The Art Bulletin*, LVI (1974), 201–23; W. Oakeshott, *The Two Winchester Bibles* (Oxford 1981), esp. 68 ff.

7. L. W. Jones and C. R. Morey, *The Miniatures of the Manuscripts of Terence prior to the XIIIth Century* (Princeton 1931), 2 vols, 92, Fig. 35; W. Oakeshott, *The Artists of the Winchester Bible* (London 1945), 18 f.; idem, *Winchester Bibles*, 53.

8. L. M. Ayres, 'The Role of an Angevin Style in English Romanesque Painting', *Zeitschrift für Kunstgeschichte*, XXXVII (1974), 193–223.

9. L. M. Ayres, 'English Painting and the Continent during the Reign of Henry II and Eleanor,' in *Eleanor of Aquitaine: Patron and Politician* (Austin, Texas 1976), 115 ff.

10. Oakeshott, *Artists*, 4–5, 8–10; idem, *Winchester Bibles*, 43 ff.; H. Roosen-Runge, *Farbgebung und Technik frühmittelalterlicher Buchmalerei*, 1 (Berlin/Munich 1967), 123 ff., notes the vitality shared by colour and formal articulation in the Master of the Leaping Figures painted miniatures.

11. C. M. Kauffmann, *Romanesque Manuscripts, 1066–1190 (A Survey of Manuscripts Illuminated in the British Isles*, III) (London 1975), 25.

12. W. Koehler, 'Byzantine Art in the West', *Dumbarton Oaks Papers*, I (1941), 63 ff.

13. E. Kitzinger, 'The Byzantine Contribution to Western Art of the Twelfth and Thirteenth Centuries', *Dumbarton Oaks Papers*, XX (1966), esp. 37 ff.

14. For these masters and their initials, W. Oakeshott, *Sigena: Romanesque Paintings in Spain and the Winchester Bible Artists* (London 1972); idem, *Winchester Bibles*, 58 f.; Ayres, 'Morgan Master', 207 ff.

15. K. Wietzmann, 'Eine spätkomnenische Verkündigungsikone des Sinai und die zweite byzantinische Welle des 12. Jahrhunderts', *Festschrift für Herbert von Einem* (Berlin 1965), 299 ff.

16. E. Kitzinger, 'Norman Sicily as a Source of Byzantine Influence on Western Art in the Twelfth Century', *Byzantine Art: An European Art* (Lectures Given on the Occasion of the Ninth Exhibition of the Council of Europe) (Athens 1966), 137.

17. O. Demus, *The Mosaics of Norman Sicily* (London 1949) 443 ff.; Weitzmann, op. cit., 309–12; idem, 'Various Aspects of Byzantine Influence on the Latin Countries from the Sixth to the Twelfth Century', *Dumbarton Oaks Papers*, XX (1966), 23–24; Kitzinger, 'Byzantine Contribution', 38 ff.; O. Demus, *Byzantine Art and the West* (New York 1970), 150 ff.; H. Belting, 'Zwischen Gotik und Byzanz: Gedanken zur Geschichte der sächsischen Buchmalerei im 13. Jahrhundert', *Zeitschrift für Kunstgeschichte*, XLI (1978), 230 ff.

18. Now reproduced in colour by Oakeshott, *Winchester Bibles*, Pls II, VII.

19. K. H. Usener, 'Les débuts du style roman dans l'art mosan', in *L'Art Mosan* (Paris 1953), 104 ff., Pl. XV (2).

20. While the image of the amphora carrier found in the Winchester (Morgan Leaf) and Stavelot Bibles must derive from a pictorial recension(s) devoted to the Books of the Kings, the shape given the vessel by the Apocrypha Master in the Morgan Leaf seems closer to that of the amphora shouldered by a figure in one of his drawings in the St. Albans Terence manuscript (Oxford, Bodleian Library, MS Auct. F. 2.13, fol. 4ᵛ). Here we must consider the possibility of an interplay or revision of pictorial sources, or assume that the Apocrypha Master, in line with his own artistic experience, updated features of the imagery found in the iconographical guide(s) which was employed by the artists of the Winchester Bible.

21. G. Zarnecki, *Art of the Medieval World* (New York 1975), 375, colourplate 48; Oakeshott, *Winchester Bibles*, 92, fig. 118.

22. Usener, op. cit., 105 f.; D. H. Turner, *Romanesque Illuminated Manuscripts in the British Museum* (London 1966), 10–12, Pl. 3; W. Dynes, *The Illuminations of the Stavelot Bible* (Ph.D. Dissertation, New York University 1969), 79 ff.; *Rhein und Maas*, I (Exhibition Catalogue, Cologne 1972), no F27. To Oakeshott's reference (*Winchester Bibles*, 65) to another instance of stylistic pluralism, in miniatures of the Codex Aureus written at Echternach between 1043 and 1046 (Escorial, MS Vitrinas 17), should be added recent investigations regarding the source and role of the Byzantine renderings of the heads and hands of Christ and the Virgin in the dedication pictures: K. Weitzmann, 'Various Aspects of Byzantine Influence', p. 4; C. Nordenfalk, *Codex Caesareus Upsaliensis: An Echternach Gospel-Book of the Eleventh Century* (Stockholm, 1971) 143 ff. That the Byzantine features date from the 11th century seems established by comparison with illuminations in Greek manuscripts and icons of the period. Byzantine illumination of the period was known to the West in examples such as the Greek Psalter destined for St Gereon in Cologne (Vienna, Österreichische National-bibliothek, Cod. Theol. gr. 336); O. Mazal, *Byzanz und Das Abendland* (Exhibition Catalogue, Vienna 1981), 480–81, no. 381, Abb. 22.

23. See K. H. Usener's review of the scholarship on the manuscript in *Kunst und Kultur im Weserraum, 800–1600*, II (Exhibition Catalogue, Münster 1967), 503–05, no. 192; H. Swarzenski, *Monuments of Romanesque Art*, second edition; (London/Chicago 1967), 78–79. Fig. 478; W. Eckhardt, *Alte Kunst im Weserland* (Cologne 1967), Abb. 57–58; R. Haussherr, 'Zur Datierung des Helmarshausener Evangeliars Heinrichs des Löwen', *Zeitschrift des Deutschen Vereins für Kunstwissenschaft*, XXXIV (1980), 3 ff.

24. Turner, op. cit., 21–22, pl. 12; *idem, Illuminated Manuscripts Exhibited in the Grenville Library* (London 1967), 37–38, no. 38, Pl. 11; C. R. Dodwell, *Painting in Europe, 800–1200* (Harmondsworth 1971), 164–55, Pl. 181; R. Kroos in *Die Zeit der Staufer*, I (Exhibition Catalogue, Stuttgart 1977), 584–85, no. 755; idem, in *Wittelsbach und Bayern*, I, *Die Zeit der frühen Herzöge* (Exhibition Catalogue), Landshut, 1980, p. 10 ff., no. 9; Haussherr, ibid., p. 12 ff.

25. Kroos, ibid., 13; Haussherr, op. cit., 11 ff.

26. For these ornamental patterns, see also F. Steenbock. 'The Cross from Valasse', in *The Year 1200: A Symposium* (New York 1975), 166–67, Fig. 5.

27. Haussherr, op. cit., 11.

28. Usener, *Kunst und Kultur im Weserraum*, 506–07, no. 193, Abb. 187–89, 193b, c, 231; K. Hoffmann in *The Year 1200*, I (Exhibition Catalogue), New York 1970, 264; O. Mazal, *Buchkunst der Romanik* (Graz 1978), 190–92; Haussherr, op. cit., 13.

29. E. Krüger, *Die Schreib- und Malwerkstatt der Abtei Helmarshausen bis in die Zeit Heinrichs des Löwen* (Darmstadt/Marburg 1972), I, 313–15, 356–58; II, 915–26.

30. G. Swarzenski, 'Aus dem Kunstkreis Heinrichs des Löwen', *Städel Jahrbuch*, VII-VIII (1932), 262 ff.; F. Jansen, *Die Helmarshausener Buchmalerei zur Zeit Heinrichs des Löwen* (Hildesheim/Leipzig 1933), 118 ff. This is not the place to take up again the question of the possible influence of 'English' or 'Winchester' pictorial traditions on Saxon painting of the period as discussed by Swarzenski, 273 ff.; Jansen, 130., and Belting, op. cit., 220 ff., but, in this context, it should be kept in mind that during the period of his exile, Henry the Lion found refuge at his father-in-law's court between 1182–85. A son, Wilhelm, was born to Henry the Lion and Matilda at Winchester in July or August 1184, and this child was to become the progenitor of future generations of the Guelph house. See A. L. Poole, 'Die Welfen in der Verbannung', *Deutsches Archiv für Erforschung des Mittelalters*, II (1938), 129 ff; K. Jordan, *Heinrich der Löwe* (Munich 1979), 215.

31. Ibid., 273.

32. Usener, *Kunst und Kultur im Weserraum*, 506–07.

33. For the Judgment Master's adaptations to the colour schemes of Herimann's garment patterns, see G. Swarzenski, op. cit., 272.

34. Kroos, op. cit., 13; Haussherr, op. cit., 11 ff.

35. Reproduced in colour by Oakeshott, *Winchester Bibles*, 65 f., Pl. IX.

36. T. S. R. Boase, *English Art, 1100–1216* (Oxford 1953), 180 ff.; W. Cahn, 'St Albans and the Channel Style in England', *The Year 1200–A Symposium* (New York 1975), esp. 197 ff.

The 'Henry of Blois plaques' in The British Museum

By Neil Stratford

In 1852 the two famous Romanesque enamelled plaques (Pl. X) were presented to the British Museum by the Rev. George Murray 'at the desire of the late Rev. Henry Crowe.'[1] Their earlier history, in so far as it can be established, has not been fully recorded in any of the numerous publications which have referred to them.[2] It may be briefly outlined here.

In December 1813 the editor of *The Gentleman's Magazine*, John Nichols, published an engraving, which shows the plaques joined together as a dish.[3] This engraving seems to be executed after a lost drawing by Thomas Fisher, the celebrated draughtsman and antiquary, who was a regular contributor to the Magazine in the early 19th century.[4] The facts of the 1813 article are probably also due to Fisher: 'The Plate is composed of two pieces, or halves; it is clumsily riveted by clamps at the back, two on the rim, and one (a circular piece of brass) in the centre, which also serves as a stand for the plate'.[5] At this time it was 'in possession of a Correspondent' and had been 'preserved in a respectable family for a number of years'. If Fisher is indeed the source of these remarks, then it seems possible that the plaques did not yet belong to him in 1813. Acquire them he did at some subsequent date, because the Rev. Henry Crowe, Vicar of Buckingham, bought them at the sale of his effects at Southgate's in Fleet Street in 1837.[6] One other point. Nothing in the career of the earliest recorded owner of the plaques, Thomas Fisher, would suggest an obvious connection either with Hampshire, let alone with Winchester, or with Glastonbury.

The plaques measure respectively 17.8 and 17.9 cm in diameter. They are 'dished', that is concave (at deepest 1.75 cm), with a flat rim (1.8 cm across), and they are hammered from single sheets of virtually pure copper. In this respect they resemble all the other Romanesque enamelled plaques (including Mosan and Limoges enamels), which have so far been analysed by the British Museum Laboratory.[7] For it seems that a high percentage of zinc in the copper causes a chemical reaction during firing which discourages adherence of the enamel to the surface of the metal. Again, the process of mercury gilding is made infinitely more difficult by the presence of zinc and particularly of lead, as is proved by analysis of a series of Romanesque 'bronzes' (in fact of brass or latten), which are not enamelled and where notably higher percentages of alloying agents are found in precisely those objects which were never gilded.[8] On the other hand, even the gilded 'bronzes' are never anything like as high in copper content as the enamels. It looks as if the enameller consciously employed a pure copper, and the advantage of this at the gilding stage was only a secondary consideration.

The *champlevé* fields of the two plaques are engraved with a precision which is extraordinary even in this period of high technical accomplishment, cf. the hand of one of the angels holding a chalice (Pl. XIIIB), with a detail of a cup on a more or less contemporary Mosan plaque, so much less accurate in execution (Pl. XIIIc).[9] Other details of the *champlevé* process are laid bare by radiography (Pls XI, XIIB). For instance, the outline of the area to be enamelled was probably cut first by the engraving tool but then the metal was cleared away from the rest of the field to a perfectly uniform depth so that no trace is left of the original outline. However a line of prick-marks placed opposite each of the wing feathers of the censing angels is a legacy of the sharply pointed gouge which was used to dig out the metal between each of the wing pinions. Too deep to be smoothed away, they are

nevertheless invisible through the surface enamel (Pls XI, XIIc, D).[10] Such technical details brought to light by X-rays may well help in due course with the identification of individual workshop procedures, but they have an even more fundamental potential for the art-historian. The coloured enamel 'stands between' the spectator and the original drawing style of the coppersmith. Radiography 'removes' this enamel barrier, leaving his drawing exposed. It is not difficult to imagine how radically X-rays may one day alter our assessment of the stylistic position of certain enamels, just as with the Winchester Bible, photographic techniques have allowed a new assessment of the underdrawing of some of the initials.[11] Who for instance would ever have suspected the subtly different weighting of the lines in the drawing of Bishop Henry's head (Pl. XIIB)? A wide deep channel outlines the forehead and nearer side of the face but the beard and hair are executed with delicate shallow strokes whilst the lines of eyebrows, eyelids and pupils, as well as the uppermost lines of beard and moustache are cut to just a fraction deeper. I will return to this drawing technique with its remarkable variations of weight and width of line, when considering the stylistic pedigree of the plaques.

The glasses used for the two plaques were: white, yellow, 2 greens, 3 blues, including turquoise, an opaque red and a purple, the latter the only translucent glass, probably because if an opacifier had been added, it would have fired to a murky mauve colour.[12] All these colours are absolutely standard to Mosan enamelling and are used there in exactly the same way, distributed in the same sequences.[13] Although it is obviously impossible to illustrate this point without coloured plates, it remains of the greatest significance to an assessment of the art historical position of the Henry of Blois plaques and will therefore be mentioned again, but first some other technical observations about their enamelling. There is no use of speckled enamel (granules of two opaque colours, such as red and blue or green, mixed together before firing). This is a speciality of certain Mosan enamel workshops but is used sparingly until it inspires a wide range of virtuoso variations on the Klosterneuburg Ambo of 1181, the last and greatest work of Mosan 12th-century figured enamelling.[14] Secondly, the inscriptions[15] and the engraved lines in, for instance, the reserved areas on Henry's face and hair (Pl. XIIA), are filled with blue enamel, whilst the surviving copper surfaces were as usual mercury-gilded. Thirdly, the thin line of red which shows against the edges of some of the fields and is found on so many Romanesque *champlevé* enamels is not glass at all but cuprous oxide thrown out by the metal during firing.

The two plaques have often been published with the Henry plaque above the angels' plaque, since this was their arrangement when they were joined together as a dish. In fact the angels must originally have been set at the top of an object, censing something below, whereas Bishop Henry (HENRICVS.EPISCOP.') was a kneeling donor beneath the principal scene. Thus arranged, the two border inscriptions read the right way up (Pl. X). But what type of object were they set into? Seven original pinholes for attachment to a wooden core are evenly spaced on the rim of each plaque.[16] Since the plaques must have been related to some central scene or figure (or possibly relic), various possibilities assuming other lost plaques can be envisaged: an elaborate arrangement of radiating plaques as on the upper part of the St Remaclus retable from Stavelot[17] or on certain phylacteries,[18] or a simpler disposition, if they are two of the four terminals of a large altar cross. This latter proposal is plausible, especially since one of the censing angels is carrying a chalice.[19] The only obvious objection to it is that the object carried by Bishop Henry is certainly not meant to represent a cross and much hangs on how the donor portrait is interpreted. But leaving aside this problem for the moment, it may be said that although no close parallels exist where two plaques of this scale and concave form are arranged radially so that their straight edges are set towards the exterior, they must nevertheless have been so arranged.[20] The only doubt

concerns the precise position of the Bishop Henry plaque. It could have been either directly beneath or, given the direction of his gaze, to the left below the central scene.

The two border inscriptions are obscure in several points of meaning.[21] A glossed attempt at translation can be found in the Appendix (below);[22] it is as far as possible a dispassionate rendering and it takes into account two factors: (1) the inscriptions are unlikely to have followed on immediately one from the other (a sequence has always been assumed by translators but, as has already been argued, the plaques were probably separated by one or more intervening plaques); (2) whatever the precise original relationship between the two plaques, the inscription around the angels at the top was probably intended to be read before the Henry inscription at the bottom, within a lost series of inscriptions. Previous translations have always placed the Henry verses first, because in this way an eight-line poem can be reconstructed. Since this cannot be justified on archaeological grounds, it is actively misleading. What is more, the two inscriptions are in different verse forms and unlikely to belong together: the angels' inscription consists of four hexameters, while the Henry inscription is made up of two elegiac couplets. Nevertheless, and with all these reservations, the general meaning of the inscriptions is clear: the first begins with an enigmatic line, which would presumably be comprehensible if the preceding inscriptions had survived; it then sings the praises of a donor who is not named, but who is of the utmost importance to England's state. The other inscription, after opening with a reference to the author, who is probably the patron rather than the artist, ends with a paean of praise for a donor, Henry, who is represented here in bronze.

Quite apart from their intrinsic beauty as works of art, the plaques have attracted a good deal of attention as historical documents. Here after all is a very rare survival, outside the demesne of seals, with a contemporary image of one of the greatest political figures of 12th-century England. For the Bishop Henry of the plaques must indeed be Henry of Blois, as Franks long ago observed. He is the only eligible English Bishop Henry of this period.[23] But at this point, fanciful interpretation of the significance of the inscriptions has taken over and dominated the arguments. For instance, early dates have been attached to the plaques on the basis of the reference in the angels' inscription to peace and war in England. Surely, it is argued, the plaques were made before King Stephen's death in 1154, when Henry was at the height of his power, perhaps even in the period 1139–46?[24] But the most cursory glance at Henry of Blois' long and eventful career will reveal that he always considered himself a major influence on the political stage, whether he was or not.[25] It is a pure assumption that the plaques belong to the period of his papal legatine activities or of the civil war. An equally valid but equally unprovable interpretation of the inscriptions would be that they were composed when he was well-advanced in age, unless it was at a time of severe illness, since one of them dwells on the eventuality of his death as a cause of concern. All that can be said with certainty is that the inscriptions are not posthumous,[26] and that the plaques therefore date from the period when Henry was Bishop of Winchester, between 1129–71.

In 1919 Mitchell was the first to associate the two plaques with the shrine of St Swithun at Winchester, to interpret the object being carried by Bishop Henry as a representation of the shrine and to mention in this connection a translation of the saint's relics in 1150.[27] This hypothesis which was put forward in all humility by Mitchell has since achieved canonical status; it is so widely accepted that it is hardly considered worthy of further discussion.[28] But can the object carried by Bishop Henry indeed be read as a shrine? The question is important, for the tradition of representing medieval donors holding something which approximates rather precisely to their actual gift is too well documented to be ignored.[29] Henry's gift (Pl. XIIA) is an oblong object, slightly tapering towards the bottom in a 'false perspective', its surface decorated with three more or less (allowing for irregularity and

'perspective') oval enamelled discs. These discs are framed by bands of reserved gilt metal engraved with a pearled motif. A hatched circle or semi-circle marks the junction between neighbouring discs and the outer border. All these pearled or hatched frames are reserved against red enamel. The enamelled areas of the three discs are turquoise, of the spandrels purple, and of the outer border azure blue/pale blue/white. Nothing in this description would immediately suggest a shorthand representation of a shrine, although if the artist wished to show not a house-shrine with gabled roof (by far the commonest form of shrine in the 12th century) but a flat-topped rectangular box such as the arm-reliquary of Charlemagne in the Louvre,[30] it is just possible that he might have drawn it as a tapering rectangle.[31] However, the object set as it is with different coloured glasses looks if anything like the top of an altar, encrusted with rare stones or marbles, either a very large portable altar[32] or a full-scale church altar.[33] This interpretation would still allow the two plaques to be cross terminals, for if cross and altar were joint gifts, Henry might well have been shown presenting the altar on which the cross stood.[34]

As to the tradition that Henry of Blois contributed to the shrine of St Swithun, it is based on a single entry in the *Winchester Annals*: 'MCL. Hoc anno translatae sunt reliquiae sanctorum confessorum Birini, Swithuni, Aeddae, Birstani, Elfegi. . .' (this is followed by notes on a great frost which caused the Thames to freeze up so that it was passable on foot and horseback; on the capture of Lisbon; on the death of Abbot Geoffrey of St Albans).[35] This sentence about the 1150 translations can be found in more or less identical form in two other roughly contemporary MSS, written in the late 13th or early 14th century.[36] It therefore represents the 'official' Winchester record. Additional weight is given to it by the claim in the preface to one version of these annals that they were compiled successively at the end of each year.[37] On the other hand, they have their share of mistakes, particularly as far as dates are concerned; a howler even occurs under this very year, 1150.[38] But none of this is relevant to the issue, for even if the entry is taken at face value, it makes no mention of new or restored shrines for the translated relics and Henry of Blois' name is omitted altogether from the entry. This would not necessarily be remarkable, were it not for the fact that elsewhere in this part of the annals he is given very full credit for his achievements, and that in this year, 1150, he may hardly have been at Winchester at all.[39] Compare for instance the entry in the annals for 1167, which includes the sentence: 'Magna crux consecrata est ab Henrico episcopo.'[40] This refers of course to the great gold and jewelled reliquary cross, which heads the posthumous list of Bishop Henry's gifts to Winchester.[41] So we should allow this list, which survives in two detailed, though slightly differing late 12th-century versions, to act as the final arbiter of the claim about Henry and St Swithun's shrine. Surely such a list would not fail to mention an embellishment of St Swithun's shrine which had been paid for by Henry? Indeed it would certainly come high on the list, if not first. Yet there is no mention of St Swithun among its 63 items. What is more, there is no other documentary or archaeological evidence for a new or refurbished shrine to St Swithun in the middle years of the 12th century.[42] It is time once and for all to abandon the theory, for which there is not one shred of evidence, that the two plaques come from St Swithun's shrine.

The list of Bishop Henry's gifts to Winchester is remarkably evocative and contains at least two items which could have provided the original setting for the plaques: 'Tabula aurea ad maius altare operta auro et ornata esmallis et multis lapidibus pretiosis' (no. 2); 'Item cassula aurea signata cum esmallis desuper' (no. 18).[43] It is also perfectly possible that the enamels never had anything to do with Winchester. They could just as well have been made for Glastonbury, St Martin-le-Grand, Montacute, or any one of a number of other places connected with or visited by Henry. As Professor Christopher Brooke recently remarked to me, Henry of Blois was the kind of man who liked to leave his mark wherever

he went. There is, for instance, a record of Henry's gift of a great jewelled ring to St Albans. Characteristically he had his name inscribed on it.[44]

Finally, there is the question of the art-historical pedigree of the plaques. Are they 'English', that is, was the artist English-trained and do they belong to a list of the major English Romanesque works of art, a list which would undoubtedly include several other *champlevé* enamels?[45] Admittedly it is often impossible in our state of nearly total ignorance about the history and identity of metalworkers in 12th century England to place a particular piece on this side of the Channel rather than the other,[46] but in the case of the Henry of Blois plaques, there can be a measure of certainty that the artist who made them was not English, but Mosan.

To establish this claim, I would propose a number of comparisons, technical, stylistic and compositional, none of which taken in isolation would be decisive but which taken together must prove binding. Several of them have been proposed by earlier writers, particularly by Mitchell and Haney.

The drawing style of the plaques is identical to that of a Mosan plaque in the British Museum, which shows the healing of Naaman's leprosy in the River Jordan,[47] cf. the X-rays (Pls XI, XIIIA), where the strikingly similar method employed to cut the drapery and reserve the folds of cloth in the metal can be so clearly seen, or cf. the X-rays (Pls XIIB, XIIID), where an enlargement of Henry's head can be compared with Naaman's head, which has been enlarged to the same degree. It would be impossible to imagine a closer identity of execution than exists between these two heads, and this is not a coincidental similarity, for their execution is of great subtlety. The lines are weighted with differing strengths of the engraving tool in precisely the same way, whereas none of the other Mosan enamels in the Museum, which have so far been X-rayed, reveal this particular variety of line.[48] The rendering of the muscles on Henry's neck and hands is also closely similar to the sketched muscles which articulate Naaman's naked body in the reserved metal. Moving from the particular to the more general comparison, the head of the left-hand angel (Pl. XIIC) is of exactly the same physiognomic type as other Mosan heads.[49] Minor details, the hatched and scalloped decoration of belts and cuffs, and the form of Henry's crozier (Pl. XIIA), can also be paralleled in Mosan art,[50] whilst the epigraphy of the inscriptions, even in the more wayward letter forms (such as the R with a curled tail), is remarkably similar as between the Naaman group of plaques and the Henry of Blois plaques. Again, Haney has recently pointed out interesting compositional parallels: the half-length censing angels and the kneeling Henry reappear as figure types on several occasions in Mosan art of the same related group, for instance in manuscripts in Berlin and Brussels.[51] The conclusion to be drawn from these compositional transpositions is inescapable: the censing angels and the kneeling donor figure belong to the artistic repertoire of a particular group of Mosan artists of the mid- to third quarter of the 12th century. It has been suggested that we are dealing here with transference through model-books, but such a suggestion seems unnecessary, if one postulates a closely-knit and well established workshop tradition.[52] Finally, to add to the stylistic and compositional features which the two plaques share with Mosan art, their technique is indistinguishable from the Mosan group, to which the Naaman plaque belongs. The range of coloured glasses used on the Naaman plaque is when measured on a colour scale virtually identical to that of the Henry of Blois plaques.[53] This has been questioned,[54] probably only because the Henry of Blois plaques have lost so much of their gilding. Their appearance is seriously modified, the eye reads the enamels of the ungilded plaques as less bright and vibrant than those of the Naaman plaque, which are still set within expanses of gold. After close study in the Laboratory, the fact remains that the Henry of Blois plaques are enamelled in identical fashion to the Naaman plaque.

I am thus reduced to returning the Henry of Blois plaques to the position which Mitchell gave them. If we discount his obsession with the artistic 'personality' of Godefroid de Claire and simply accept the series, to which the Naaman plaque belongs, as the work of a major Mosan enamel workshop of the mid- to third quarter of the 12th century,[55] then I see no reason to dispute the rest of his hypothesis, that the same workshop was responsible for the Henry of Blois plaques. As for the date which this implies, it does not exclude the possibility that the plaques belong to the later years of Stephen's reign before 1154, but it points rather to a slightly later date. This is more in keeping with what can be deduced of Henry's activities as a patron. Although it is tempting to connect the plaques with one of his foreign journeys, e.g. to Champagne or Flanders, I would prefer to leave the last word to the great Edmund Bishop: 'It is probable that during these last years [that is, after 1154 and before his death in 1171] the most quiet of an always agitated life, his personal care was given to the interests of Winchester and Glastonbury; and it is to this period that may be attributed the enrichment of the Winchester treasury . . .'.[56]

In memoriam Charles Oman, who perceived that the Henry of Blois plaques were the work of a major Mosan artist, executed for a great English patron of the arts. It is also entirely possible that the artist made the plaques in England, but this is and always will be incapable of proof.

APPENDIX

THE INSCRIPTIONS

A. Two censing angels

> \+ MVNERA GRATA DEO PREMISSVS VERNA FIGVRAT :
> ANGELVS AD CELVM RAPIAT POST DONA DATOREM?·
> ⊤ NE TAMEN ACCELERET NE SVSCITET ANGLIA LVCTVS :
> CVI PXA VEL BELLUM MOTVSVE QVIESVE PER ILLVM

> The afore-mentioned slave[57] shapes gifts pleasing to God.
> May the angel take the giver[58] to heaven after his gifts,
> but not just yet, lest England groan for it,[59] since on
> him it depends for peace or war, agitation or rest.

B. Bishop Henry

> \+ ARS AVRO GEMMIS PRIOR·PRIOR OMNIBVS AVTOR·
> DONA DAT HENRICVS VIVVS IN ERE DEO :
> . . MENTE PAREM MVSIS· MARCO VOCE PRIOREM :
> FAMA VIRIS·MORES CONCILIANT SVPERIS

> Art comes before gold and gems,[60] the creator[61] before everything.
> Henry, alive in bronze,[62] gives gifts to God.
> Henry, whose fame commends him to men, whose character
> commends him to the heavens, a man equal in mind to the
> Muses and[63] in eloquence higher than Cicero.[64]

D

REFERENCES

1. *BM. MLA* 52, 3–27, 1.

2. George Isaacs, On an enamelled plate of the twelfth century, in the possession of the Rev. Henry Crowe, *JBAA*, III (for August 1847), (1848), 102–05; A. W. Franks, On the additions to the collection of National Antiquities in The British Museum, *Archaeol. J.*, x (for March 1853), 9–11; Jules Labarte, *Histoire des Arts Industriels au Moyen-Age . . .* , 2nd edn, III (Paris 1875), 136; O. von Falke, H. Frauberger, *Deutsche Schmelzarbeiten des Mittelalters . . .* (Frankfurt a.M. 1904), 72; O. M. Dalton in: *A Guide to the Mediaeval Room* (British Museum 1907), 111 (Fig. 93), 118; H. P. Mitchell, 'Some enamels of the School of Godefroid de Claire — IV', *Burlington Magazine*, xxxv (1919), 92–102; M. Chamot, *English Mediaeval Enamels* (London 1930), 5, 34–35 (No. 17), Pl. 9; T. S. R. Boase, *English Art 1100–1216* (Oxford 1953), 170–71; Charles Oman, 'Influences mosanes dans les émaux anglais', in: *L'Art Mosan*, ed. P. Francastel (Paris 1953), 155–56; Madame S. Gauthier, in: ibid., 133–34; H. Swarzenski, *Monuments of Romanesque Art* (London 1954), Fig. 446; R. H. C. Davis, *King Stephen 1135–1154* (London 1967), opp. 69; Marcia L. Colish, 'A Twelfth-century Problem', *Apollo*, LXXXVIII No. 77 (July 1968), 36–41; John Beckwith, *Ivory Carvings in Early Medieval England* (London 1972), 99–101; Peter Lasko, *Ars Sacra: 800–1200* (Harmondsworth 1972), 238, Pl. 279; M.-M. Gauthier, *Emaux du moyen âge occidental* (Fribourg 1972), 157–58, 360–61 (Cat. 112); W. Oakeshott, *The two Winchester Bibles* (Oxford 1981), 7, Pl. 5, 135–36; K. E. Haney, 'Some Mosan sources for the Henry of Blois enamels', *Burlington Magazine*, xxiv (1982), 220–30.

3. *Gentleman's Magazine*, LXXXIII (December 1813), 545. A copy of the engraving, together with a coloured rendering, exists in The Society of Antiquaries of London, *Instrumenta Ecclesiastica*, fol. 28. Gauthier, op. cit. (1972), wrongly describes this as a pre-19th-century watercolour.

4. For Thomas Fisher (1781?–1836), see *DNB*.

5. The marks left by these clamps are still clearly visible on the backs of the plaques.

6. Isaacs, op. cit. (1847), refers to the joined plaques as an alms dish. I would therefore identify the plaques with the following item in Fisher's sale catalogue, Southgate and Son, 22 Fleet Street, 31 August–2 September 1837, lot 381: 'Ancient Alms Basket, of Copper, inlaid with Figures, in Colours.' £4 13s. The plaques were exhibited to The Society of Antiquaries at Crowe's request by the Rev. Joseph Hunter on 16 November, 1837, when they were stated to have been bought at the Thomas Fisher Sale (Soc. Antiqs. Minutes 37, 1835–39, 204).

7. Analysis by X-ray fluorescence shows the metal of the plaques to be:

	Cu %	Sb %	Pb %	Ag %	Zn %	Sn %	Fe %	As %
(angels' plaque)	98.8	0.23	0.68	0.16	0.06	0.05	0.08	0.02
(Henry plaque)	98.9	0.18	0.60	0.13	0.06	0.03	0.09	0.04

For the quantitative analyses, radiographs and several technical observations I am most grateful to my colleagues, Miss Mavis Bimson and Dr Michael Hughes of the Research Laboratory.

8. The results of these analyses are to be published shortly by Mrs Susan La Niece and Mr Andrew Oddy, of the Research Laboratory.

9. Pl. XIIIc is a detail of the plaque with the scene of Passover (*BM. MLA* 56, 12–17, 1).

10. I am indebted to my colleague, Mr David Buckton, for this observation.

11. W. Oakeshott, *The Artists of the Winchester Bible* (London 1945), 14–15, passim.

12. Certain areas have been restored with a resinous inlay: (angels' plaque) several bands of the clouds, parts of the wing and halo of the left angel (Pl. XIIc); (Henry plaque) the extremity of Henry's right foot, part of the top disc and border of the object he is carrying (Pl. XIIA).

13. They have been measured using the Munsell System of Colour Notation: (yellow) 5Y 8.5/8; (pale green) 2.5 GY 7/8; (deep green) 7.5 G 4/4; (turquoise) 10 BG 5/6; (pale blue) 5 PB 6/6; (deep blue) 5 PB 2/6; (purple) 10 RP 2/1; (red) 10 R 3/8. Where the glasses are fired in mixed fields (white/pale blue; yellow/pale green) and shade into each other, the deepest value has been given. The colours conform closely to those of several Mosan enamels in the British Museum, and particularly to the Naaman plaque, which is discussed below. On this plaque, only the yellow differs slightly (5Y 8.5/10).

14. See H. Buschhausen, *Der Verduner Altar* (Edition Tusch Vienna 1980), e.g. Taf. 27, where the backgrounds to the double colonnette plaques are fired with granules of white, yellow, red, grey, azure blue and turquoise. The overall printing of this plate is far too red, a criticism which can also be levelled at the other plates in this book.

15. The X-rays show that the engraving of the inscriptions was less precise than that of the figures (Pl. XIIB). There are various possible explanations for this, but the contemporaneity of the inscriptions is not in doubt.

16. On each plaque there are five small pinholes on the beaded outer rim and two others along the straight concave edge. Two large holes at the start and finish of each inscription and a single hole plugged with metal in the centre of each plaque date from the period when they were clamped together as a dish.

17. See most recently D. Kötzsche, 'Das Medaillon mit der OPERATIO vom Remaklus-Retabel in Stablo', *Berliner Museen* (Berichte aus den Staatlichen Museen Preussischer Kulturbesitz, 3 Folge, 1978), 2–5. The upper part of the retable with its grouping of ten plaques around a central disc is known from the celebrated drawing of 1661. These plaques were probably enamelled and even larger than the Henry of Blois plaques.

18. E.g. the Mosan enamelled phylactery in Leningrad, see J. Lafontaine-Dosogne, 'Oeuvres d'art mosan au Musée de l'Ermitage à Leningrad', *Revue Belge d'Archéologie et d'Histoire de l'Art*, XLIV, 1975 (1976), 91–94, where the central Christ plaque is flanked, above and below, by two semi-circular plaques with figures similar to those of the Henry of Blois plaques: above, a censing angel, also holding a cup; below, St John in a kneeling posture, like Bishop Henry.

19. Gauthier, op. cit. (1972), where the suggestion that the plaques come from a cross is credited to Dr Rosalie Green, formerly the Director of the Princeton Index of Christian Art.

20. In stained glass of the second half of the 12th century, the normal arrangement of radiating panels, whether semi-circular or irregular segmental, is with the chord of the circle towards the exterior but there are exceptions, e.g. at St-Denis, Poitiers, Troyes and Canterbury. In metalwork, the case of the Alton Towers' triptych can be cited as proof of the currency of such an arrangement, although the semi-circular scenes with their straight sides towards the exterior are not there enamelled on separate plaques. Ills. L. Grodecki, *Les vitraux de Saint-Denis*, I (Paris 1976), 94; L. Grodecki, *Le Vitrail Roman* (Fribourg 1977), 22–23, 75, 130; C. T. Little, '*Membra disjecta*: More early stained glass from Troyes Cathedral', *Gesta* XX/1 (1981), 122–23, Figs 5–7.

21. Previous translations or commentaries by Isaacs, Franks, Mitchell, Boase, Chamot, Colish, Gauthier (1972) and Oakeshott — see note 2.

22. It owes much to correspondence with Professor Christopher Brooke, who in his turn consulted Dr Michael Winterbottom, and with Sir Walter Oakeshott. I am most grateful to them for their help, direct and indirect. The final version is however my own responsibility.

23. See most recently Oakeshott, op. cit. The only serious rival candidate would be Henry Murdac, Archbishop of York (1147–53). However the inscription is specific that this is a Bishop, not an Archbishop, and the figure is not wearing the pallium.

24. Franks, op. cit., was the first to propose the very early dating. All writers, with the exception of Mitchell and of Gauthier (1972), have accepted that the plaques must be pre-1154.

25. For Henry's life, see *inter alia* Lena Voss, *Heinrich von Blois, Bischof von Winchester* (1129–71) (Berlin 1932); David Knowles, 'Henry of Blois, Bishop of Winchester 1129–71', *WCR*, no. 41 (1972).

26. See note (59).

27. Mitchell (note 2) suggested that the two plaques come from 'the structure supporting the shrine' and dated them to *c.* 1160–65.

28. Accepted, though sometimes with caution, by Chamot, Swarzenski, Davis, Colish, Beckwith, Lasko and Haney. Only Boase, Gauthier (1972) and Oakeshott have made alternative suggestions.

29. For a good series of illustrations of donor scenes, Peter Bloch, 'Zum Dedikationsbild im Lob des Kreuzes des Hrabanus Maurus', in: ed. V. H. Elbern, *Das erste Jahrtausend. Kultur und Kunst im Werdenden Abendland an Rhein und Ruhr*. Textband I (Düsseldorf 1962), 471–94. Shorthand renderings of e.g. altars, books, churches and crosses in donor scenes are too numerous to be listed here but their accuracy is often remarkable, e.g. on the Welandus reliquary of Henry II, ill. Catalogue *Die Zeit der Staufer* (Stuttgart 1977), Nr. 575, Abb. 380.

30. Ill. Catalogue *Rhin-Meuse. Art et Civilisation 800–1400* (Cologne/Brussels 1972), 244 (G6).

31. Boase, op. cit., suggested that Henry is carrying a reliquary box and that the plaques come from an altar frontal. These he mentions in connection with nos 12 and 2 of Henry's inventory, see Bishop, note 41 below.

32. Franks, op. cit., proposed that it was a 'super-altar or *tabula*'. Almost all surviving Romanesque portable altars are set with a circular, square or rectangular slab of some rare stone, such as porphyry. I do not know of an example where three such slabs form part of an overall decorative pattern. As I suggested to Dr Oakeshott, the effect would have been 'Cosmatesque', see Oakeshott, op. cit.

33. Oakeshott, op. cit., has recently put forward a new hypothesis, that Henry is carrying the altar stone reputed to have been given to Glastonbury by St David and richly set with gold, silver and precious stones by Henry after its rediscovery. There are two sources for the story of this benefaction of Henry of Blois: William of Malmesbury, as quoted by Oakeshott, and Adam of Domerham *Historia de rebus gestis Glastoniensibus*, ed. T. Hearne, II (Oxford 1727), 316–17. The latter tells the story in closely similar language but specifies that St David's stone was 'de saphiro'. Adam may have been using the word imprecisely of any precious or semi-precious blue stone but he is talking about a single piece, whereas the object carried by Bishop Henry has three blue areas and not a single focal point. For a recent discussion of the meaning of *saphirus* in the 12th century, see John Gage, 'Gothic glass: two aspects of a Dionysian aesthetic', *Art History*, 5, no. 1 (March 1982), partic. 42–46.

34. For four even larger Limoges enamelled terminals from an altar-cross of *c.* 1185–90, see Marie-Madeleine

Gauthier, G. François, *Medieval Enamels. Masterpieces from the Keir Collection* (British Museum 1981), no. 2. Donors are occasionally represented on an object, presenting a different object, e.g. a model of a church on a capital at St Lazare, Autun, and on the altar at Avenas (Rhône), ill. D. Grivot, G. Zarnecki, *Gislebertus. Sculptor of Autun* (London 1961), Pl. 13a, B9–10. In such cases the representation commemorates the donation of the whole building, of which the capital, altar, etc., is a part. The same relationship could well have been created between a donor scene on an altar-cross and the altar ensemble.

35. *BL*. Cotton MS Domitian A. XIII, fol. 34, printed *Annales Monasterii de Wintonia* (A.D. 519–1277) in: ed. H. R. Luard, *Annales Monastici*, II (Rolls Series 1865), 54. Luard believed that this MS was copied at the end of the 13th- or the beginning of the 14th century, probably from the original.

36. The 1150 relics' translation occurs in *BL*. Cotton MS Vespasian E. IV, fol. 172 with slight differences: 'Anno MCL. Henricus dux suscepit ducatum Normanniae. Reliquiae Sanctorum Birini, Heddae, Swithuni, Brinstani, Frithestani, et Elphegi translatae sunt' and in *BL*. Cotton MS Caligula A.X, fol. 91, see *Annales Prioratus de Wigornia* (A.D. 1–1377), in ed. H. R. Luard, *Annales Monastici*, IV (Rolls series 1869), 379. For Luard, the Worcester annals in an early 14th-century hand closely copy the Vespasian MS, which was written at Winchester in the late 13th century. The references to the 1150 translation are virtually identical in the two MSS.

37. See H. Pauli, 'Englische Analekten II: Ein Regulativ des dreizehnten Jahrhunderts zur Führung von Jahrbüchern', in: *Neues Archiv der Gesellschaft für ältere Deutsche Geschichtskunde . . .* , 3 (Hanover 1878), 214–15.

38. Abbot Geoffrey of St Albans died in 1146 and was not directly succeeded by Abbot Robert, as the Winchester annalist claimed. For this and other mistakes, see Luard's preface (note 35), XXVII–XXIX, with his conclusion that the annals 'cannot always be relied on with certainty'. Since Abbot Geoffrey's death is correctly entered under the year 1145 (1146), the annalist may be recording Abbot Ralph's death which took place in 1151, but mistaking his name.

39. For differing views on the date of Henry's visit or visits to the Papal Curia, see C. N. L. Brooke's Appendix I to *The Letters of John of Salisbury, Volume I*, ed. W. J. Miller, S.J. and H. E. Butler (Nelson Medieval Texts 1955), 253–54; ed. M. Chibnall, *John of Salisbury's Historia Pontificalis* (Nelson 1956), 91–94. Both agree that Henry was probably in Rome in the early months of 1150. He was however in England in November 1150, see Voss, op. cit., 65 and note 57.

40. Ed. Luard (note 35), 59.

41. See Edmund Bishop, 'Gifts of Bishop Henry of Blois, Abbot of Glastonbury, to Winchester Cathedral', *Downside Review*, III (1884), 33–44, reprinted in: E. Bishop, *Liturgica Historica . . . Papers on the liturgy and religious life of the Western Church* (Oxford 1918). The cross is no. 1 (p. 41).

42. The 1150 translation has been confused with an 1158 translation of the bones of various early kings and bishops, e.g. in ed. M. Biddle, *Winchester Studies I. Winchester in the Early Middle Ages . . .* (Oxford 1976), 312 and note 7. The primary source for this 1158 translation, which is specifically connected with Henry of Blois as its instigator, is a charter, see ed. A. W. Goodman, *Chartulary of Winchester Cathedral* (Winchester 1927), no. 4. Thomas Rudborne, writing *c*. 1440, also refers to this translation on several occasions in discussing the burial-places of various kings and bishops, e.g. Aescwine and Centwine, Cuthred and Sigeberht, Edmund, Matilda (Henry I's wife) and Queen Frytheswyde. Henry of Blois had them removed into lead coffins and placed above The Holy Hole. Twice Rudborne quotes his source as the lost *de actibus Willelmi et Henrici, Episcoporum Wyntoniae*, by Robert, prior of Winchester and Abbot of Glastonbury (1173–80) but on no occasion does he refer to the 1150 translation of St Swithun. For the Rudborne extracts, see ed. H. Wharton, *Anglia Sacra*, I (London 1691), 194–95, 207, 276–77. For Bishop Fox's later replacement of the lead coffins by the present mortuary chests, see J. Milner, *The History Civil and Ecclesiastical, and Survey of the Antiquities of Winchester*, II, 2nd edn (Winchester 1809), 46–47, note 1.

43. If these items were entirely of gold, then their enamels were *cloisonné* enamels on gold.

44. O. Lehmann-Brockhaus, *Lateinische Schriftquellen zur Kunst in England, Wales und Schottland vom Jahre 901 bis zum Jahre 1307* (Munich 1956), no 3970. For a 13th-century coloured representation of Henry's St Albans ring, see *BL*. Cotton MS Nero D.1, fol. 146v°, discussed and illustrated by C. C. Oman, The jewels of Saint Albans Abbey, *Burlington Magazine*, LVII (1930), 81–82.

45. The following enamels are probably English: the Masters plaque (V & A); seven plaques with scenes from the lives of SS Peter and Paul (V & A, Metropolitan, Nürnberg, Dijon (Musée des Beaux-Arts), Lyon (Musée du Palais St-Pierre); and a group consisting of three ciboria (V & A, Morgan Library), two croziers (Edinburgh (National Museum of Antiquities), Bargello), five boxes (V & A, Fitzwilliam, Boston (Museum of Fine Arts), Troyes (Trésor de la Cathédrale), Bargello) and three loose plaques from a box (ex-von Hirsch). Most of these ill. Chamot, Swarzenski (note 2).

46. I am thinking here particularly of several enamels of Madame Gauthier's 'Angevin Group', see Marie-Madeleine Gauthier, 'Le goût Plantagenet', *Stil und Uberlieferung in der Kunst des Abendlandes. Akten des 21. Internationalen Kongress für Kunstgeschichte, Bonn 14–19 Sept. 1964* (Berlin 1967), Band I, 139–55.

47. *BM*. MLA 84, 6–6,3.

48. E.g. the head of Isaiah on a Mosan medallion (*BM.* MLA 56, 7–18, 2) is drawn with uniform broad strokes for hair, beard and face.

49. E.g. the head of the angel on the plaque with the Three Maries at the Sepulchre (New York, Metropolitan Museum), which belongs to the same series as the *BM.* Naaman plaque and several others, in all eleven (with a possible twelfth), measuring 10.2 × 10.2 cm ill. W. H. Forsyth, 'Around Godefroid de Claire', *The Metropolitan Museum of Art Bulletin* (June 1966), 305–15, Fig. 22. There are also similar heads in the Berlin MS. Kupferstichkabinett 78 A 6, see Elisabeth Klemm, *Ein romanischer Miniaturenzyklus aus dem Maasgebiet* (Vienna 1973), passim. A head of a youth is also similar to the right censing angel's head (cf. Pl. XIID with Klemm, Abb. 10, top, among group facing Jacob).

50. For the decoration of reserved bands at belt or cuff, see Gretel Chapman, 'Jacob blessing the sons of Joseph: a Mosan enamel in the Walters Art Gallery', *The Journal of the Walters Art Gallery*, XXXVIII (Baltimore 1980), partic. 34. Haney (note 2) makes a telling comparison between the scalloped decoration of Henry's cuff and a hem in the Berlin MS (Klemm, Abb. 17). For a similar crozier, held by a kneeling abbot, see J. Stiennon, 'Du Lectionnaire de Saint-Trond aux Evangiles d'Averbode. Contribution à l'étude de la miniature mosane au XIIᵉ siècle', *Scriptorium*, VII (1953), Pl. 5 (after page 176).

51. Cf. particularly the half-length angel emerging from a cloud to address Hagar in the Berlin MS, fol. 2ᵛ (Klemm, op. cit., Abb. 4); two crouching figures with knees bent exactly like Bishop Henry in the Brussels MS, Bibliothèque Royale 9916–17, fols 27, 30 (Haney (note 2), Figs 5, 6).

52. See Chapman, op. cit., for an extreme recent statement on the subject of model-books, in relation to the Berlin MS and the Liège and London leaves. Haney (note 2) also accepts the premiss of model-books to explain the differences which she sees between the two plaques and Mosan enamels.

53. See note 13.

54. E.g. by Lasko and Haney (note 2). The latter writes: 'the colours are not as brilliant as those of Mosan enamels but are more muted shades'. Already in 1953, Madame Gauthier (note 2) described the plaques as 'd'inspiration mosane' and in 1972 characterised the artist as 'formé à la technique et à la palette mosane'.

55. For a sound basis for further discussion of the major Mosan workshops, with due respect paid to the documents and with a healthy scepticism towards Godefroid de Claire attributions, see Josef Deér, 'Die Siegel Kaiser Friedrichs I. Barbarossa und Heinrichs VI. in der Kunst und Politik ihrer Zeit', *Festschrift Hans R. Hahnloser* (Basel/Stuttgart 1961), 47–102.

56. Bishop (note 41), 39.

57. The phrase 'praemissus verna' has been taken variously to refer to the artist, to the donor or even to a dead saint 'sent before' (i.e. St Swithun, whose bones would be contained in the reliquary from which the plaques are assumed to come). Certainty is impossible since the preceding inscription has been lost but the most obvious meaning for 'praemissus' is 'aforementioned', in which case the slave is probably the artist, not the donor who is referred to in the next line.

58. It can probably be assumed that the donor is Bishop Henry, because he is named as the donor in the other surviving inscription. However the possibility that there was more than one donor should not be entirely ruled out. The following two lines could obviously be suitable, for instance as a reference to the King.

59. These words rule out the possibility that the lines are commemorative of the donor. Whether the angel or England is the subject of the verb 'acceleret' is not clear, but this does not alter the general sense.

60. This is a standard literary *topos*, cf. the well known sentiment: 'materiam superabat opus' (Ovid, *Metamorphoses* II, 5). This phrase was not only quoted in comments on 12th and 13th-century goldsmiths' work at St Albans and Westminster (Lehmann-Brockhaus, op. cit., nos. 2714, 3867), but e.g. by Abbot Suger (ed. E. Panofsky, *Abbot Suger on the Abbey Church of St-Denis and its Art Treasures*, 2nd edn (Princeton 1979), 62, line 1, cf. also 46, line 26). See also, Gage, op. cit. (note 33).

61. The patron or the artist? Probably the former as a synonym for the donor Henry who is after all the prime object of praise in the following couplets. 'Auctor' can certainly be used of a patron, cf. the inscription on the Speyer bucket, of 1116–1119: 'Haertwich erat factor et Snello mei fuit auctor' (F. X. Kraus, *Die Christlichen Inschriften der Rheinlande*, 2 (1894), no. 150), or the inscription on an 11th century cross-foot in Dublin: 'Abbas Walterus fuit auctor opus super istud' (P. Springer, *Kreuzfüsse. . . . Bronzegeräte des Mittelalters, Bd. 3* (Berlin 1981), 76).

62. Several translators from Isaacs and Franks onwards have parsed this verse as 'Henry while alive gives gifts of bronze to God', but the order of the words favours the present translation, as Mitchell saw.

63. There is a Tironian 'et' before 'Marco'.

64. Isaacs and Franks already translated 'Marcus' as Cicero and this is surely correct, see Voss, op. cit., 178, for the transcription of a poem (Winchester Cathedral Library, Cod. 3, fol. 123–24), in which Henry is referred to as 'Tempore pro nostro noster erat Cicero' (cf. Oakeshott, op. cit., 135).

The Wall Paintings of the
Holy Sepulchre Chapel

By David Park

From the outside, the Chapel of the Holy Sepulchre is rather unimpressive. It is a small structure, inserted in the 12th century between the northern piers of the crossing, and much altered at later dates. Inside, however, it is almost entirely covered with superb late 12th and early 13th-century wall paintings, which make this one of the most exciting medieval interiors to survive in England (Pl. XIIIE).

Until the 1960s almost all the painting that could be seen in the Chapel was of 13th-century date. This painting was in very poor condition, partly because of the misguided conservation treatment it had received in the past. It had been waxed, and even hairnets had been applied, in an effort to stabilise it; but in time the wax had darkened, and in preventing the damp in the plaster from expiring, had resulted in a blistering of the paint surface. Through one large hole in the plaster, on the east wall, it could be seen that there was earlier painting underneath. To save the 13th-century painting, conservation work was undertaken by Mrs Eve Baker and her assistants from 1963 onwards.[1] They found that, in order to conserve the painting, it was necessary to detach some of it from the wall; and, in so doing, they revealed the earlier work. It was immediately apparent that this earlier painting was of even higher quality and greater interest than the painting which had covered it. It needed a considerable amount of conservation treatment itself — not least, because it had been keyed for the later layer, and all these holes had to be filled with special mortar repairs. A new site also had to be found for the 13th-century east wall painting, and in the late 1960s it was transferred to an artificial wall constructed for the purpose at the west end of the Chapel.

The 13th-century paintings are splendid enough, but the earlier layer is even finer, and has justly been described as 'the most important new work of English medieval painting to come to light in recent years'.[2] This painting is stylistically very close to the later illumination of the great Winchester Bible — dating from *c.* 1175–85 — with which it is doubtless approximately contemporary. The Chapel itself also probably dates from this time; the fabric includes two late Norman scallop capitals on the south side (see Pls XIIIE, XVB).[3] The 12th-century paintings also provide fascinating comparative material for the early 13th-century scheme which replaced them; and also for the great scheme of wall paintings formerly in the chapterhouse of the nunnery of Sigena in northern Spain, which was executed by English artists, perhaps from Winchester itself, and which in date falls mid-way between the earlier and later Holy Sepulchre Chapel paintings.[4] Before turning to consider general questions of iconography, style, attribution, and so on, it will however be best to examine in some detail the actual remains of painting in the Chapel.

The account may start with the 12th-century painting on the east wall (Pl. XIV). The subject-matter here consists of scenes of Christ after the Crucifixion, and is divided into two tiers by a decorative border. Occupying the whole of the upper tier is the Deposition; while, in the lower tier, is a large combined subject of the Entombment and Maries at the Sepulchre, and also the Harrowing of Hell. It can be seen immediately from plate XIV why it was found necessary to repaint the Chapel in the early 13th century. Extensive alterations to the Chapel at this time — in particular, the insertion of a rib-vault — severely damaged the 12th-century scheme; for example, the figures at the sides of the Deposition were partly

destroyed. Because of their damaged state, there has been some confusion in the recent literature as to the identity of these figures. However, as will be seen, the standing female figure at right, decapitated by the vault, is Mary Magdalene; while the Virgin was shown standing on the left, behind Christ. She was almost totally destroyed by the vault; but one can still see, for instance, her left hand resting on Christ's shoulder.[5] Allowing for these side figures, the 12th-century composition was obviously designed to fit a more or less square field; it seems most likely therefore that the Chapel originally had a flat — and presumably wooden — ceiling. The other figures in the Deposition are easily identifiable: on the left is Joseph of Arimathea, supporting the body of Christ in his cloak; and, on the right, Nicodemus, removing the nail from Christ's foot with a long pair of pincers, and behind him St John the Evangelist.

The lower tier of painting on the east wall has also suffered much damage, again particularly at the sides. Most of the tier is occupied by the combined Entombment and Maries at the Sepulchre. In the centre, Joseph of Arimathea and another figure lower Christ on a shroud into the sarcophagus. His left hand is kissed by the Virgin, who stands behind, while His legs are anointed by another figure, probably Nicodemus, and a censing angel flies above. Strangely located, to the left of this group, are the two Maries, while the angel, seated on the slanting lid of the sarcophagus and announcing the Resurrection to them, actually points down at the body of Christ in the Entombment scene. As will be demonstrated below, this curious arrangement is quite deliberate, and there is not — as has been argued — a second, empty sarcophagus at the foot of the tier at which the angel is really pointing.[6] On the other side of the Entombment is the Harrowing of Hell. This scene has also on occasion been misinterpreted, as the *Noli me Tangere*,[7] doubtless partly because it is very damaged, and also perhaps because in the 13th-century representation of that subject in the Chapel the same graceful contrapposto pose was used for the figure of Christ.[8] But the Harrowing of Hell identification of this scene is quite clear: on the left is Christ, holding the vexillum, and, at bottom right, a profile hell-mouth with sharp white fangs, and the remains of several small figures of souls within it.

On the south wall of the Chapel there is much less 12th-century painting, but what has been found here is nevertheless of the greatest interest. In the lower half of the wall are two shallow round-headed recesses, separated by a pilaster with the scallop capitals already referred to. Above each recess is what is now, because of the 13th-century vault, a gable-shaped area, but which would presumably have originally been rectangular. Above the western of the two recesses is the one sizeable area of 12th-century painting in the Chapel that was visible even before the 1960s conservation programme. It is a representation of the Resurrection of the Dead, with on either side a large angel blowing the Last Trump, and between them smaller angels flying down to naked resurrecting souls.[9] The trumpeting angel on the right was cut through by the setting-out of the 13th-century vault, which was finally constructed a little higher. Only this angel received conservation treatment in the 1960s; the rest of the painting is still covered by wax, and is badly darkened.

In the corresponding position above the eastern recess in the south wall, 12th-century painting of even greater interest was uncovered in 1963. This was from underneath the 13th-century paintings of the Entry into Jerusalem and Raising of Lazarus, which will be described later. The only finished piece of 12th-century painting found here was a damaged, but extremely fine mitred head (Pl. XVA). Beneath this, however, was a find which is so far unique in English medieval wall painting — a sinopia drawing for several scenes (Pl. XVC). This drawing, of which only the upper half survives — and even this has been badly damaged by keying for the 13th-century layer — shows three scenes, all set under architectural canopies. Following their discovery, both the sinopia and the mitred head

were detached from the wall, and subsequently transferred to the north wall (where no painting survives); the 13th-century upper layer, being in more perfect condition, was replaced in its original position. At this point, it might be useful to explain briefly the technique of the 12th-century wall paintings.[10] They are in the fresco technique; that is to say, executed on the plaster while it was still wet. The painting was first sketched out in red outline on a base layer of plaster ('sinopia' is the Italian term used for such a drawing); and then the final painting was executed on a thin layer of plaster above this. This upper layer of plaster was laid and painted one patch at a time, the painting thus being done before the plaster dried out. Fresco is now known to have been the usual technique employed in English Romanesque wall painting,[11] although the Holy Sepulchre Chapel provides the first case of such a sinopia to be uncovered. In fact, it is clear that the sinopia beneath the 12th-century paintings on the east wall still survives, and awaits uncovering. In places on this wall where the final painting, and the thin layer of plaster on which it is executed, have been lost, the sinopia shows through. Thus it can be seen that the central border was originally planned slightly higher, especially at the right; and the under drawing for the bottom part of the Magdalene's robe in the Deposition is also clearly visible (see Pl. XIV). Fresco is a more difficult technique than secco — that is, painting on dry plaster — which was the method commonly used in England in the Gothic period, but it has the advantage that a chemical reaction takes place which binds the pigments to the plaster. This is one reason why the colouring of the 12th-century paintings in the Chapel survives better than that of the later paintings which replaced them, which were executed to a large degree when the plaster was dry or almost dry.[12]

The subject-matter of the south wall sinopia is very difficult to interpret, partly because this painting is by its nature only a sketch, and also partly because it is so damaged. The mitred head above it has previously, and understandably, been interpreted as that of a bishop, but this is almost certainly incorrect.[13] It was found directly above the head of the left-hand figure in the central scene of the sinopia. This figure is observing an act of violence: the rest of the scene shows, in the centre, an evil-looking figure, who is about to strike another figure on the right. The central figure is shown with his head in profile, his right hand raised to deliver the blow, and his left hand grasping his victim by the shoulder. Under his outstretched left arm is, rather oddly, but unmistakably, a crutch. The figure on the right faces away from both his tormentor and the other figure, and appears to have his right hand covered with drapery and raised to his face. Such a scene, showing an evil figure about to strike another figure, is an unlikely context for a bishop. But, in any case, the mitre he is shown wearing in the finished painting (in the sinopia his headgear is only roughly sketched in) is most probably not a bishop's mitre. Although this type of mitre, with rounded horns, was worn by bishops until the mid-12th century, by c. 1175–85, when these wall paintings were executed, it had been generally superseded by the pointed type, with one horn at the front and one at the back of the head, which is essentially the kind still used today. At Winchester, both seals of Bishop Richard of Ilchester (1174–88) show him wearing the new type of mitre.[14] The correct interpretation of the headgear of the figure in the wall painting is most likely to be not as a bishop's mitre but as that of a Jewish priest. On the Morgan Leaf, illuminated at Winchester and completed at about the same time that the 12th-century paintings in the Chapel were executed, a similar mitre is worn by the priest Eli, in the scene of Hannah presenting Samuel in the Temple (see Pl. IVB).[15] Mitres of the same type are also worn by the high priests in the scenes of the Passion of Christ on a detached Psalter leaf, of c.1140, illuminated probably at Canterbury;[16] and this may well provide a clue to the correct identification of the subject-matter of the wall painting. Just as the Psalter leaf scenes depict events in the Passion, it seems very possible that the sinopia scenes originally formed

part of a Passion cycle, which culminated in the post-Crucifixion scenes on the east wall of the Chapel. One of the leaf scenes shows Christ before a number of figures, including two high priests, and another figure with his hand raised who is about to strike him. This must show the moment when Christ, being questioned by the high priest Annas, was struck by an officer for the way in which he replied (John 18, 22).[17] This could be the incident represented in the central scene of the sinopia, with Annas looking on from the left as the officer strikes Christ. Although it must be admitted that the right-hand figure in the scene does not look very like Christ — he has no beard, for example — it should be remembered that this is only a sketch, and that other details, such as the priest's mitre, are not accurately represented.[18] A possible alternative explanation of the sinopia scene would be as a representation of the Mocking of Christ after his hearing before Caiaphas; however, rather than appearing in such an abbreviated form, this subject is normally represented with several mocking figures, Christ shown blind-folded, and without the high priest himself being present.[19]

If the central sinopia scene is of Christ before one of the high priests then the scene to the left (Pl. XVc) would be readily identifiable as Christ before Pilate. This scene shows three figures, of which the one in the centre appears to be held by the figure on the right, whose face is in profile. Both these figures face towards another on the left, who is seated, and whose profile face is obviously intended to appear evil — with its large nose, curling moustache, and double chin. This last figure would be a fairly typical representation of Pilate; not unlike that, for example, in the Flagellation scene on the detached Psalter leaf of c. 1140 already referred to. One hand of this figure, in the sinopia scene, is very prominent, and it is perhaps possible that the Washing of Hands was shown. If this is indeed a representation of Christ before Pilate, it would follow on logically from the preceding scene, the sequence of the sinopia scenes being from west to east towards the later scenes of Christ after the Crucifixion depicted on the east wall.

The westernmost sinopia scene is even more badly damaged than the others, and is very difficult to make out. However, it seems possible to distinguish the head of a male figure, in profile, which is supported by his hand. The architectural canopy of the scene appears to descend immediately to the right of this figure, making this scene much narrower than the other two. The motif of resting head on hand can denote in medieval art thinking, sleeping or grieving. In Passion Cycles, the sleeping apostles in the Agony in the Garden are often shown in this way, as is the grieving Peter in representations of his Denial. It seems impossible to identify the Winchester scene as the Agony in the Garden; partly because there is no representation of the Betrayal intervening between it and the scene to the left with the high priest, and also because only one figure seems to be represented. The Denial of Peter, however, seems a likely interpretation, partly because this event occurred at the time of Christ's hearings before the high priests, and also because it is a scene that could be abbreviated to just one or two figures. Once again, the detached Psalter leaf provides an interesting comparison, in that although Peter's denial is here shown in three separate scenes — in one of these (that represented directly below the scene of Christ before Annas), Peter is shown alone at one side, beneath an arch, and resting his head on his hand.

As well as the sinopia, one other example of what appears to be a 12th-century drawing was uncovered in the 1960s on the south side of the Chapel. It is on the pilaster which divides the two recesses in the south wall, and is of a grotesque creature (Pl. XVb). This has a hooded head, and a large open mouth; and its one hoofed leg is raised in front of it. It is in red outline, like the sinopia, and has simiarly suffered from keying for a later layer of plaster (again, presumably, for the 13th-century layer). This drawing is quite large — approximately 0.72 m in height. Although it has previously been dismissed as a 'medieval

"doodle"',[20] it is in fact of precisely the sort of subject that might be expected to appear in this position in a late Romanesque scheme. It was common at this period to represent grotesque creatures in the peripheral areas of wall painting schemes, just as it was later to become common to do so in the margins of manuscripts.[21] The position of the Winchester drawing is doubly peripheral, in that it is not only on a dividing pilaster, but is also rather low down — indeed, virtually at dado-level. Dado grotesqueries are particularly common in north Italian wall paintings of this period, which may be significant in view of the Mediterranean links with Winchester painting which will be referred to later. There are notable examples at Castel Appiano, in the castle chapel paintings (*c.* 1200), where a centaur and an armed figure riding a lion are represented in the east wall dado;[22] and, particularly close to the Winchester drawing, in the church of San Jacopo at Termeno (early 13th-century), where the grotesque creatures include one wearing a hood and with its mouth open.[23] The fine dado paintings in the crypt of Aquileia Cathedral (*c.* 1195–1205), though in no sense grotesque — they may illustrate scenes from an as yet unidentified Crusader romance[24] — nevertheless provide another important clue as to the original nature of the Winchester drawing. Like certain other examples of dado paintings,[25] they are not fully painted, but are executed in red outline. It seems very likely that the Winchester drawing, rather than being merely the sinopia for a fully finished painting (like the drawings higher on the same wall), was itself intended to be visible, as another such 'dado' drawing. One other example of such a dado drawing in red outline, of only slightly later date, survives in England. This is in the parish church of Stowell (Glos.), where in the dado of the nave north wall, a small drawing of two figures engaged in judicial combat is represented, below a fully painted composition of the Last Judgement.[26]

No other 12th-century painting is now extant in the Holy Sepulchre Chapel. The scheme would no doubt originally have extended on to the north wall of the Chapel, but this wall was considerably altered in the 13th century when two wide arched openings were constructed in it. There is a 19th-century record of painting on the west wall of the Chapel: 'The Crucifixion probably occupied part of the west wall. There are still remains of figures on horseback to be traced through the smearing of limewash; but the greater part of the plaster of this wall has been destroyed. The subject beneath appears to relate to the murder of Abel'.[27] None of this painting survives now, and it is not in fact clear whether it belonged to the 12th rather than to the 13th-century scheme.

The 13th-century scheme in the Chapel can be described fairly briefly.[28] The painting on the east wall followed that of the original 12th-century scheme quite closely (Pl. XVIA shows this 13th-century painting in its present state, transferred to an artificial wall at the west end of the Chapel). The format of the Deposition was changed somewhat, partly in order to fit it to the new, pointed shape of the field which had resulted from the insertion of the vault. Two particularly significant changes in this scene were the omission of the Magdalene, and the inclusion on the right of the Centurion, holding a long scroll.[29] The tier below is occupied wholly by a combined representation of the Entombment and Maries at the Sepulchre. The scene of the Harrowing of Hell, which in the 12th-century scheme was represented at the south end of this tier, is in the later paintings located instead in the adjacent eastern recess in the south wall, where it is accompanied by the *Noli me Tangere*. In the latter scene, as has already been mentioned, Christ is represented in the same contrapposto pose in which he was shown in the 12th-century Harrowing. In the 13th-century representation of the Harrowing, Christ is shown in a much more vigorous pose than in the earlier version, striding forward and plunging the vexillum into the mouth of Hell, and also now displaying his wounds. On the wall above the eastern recess the Entry into Jerusalem and Raising of Lazarus are depicted; oddly, with Christ in the Entry scene riding towards

the Lazarus scene, to the west. The wall-space here became gable-shaped with the insertion of the vault; and this presumably accounts for the strange compression of the Raising of Lazarus, with its diminutive figure of Christ, and omission of the sisters Mary and Martha. The subjects here, unlike those on the east wall, are different to those in the same position in the 12th-century scheme (it was here that the sinopia scenes were found). This difference in the programme on the south wall may well be partly due to the need to accommodate here subjects which, in the earlier scheme, were represented on the north wall of the Chapel — pierced by wide arches as part of the 13th-century architectural alterations. In the right-hand spandrel above the eastern recess in the south wall is a bust of a prophet within a roundel, of a type which also occurs on the vault of the eastern bay (Pl. XIIIE). In the eastern segment of this quadripartite vault is a Pantocrator, surrounded by Evangelist Symbols; and in the other segments, Infancy scenes in roundels — the Annunciation, Nativity, and Annunciation to the Shepherds — with busts in roundels, and surrounding foliate scroll-work.[30] More busts of prophets and kings are represented on the soffits of the arches on the north side of the Chapel. Within the recess at the west end of the south wall are several small scenes of the Martyrdom of St Catherine of Alexandria; for example, one showing her being beheaded, with her soul being carried up to heaven by an angel, and the executioner wiping his sword blade on his robe.

Having thus now reviewed the remains of painting, both surviving and recorded, in the Holy Sepulchre Chapel, we can turn to considering the general questions to which they give rise. Firstly, what were the sources of the iconography of the two schemes? Much of the iconography of the 13th-century scheme is of straightforward western type: for example, that of the Infancy scenes on the vault, and of the St Catherine scenes on the south wall. However, the iconography of the 13th-century paintings is also partly Byzantine-derived; in some — indeed, perhaps all cases — *via* the intermediary of the 12th-century scheme. The Pantocrator on the vault (Pl. XVIB) is of obvious Byzantine derivation; it can be compared especially to examples in the mosaics of Norman Sicily, such as that of Cefalù Cathedral (*c*.1155).[31] These Byzantine examples are located in the semi-dome of the apse; in the absence of any such location in the Holy Sepulchre Chapel, the Pantocrator is sited in the nearest approximation to it — the eastern segment of the vault. It is possible that a Pantocrator was also represented in the 12th-century scheme; if so, this would presumably have been on the flat ceiling with which, as has been mentioned, the Chapel was probably originally provided. In the 13th-century representation, the Pantocrator has been curiously westernised, by being enclosed in a Gothic trefoil arch, and surrounded by the Evangelist Symbols. In the confined triangular space of the vault segment, there was insufficient room to depict the whole of the upper two Symbols, and thus of the eagle of St John only the head appears (Matthew's Symbol has been completely destroyed). This is one example of what, despite their overall fineness, might be regarded as a certain ineptitude in the 13th-century paintings, which we shall have cause to examine in greater detail later.

Much of the iconography of the first scheme is Byzantine-derived, as might be expected of late 12th-century Winchester painting. At this period, English painting in general under-went a wave of Byzantine influence, which thoroughly permeated for instance the later illumination of the Winchester Bible. Much of this influence appears to have reached England *via* the mosaics of Norman Sicily, whilst some was probably derived from more direct Byzantine sources (see discussion below of the style of the Holy Sepulchre Chapel paintings, p. 45). To consider firstly the iconography of the Deposition in the 12th-century scheme (Pl. XIV). This is not of the type usual in the West, which shows Christ with one hand still attached to the cross, or being lowered from it, and the other hand being kissed by the Virgin. Rather, as Lee has shown, the composition is of Byzantine origin.[32] An early, but

extremely close parallel — except that the composition is reversed, and the figure of the Magdalene omitted — is provided by a mid 10th-century Byzantine ivory relief now in Hannover.[33] The Winchester scene can also be closely compared to the Deposition miniature of the Ingeborg Psalter (c. 1210),[34] which is similarly Byzantine-derived, and where the composition is not reversed. Here, as in the ivory, the hands of the Virgin, who supports Christ from behind, are in exactly the same position as in the Winchester painting — with one on Christ's left shoulder, and the other on his right arm (in the wall painting, the tip of one finger of her otherwise destroyed right hand can just be seen on Christ's arm). The 13th-century version of the Deposition in the Holy Sepulchre Chapel (Pl. XVIA) shows Christ with both hands detached from the cross, but makes a concession to the more normal western type in showing one of them being kissed by the Virgin.

In the lower tier of the east wall painting, in both the 12th-century and the 13th-century schemes, the iconography of the Maries at the Sepulchre appears to be almost purely Byzantinising. The elegant contrapposto pose of the angel is typical of Byzantine versions; it may be compared with that, for example, in the more or less contemporary mosaics of Monreale Cathedral (1183–89).[35] It also seems probable that both Winchester versions of the scene followed the common Byzantine formula of showing only two Maries, rather than the three normal in western representations. Although both scenes are very damaged, and it is therefore impossible to be entirely certain that a third Mary was not represented, the remains of only two can now be discerned in each scene.[36]

It is in the Entombment, in both schemes, that by far the most interesting case of Byzantine iconographical influence is to be found. Both representations of this subject have been influenced by the Byzantine iconography of the Lamentation of Christ — the Threnos — a subject closely associated with the Entombment, and which in fact evolved from earlier Entombment iconography.[37] In the Winchester compositions, features derived from Byzantine representations of the Lamentation are the inclusion of the Virgin in the centre, and the depiction of Christ's hand being kissed. However, whereas in the Byzantine scenes, such as that of an 11th-century ivory relief now in Constance,[38] the Virgin embraces Christ's shoulders, and St John the Evangelist kisses Christ's hand, in the Holy Sepulchre Chapel scenes St John is omitted, and the Virgin stands in his place and performs his usual action. In fact, in the 12th-century scene in the Chapel, a male figure *was* originally painted in the Virgin's position, but it was not St John, but rather the figure — probably Nicodemus — who is now seen to the right, pouring ointment over Christ's legs. Close examination of the painting immediately to the left of the Virgin's face reveals traces of his face, and of the same broad-brimmed hat. Thus, originally, rather than anointing Christ's legs, he must have been represented anointing the upper part of Christ's body, as in the Entombment in the Winchester Psalter (c. 1150)[39] — in which the Virgin is now shown, and which is of standard western type. When the Virgin was substituted in this position in the wall painting, she also blocked out with her head the censer which the flying angel was shown swinging; its chains can be seen to the right of her (in the 13th-century painting, the angel was placed slightly higher up, immediately above the Virgin, and it was thus possible to show the censer to the left of her head). Censing angels in the Entombment are also a western feature; in Byzantine representations of the Lamentation the angels are not shown with censers, but often with their hands veiled, as in the case of two of those on the Constance ivory.[40] It is therefore clear that in the 12th-century scheme in the Holy Sepulchre Chapel, the artist started to represent the normal western type of Entombment, but then altered this as a result of being influenced by a Byzantine representation of the Lamentation. He himself seems to have been responsible for modifying the traditional Byzantine iconography, by showing the Virgin rather than St John kissing Christ's hand. The greater prominence thus given to the

Virgin is perhaps not surprising in view of the particularly strong devotion to her in England in the 12th century.[41] Another oddity in the depiction of the Virgin, in both Holy Sepulchre Chapel versions of the Entombment, is that she is shown crowned; this appears to be unparalleled in any other examples of this scene. The Coronation of the Virgin takes place, of course, in heaven; although the Virgin is occasionally shown crowned in representations of the Assumption.[42] It is extremely unusual for her to be shown crowned in a scene prior to her death, though she occasionally appears thus in representations of Pentecost, as in the Ingeborg Psalter.[43]

In considering the style of the Holy Sepulchre Chapel paintings, their debt to Byzantine art is even more clear. This is particularly true of the 12th-century scheme which, as has already been noted, is extremely close to the illumination of the later artists who worked on the Winchester Bible. The Byzantine characteristics and sources of this illumination have been examined in detail by Oakeshott, Ayres, and others,[44] and their findings also throw light on the 12th-century Holy Sepulchre Chapel paintings. It was Oakeshott who, in his pioneering study of the Bible published in 1945,[45] established that six main artists were responsible for its illumination, and who invented the names for these artists by which they have since been known. Oakeshott originally thought that the date-span of these different artists' work on the Bible was from c. 1150 to c. 1220, but he has recently revised this dating to c. 1160–85 (see below). The principal of the earlier artists — the Master of the Leaping Figures — himself works in a Byzantinising style, his figures characteristically in violent movement, and with highly stylised, damp fold draperies.[46] Of the later artists, the two most relevant to our discussion of the Holy Sepulchre Chapel wall paintings are the Master of the Morgan Leaf — named thus because of his work on a single leaf illustrating the Book of Samuel, now in the Pierpont Morgan Library[47] — and the Master of the Genesis Initial.[48] The work of these later artists, like so much other English painting of the last third of the 12th century — though certainly to an exceptional degree — shows a renewed Byzantine influence. However, the sources from which this influence derived were different from those earlier in the century, and resulted in a considerable change in figure style. In contrast to the linear, patterned style of, for example, the Leaping Figures Master, the new style is characterised by a much greater naturalism. Poses are more relaxed (this is not, however, generally true of the Genesis Master's figures, for the reason which will shortly be mentioned); and draperies now fall relatively naturally. Faces are carefully modelled, and often heavily bearded; and there is considerable use of green underpainting for the flesh. This is also the figure style of the 12th-century paintings of the Holy Sepulchre Chapel. The half-naked figures of Christ in the east wall paintings (Pl. XIV) may be singled out as exemplifying this new style, with their very carefully modelled anatomy, and the striking green-tone of the flesh. In the case of the Morgan Master's illumination, the Byzantine influences appear to have come from Sicilian mosaics — specifically those of the Cappella Palatina, Palermo (1150s)[49] — and also probably from imported Byzantine works.[50] Such were probably also the sources of the Byzantinising style of the 12th-century Holy Sepulchre Chapel paintings. The more dynamic style of the Genesis Master — which is less close to the wall paintings — has been related by Kitzinger to what he characterises as the 'late Comnenian baroque' of the Monreale mosaics (1183–89);[51] however, these mosaics seem rather too late to have been themselves the source of influence,[52] and once again, the style may well have been transmitted at least partly by imported Byzantine paintings or manuscripts.

Although they are very close, neither the later illumination of the Winchester Bible nor the 12th-century paintings of the Holy Sepulchre Chapel show yet quite the monumental, classicising quality of so-called Transitional works of c. 1200,[53] such as the Westminster

Psalter[54] or the Sigena chapterhouse paintings.[55] This accords well with Oakshott's revised dating of the later hands of the Bible to *c*. 1175–85, which depends partly on complex but convincing arguments concerning the relationship of this Bible to another great Bible illuminated at Winchester, largely with ornamental initials — the 'Auct. Bible'.[56] In view of their closeness to the late Winchester Bible illumination, it seems most probable that the first scheme of wall paintings in the Holy Sepulchre Chapel is of about the same date. A dating of *c*. 1175–85 for the wall paintings would also seem very appropriate in view of the late Norman date of the Holy Sepulchre Chapel itself.[57]

The closeness in style of the 12th-century wall paintings to the later illumination of the Winchester Bible raises the question of whether the wall paintings can actually be attributed to one of the Bible artists. The high priest's head (Pl. XVA), with its deeply furrowed brow, has something of the violent expressiveness of the Genesis Master's work (Pl. IIIA, D). However, none of the heads in the east wall paintings correspond to any of his very limited range of types,[58] and overall the style of the wall paintings is much closer to that of the Morgan Master's illumination. If a comparison is made with, for example, the Morgan Leaf (Pls IVA, B) — which, although painted over the earlier Apocrypha Master's designs,[59] shows the essential characteristics of the Morgan Master's style — it will be seen that there are many similarities over and above the shared Byzantinising characteristics already referred to. To mention some of the most obvious similarities: the same red and blue panelled backgrounds to the scenes (used on the verso of the Leaf); the curious 'billowing' grounds on which the figures stand (these are also found in the Genesis Master's work); and, in the draperies, the lozenge-pattern decoration on light-coloured robes (compare the robe of the Magdalene, in the Holy Sepulchre Chapel Deposition, with that of the weeping David at bottom right of the verso of the Leaf), and the blue and white vair linings to the cloaks.[60] Because of the close similarities in style, it is Ayres's view that 'no major obstacles' exist 'to including the Deposition and Entombment in the oeuvre of the Morgan Master';[61] and Oakeshott has also recently described himself as 'coming more and more round to the view' that the wall paintings were executed by the Master.[62] However, as well as all the similarities, there seem too many significant differences in style for an attribution to the Morgan Master to be really plausible. One of the most obvious differences is in the facial types. Compared with those in the wall paintings, the Morgan Master's youthful faces tend to be much more elongated and oval, with strangely thick necks (this contrasts with, for example, the St John the Evangelist in the wall painting Deposition; and, especially, with the flying angel in the Entombment, whose face is actually rather compressed — the reverse of the Morgan Master's characteristic type).[63] The older faces of the Morgan Master also tend to be thinner and more elongated, and also, it might be said, somehow of nobler mien, than those in the wall paintings. There are also important differences in the drapery styles. The drapery folds of the Morgan Master tend to be in long, curving sweeps across the body, with a number of folds more or less parallel with one another; in the wall paintings, on the other hand, the folds are much less flowing, and often produce — as in the figure of Nicodemus in the Deposition — a rather untidy effect.[64] The strong black folds in the Virgin's robe in the wall painting Entombment are nowhere encountered in the Morgan Master's illumination; while the sketchy white highlights on Nicodemus's cloak in the Deposition are perhaps most reminiscent of the 'wire-like' highlights characteristic of the Genesis Master's draperies.[65] Many of the similarities between the wall paintings and the Morgan Master's illumination may be accounted for simply by the fact that they are of the same late Romanesque stylistic phase. For instance, the use of panelled backgrounds, already mentioned, is a commonplace of Romanesque painting.[66] Similar billowing grounds are also frequently seen in late Romanesque painting;[67] though it might in fact be noted that the Holy Sepulchre Chapel

examples actually differ from those in the Winchester Bible illumination, which tend to be in tight coils rather than a succession of waves. Finally, in any question of attribution, the relative quality of the wall paintings and of the illumination must be considered. Superb though the wall paintings are, there are several slightly weak passages which give one pause in attributing them to the Morgan Master — described by Oakeshott himself as 'the most distinguished of the second generation of artists who worked on the Winchester Bible'.[68] In particular, the figure of Nicodemus in the Deposition is decidedly awkward; and the soldiers in the tier below are drawn to two different scales (the smaller of these quite diminutive compared to the other figures in the tier), and — damaged though they are — it is difficult from their poses to see how they could ever have formed a convincing group. The awkward way in which the angel's censer in the Entombment is blocked out by the inserted Virgin has already been noted,[69] and the architecture of the canopy above this scene is also somewhat crowded and confused.[70]

The rather surprising attribution has recently been made of some of the 13th-century painting in the Holy Sepulchre Chapel to the Morgan Master. Oakeshott has argued that the east wall paintings in this scheme are late works by the Master, executed 'perhaps as much as thirty-five years' later than the earlier scheme, and after the intervening trip which Oakeshott believes the artist made to work on the Sigena chapterhouse paintings.[71] The date which Oakeshott assigns to the 13th-century east wall painting is *c.* 1205.[72] Flynn has also attributed the east wall paintings to the Morgan Master, and further proposed that the Genesis Master collaborated on them.[73] Neither Oakeshott nor Flynn state to what extent, if at all, they believe the rest of 13th-century scheme was executed by the Morgan Master. Whereas, it might be confessed, in the case of the 12th-century paintings, that the possibility of their having been executed by the Morgan Master is perhaps still debatable; this attribution of part of the 13th-century scheme to him seems irreconcilable with what we know of his style. Oakeshott himself, in characterising the Master's style, has rightly drawn attention to the 'quiet dignified stance of his figures';[74] and, as qualities associated specifically with his work, has spoken of a 'three-dimensional quality . . . the bodies represented in the round; standing firmly . . . happier in repose than in movement'.[75] Such phrases could be applied equally to the 12th-century wall paintings in the Holy Sepulchre Chapel. But they are emphatically not appropriate in characterising the style of the 13th-century east wall paintings. Here, the figures are much less solid and three-dimensional, and convey — as in the figure of St John in the Deposition, and the Virgin in the Entombment — a feeling of great restlessness and agitation. Oakeshott, again, has singled out as 'the most distinctive feature' of the Morgan Master's work 'that profound solemnity which so often broods over it';[76] but in the 13th-century wall paintings some of the faces, in the extremity of emotion or pain which they show, positively verge on the grotesque. The huge eyes of these figures in the wall painting are in particularly striking contrast to the Morgan Master's style, as it is characteristic of the eyes of his figures that they are peculiarly small (Pls IIIc, IVA, B). The colouring of the 13th-century east wall painting — even allowing for its relatively poor condition — is much more subdued than that of the Morgan Master's illumination, and of the 12th-century wall paintings; for instance, it has none of the powerful contrasts of strong red and greens of the latter.[77]

The softer colouring of the later wall paintings, and the more two-dimensional quality, greater movement and emotional explicitness of the figures are all respects in which these paintings are already early Gothic. They thus belong to the next stylistic phase after the classicising Transitional of the Sigena chapterhouse paintings, and are one phase removed from the still essentially late Romanesque of the Morgan Master's illumination and of the earlier Holy Sepulchre Chapel paintings. In contrast to the solid, monumental forms of the

earlier paintings, the figure-style of the 13th-century wall paintings appears mannered and precious; see, in particular, the figure of St John in the Deposition, and the swaying pose of the Virgin in the Annunciation scene on the vault (Pl. XVIB), which is purely Gothic.[78] The draperies of the later wall paintings are also much less naturalistic than those of the earlier paintings, with the folds now arranged to a considerable degree for decorative effect, and obscuring the forms of the body underneath. This new, more precious figure-style, and decorative treatment of the draperies, may be related to manuscript illumination of c. 1220, such as that of two psalters made in a workshop probably at Peterborough: the Psalter of Robert de Lindesey,[79] and the Peterborough Psalter.[80] The representations of the Majesty in these two manuscripts[81] also provide particularly close parallels to the Pantocrator on the vault of the Holy Sepulchre Chapel, in the delicacy with which the figure of Christ is conceived, and in the way He appears — in contrast to Romanesque representations — more as the beneficent Saviour than as the awe-inspiring Judge.[82] The Gothic characteristics of the wall paintings are undoubtedly why they have always previously been dated to c.1220 or later,[83] rather than to the beginning of the 13th-century as Oakeshott proposes. What basic similarities there are to the earlier Holy Sepulchre Chapel paintings, and to the late illumination of the Winchester Bible, are due to the persistence of Byzantine influences, which we have already seen in the iconography, and which continue to affect the style of much English painting until as late as the mid 13th-century; two important instances of this are the illumination of the 'Sarum Master',[84] and that of Matthew Paris.[85] A number of heads drawn by Matthew Paris are quite close to that of the Holy Sepulchre Chapel Pantocrator; and Rickert has even suggested that one of them may have been derived directly from it,[86] though this possibility seems remote. A dating of the later wall paintings in the Holy Sepulchre Chapel to c. 1220, which seems most likely on stylistic grounds, is also supported by other evidence. As has already been noted, the repainting of the Chapel was necessitated by the architectural alterations made to it, including the insertion of the vault. This vault rests on corbels carved with stiff-leaf, two of these corbels surviving in good condition. Their stiff-leaf is of a more advanced type than that of capitals in the retrochoir, some of which is very embryonic. The stiff-leaf of the corbel in the north-east corner of the Chapel (see Pl. XIIIE) is of the same kind as that of the capitals of the inner colonnettes at the entrance to the north-east chapel (The Chapel of the Guardian Angels) and the south-east chapel of the retrochoir. These are the most advanced stiff-leaf capitals in the retrochoir. The corbel against the middle of the south wall of the Holy Sepulchre Chapel (see (Pl. XVB) has stiff-leaf of an even more fully evolved type. The retrochoir seems to have been substantially complete by c. 1220,[87] and so a dating to about this time of the architectural alterations to the Holy Sepulchre Chapel would seem most appropriate.[88]

It has been argued above that the 12th-century Holy Sepulchre Chapel paintings are slightly inferior in quality to the illumination of the Morgan Master.[89] An important point to be made about the 13th-century wall paintings is that they are much inferior both to the 12th-century wall paintings and to the Winchester Bible illumination, as also to the Sigena chapterhouse paintings. Although they have often been praised for their high quality (especially before the 12th-century layer was available for comparison!),[90] and although it is true that they are much superior to the average parish church wall painting of the period, they are nevertheless noticeably weak in certain respects. The almost caricaturish nature of some of the heads has already been remarked upon; as has also the inept way in which the Evangelist Symbols are squeezed in around the Pantocrator. The drawing of the figures is much inferior to that in the 12th-century scheme; the comparison need only be made between the thin, awkward figure of Christ in the Deposition, with its spindly limbs, with the magnificent, anatomically accurate figure of Christ in the 12th-century paintings. The

crude, monochrome scrollwork border at the foot of the 13th-century east wall paintings likewise hardly compares with the complex and delicate, vari-coloured central border in the 12th-century paintings. These are not simply differences in style, but differences in quality. Compared to the earlier scheme, the 13th-century paintings seem somewhat second-rate.

If neither of the schemes in the Holy Sepulchre Chapel appear to be by illuminators who worked on the Winchester Bible, it might fairly be asked who the painters were who did execute them. It seems probable that in general it was rather unusual for wall painters also to be illuminators. There is not only the obvious difference in scale between the two types of painting, but they also involve very different techniques; thus, in the case of the earlier paintings in the Holy Sepulchre Chapel, the artist had to be a master of the fairly difficult fresco technique, which involved laying one patch of plaster at a time over the sinopia, and completing the final painting on each patch before it had time to dry.[91] Of course, we know that some outstanding medieval artists were competent in a number of different media; for example, Master Hugo of Bury St Edmunds, a layman who was employed by the Benedictine abbey at Bury, and not only illuminated the Bury Bible in c. 1130, but also cast a bell and bronze doors, and carved a crucifix for the abbey church.[92] I am unaware, however, of a single documented case before the 14th century, of the same artist undertaking wall painting and illumination. The evidence for who executed wall paintings in the medieval period is severely limited, but what there is suggests that most wall paintings were executed by professional lay wall painters. There is, for instance, the well-known case of the lay artist Fulk, the wall painter to the abbey of Saint Aubin at Angers at the end of the 11th century, who was given a house and an acre of vineyard, which was to revert to the abbey at his death 'unless he have a son skilled in his father's art and willing to use it in St. Aubin's service'.[93] There is a great deal of evidence for wall painters travelling, often considerable distances, to execute commissions; an obvious case, in relation to the Winchester paintings, is that of the English artists who travelled to Spain to undertake the painting of the Sigena chapterhouse.[94] At Winchester itself, in a survey of the city carried out for Bishop Henry of Blois in 1148, no less than five lay painters are mentioned — Henry, Richard, *et al.* — living in the High Street and elsewhere; though, admittedly, they are simply called *pictores*, and it cannot be certain that they were wall painters.[95] Another most interesting piece of evidence concerning Winchester is the documented appointment in 1239 by Henry III of Master William of Westminster as painter for life to the Priory of St Swithin (of which the cathedral was the church).[96] Master William — who, exceptionally amongst Henry's painters, was a monk — continued, despite his Winchester appointment, to work for the king at Westminster and elsewhere, and was indeed his chief painter in the 1240s and '50s.[97] There are many references in the royal accounts to his work, which even included on one occasion overseeing the making of an iron lectern or prie-dieu for the king,[98] but there is no mention of any illumination by him. Likewise, none of the other 13th-century painters mentioned in the royal accounts are recorded as having undertaken any illumination. To summarise, therefore, it seems probable that most wall painters, including those who executed the Holy Sepulchre Chapel schemes, were not illuminators as well. They would have worked in the same general style as their illuminator counterparts, but that they were not the very same artists would account at Winchester for the slight stylistic differences that we have noted between the wall painting and the illumination. It is possible that when Master William was appointed painter for life to the Priory in 1239, it was in succession to the painter of the 13th-century scheme in the Holy Sepulchre Chapel.[99]

Turning now to consider the function of the Holy Sepulchre Chapel, apparently the earliest surviving reference to it as such dates only from the end of the 18th century. Milner then wrote: 'it is evident, that this was the chapel of the Sepulchre, as it was called, to which

there used to be a great resort in holy week'.[100] There cannot, however, be any real doubt that it always was a chapel of the Holy Sepulchre. Such chapels — of which most of the surviving examples are in Germany, with a few also in France and Italy — were used for liturgical ceremonies on Good Friday and Easter Sunday. These ceremonies varied somewhat, but, essentially, a liturgical entombment was enacted of a crucifix or the host, or perhaps a figure of Christ, on Good Friday (the *Deposito*); and on Easter Sunday this 'buried Christ' was 'resurrected', and returned to the altar (the *Elevatio*). A liturgical drama would follow this, with priests enacting the visit of the Maries to the Sepulchre and their dialogue with the angel (the *Visitatio Sepulchri*).[101] Such ceremonies must have taken place at Winchester from at least the 10th century onwards. The *Regularis Concordia*, drawn up at Winchester in 970, stipulates that the crucifix used in the Mass of the Presanctified on Good Friday should then be buried;[102] and this would have been brought back to the altar on Easter Sunday, and the *Visitatio* play performed. At this early period, probably only a temporary wooden structure was used for the ceremony. It has recently been stressed by Klukas that in the post-Conquest period the 'Winchester calendar and observances remained much as they had been in the . . . days of St. Ethelwold', and he has argued that the Holy Sepulchre Chapel is just such an instance of this continuity.[103] Additional evidence for such ceremonies at Winchester in the 12th century is provided by an entry in a list of Henry of Blois' gifts to the Cathedral: 'Pixis eburnea in qua ponitur Corpus Domini in Parasceve'. This pyx in which the host was placed on Good Friday may well have been the one used in the Holy Sepulchre Chapel in the *Depositio* ceremony.[104] The location of the Chapel at Winchester, in the crossing of the north transept, is further evidence that it was originally a Sepulchre chapel. The north side of churches, and sometimes in particular the north transept, had a special significance in this respect. For instance, at Essen, the cross used in the *Depositio* ceremony was venerated in the nuns' choir in the north crossing of the transept.[105] In England, the Easter Sepulchres of the later medieval period were almost invariably sited on the north side of the chancel.[106]

The subject-matter of the Winchester Holy Sepulchre Chapel paintings — including the Deposition, Entombment, and Resurrection subjects — would obviously have been entirely appropriate to the Chapel's use. It has parallels in the elaborate sculptural programme of the Holy Sepulchre Chapel at Gernrode of *c*. 1100–30, which includes a representation of the Maries on their way to the Sepulchre; the angel seated beside the tomb; and the *Noli me Tangere*.[107] The Deposition is carved on the outside wall of a chapel, which seems to have been used for the burial of an effigy of Christ, in the Externsteine, near Horn in Westphalia, of *c*. 1130.[108] The programme of the Gernrode Chapel also includes, on the west wall, the Agnus Dei, symbolising Christ and his sacrifice.[109] In the Chapel at Winchester, the carved boss of the eastern bay of the 13th-century vault similarly shows the Agnus Dei (see Pl. XVIB).

The very peculiarity of the iconography of the east wall paintings in the Winchester Chapel — where, in both schemes, the Entombment and Maries at the Sepulchre are combined in one subject — appears to be explained by the Chapel's function. In the normal way, of course, the scene of the Maries would have been represented after the Entombment, between it and the Harrowing of Hell; but, in the Winchester paintings, the Maries are shown approaching from the left of the Sepulchre, and the angel, who even here must be perceived as announcing the Resurrection, is nevertheless pointing directly at the dead body of Christ laid out in the tomb below (Pls XIV, XVIA). It is worth emphasising that this is so, since it is sometimes thought that in the 12th-century painting a second, empty sarcophagus is represented below the one in which Christ is being laid in the Entombment, and that the angel is pointing down at that. According to this interpretation, the long, brown horizontal

strip below the figure of Christ is 'the dark, empty interior' of a second sarcophagus.[110] However, this strip is in fact simply the upper part of the base of the sarcophagus in which Christ is being laid; it is shown in perspective with the rest of the base at the right-hand end. Although it is difficult to see this now, there was also only one sarcophagus represented in the 13th-century scene.[111] Accepting therefore that the Entombment and Maries at the Sepulchre scenes are combined, and that the angel is pointing down at the body of Christ, what can account for this strange iconography? It has been suggested that the Maries scene in the 12th-century paintings is out of sequence simply because of 'pressure on space' in the scheme at the east end of the Chapel.[112] However, this explanation seems unsatisfactory since, when in the 13th-century scheme the representation of the Harrowing of Hell was moved from the east to the south wall, and thus space was left for the Maries scene to be relocated in its 'correct' position, this opportunity was not taken. It would seem most likely that the reason for the combination of the two subjects was simply a desire for the lower tier of east wall paintings — in the most prominent position in the Chapel, immediately above the altar — to reflect as conspicuously as possible the three main elements of the liturgical ceremonies which took place in the Chapel: the *Depositio,* and *Elevatio*, and the *Visitatio Sepulchri*. Had the two scenes been represented separately, then each would necessarily have been represented on a smaller scale, and neither could have occupied wholly the centre of the wall-space directly over the altar.[113]

Finally, in this discussion of the Holy Sepulchre Chapel paintings, the question must be considered *why* the Chapel was originally built and decorated. Recently, the specific historical explanation has been proposed that the Chapel was built and decorated — or perhaps just one or the other of these — in 1185, as a direct result of a meeting at Winchester, in February of that year, of Henry II and Heraclius, the Patriarch of Jerusalem. Heraclius offered Henry the throne of Jerusalem, and laid at his feet such tokens as the keys of the Holy City and of the Holy Sepulchre. It is suggested that the Chapel was either to commemorate this occasion, or to receive the keys of the Sepulchre.[114] Both suggestions are questionable. Firstly, although the chronicle evidence is divided on this point, on balance it seems likely that the meeting-place was not Winchester at all, but Reading. It appears that at the time of the patriarch's arrival in England, Henry was in Nottinghamshire, and intending to travel on to York; but he changed his plans and returned south, meeting Heraclius on 17 March at Reading.[115] Immediately after this was the great council meeting at Clerkenwell, which advised Henry to reject the patriarch's offer. The very fact that Henry did refuse the offer, of course, makes it most improbable that it would have been commemorated in the elaborate way that has been suggested. It is even more unlikely that the Chapel was intended to receive the keys of the Holy Sepulchre, since these keys were not brought by the patriarch as a gift to be treated as relics, but rather as a token to be given to Henry if he accepted the offer, together with other such tokens: the keys of the city of Jerusalem, and of the citadel, and also the banner of the kingdom. There is no justification for singling out the keys of the Sepulchre as being specially significant in this context.[116] It should also be added that since, as we have already seen, there was a long tradition of Holy Sepulchre chapels in great churches, and strong liturgical reasons for having one at Winchester, a unique historical explanation for this example is not required.[117] Although the 1185 meeting itself therefore seems irrelevant to the Holy Sepulchre Chapel at Winchester, this is not to discount the possibility that the general crusading fervour of the period — in the 1180s the kingdom of Jerusalem was under attack by Saladin, and Jerusalem itself fell in 1187 — might have been an additional factor conducive to the foundation of such a chapel at this time.[118]

There is evidence to suggest that the 12th-century paintings of the Holy Sepulchre Chapel may only have been part of a much larger scheme of painting on the north side of the

cathedral. In the north transept, which is directly opposite the Chapel, a great deal of painting is recorded, of various dates. There was much decorative painting on piers and arches, including, on the latter, rows of medallions, lozenge pattern and scroll-work; and indeed some of this ornament still survives.[119] This decorative painting is difficult to date with precision, but, although a late 12th-century dating for at least some of it has in fact been suggested, the form of the scrollwork and other stylistic details seem to indicate rather that it is all most likely to be of early 13th-century date (and thus perhaps contemporary with the *c.* 1220 scheme in the Holy Sepulchre Chapel).[120] Various painted figures are also recorded in the transept, none of which survives, and of which one at least was clearly later in date than either of the Holy Sepulchre Chapel schemes. This was a figure of a king, at the north end of the east wall of the transept, which Tristram assigns to *c.* 1250, but which appears from his drawing to have been more probably of *c.* 1300.[121] An Adoration of the Magi is recorded on the west wall of the transept, as is also a figure of St Christopher, 'perhaps of 13th-century date'.[122] Of much greater interest, however, in relation to the Holy Sepulchre Chapel paintings, are figures uncovered on the north wall of the transept in 1788 by James Schnebbelie, of which he recorded two in a drawing and engraving, and of which there is a brief written account by James Milner.[123] There were two layers of painting in this position. It seems, from Milner's account, that the figures of 'Christian martyrs and other saints' were all in the upper layer; he records that the 'wheel of St Catherine, and the name of St Agatha are in particular visible'.[124] In the lower layer were two life-size figures, each standing within a round-headed frame, and holding in his left hand an inscribed scroll, and pointing upwards with his raised right hand (Pl. XVIc). These two figures were clearly prophets, as Milner suggests, expounding the texts on their scrolls; unfortunately, insufficient survived of the lettering for it to be possible to identify them individually.[125]

It is clear, even from Schnebbelie's copy, that these two figures were of late 12th-century date.[126] Indeed, it seems very likely that they were contemporary with the first scheme of paintings in the Holy Sepulchre Chapel, and they may well have been by the same painter. Stylistically, they show very close similarities to the earlier paintings in the Chapel, as also to contemporary Winchester illuminations. The figure-style is the same — solid and monumental, the faces heavily bearded — and the draperies provide many detailed comparisons. The folds in the cloak of the prophet on the right are closely paralleled by those in the cloak worn by Joseph of Arimathea in the Deposition in the Chapel paintings (Pl. XIV); and in both figures this cloak covers a lozenge-patterned tunic, the lozenges on each tunic containing very similar quatrefoil motifs. The heavily jewelled border of the prophet's cloak is similar to that of Joseph's tunic. The cloak of the left-hand prophet is decorated with crescents and quatrefoils, and this may be compared with the sprinkling of stars and other motifs over the cloak of the Magdalene in the Deposition, and of crescents over the tunic of the seated figure of Saul on the verso of the Morgan Leaf (Pl. IVA). The cloak of this left-hand prophet is lined with ermine; and exactly the same convention for depicting ermine is used for the linings of the cloaks of no less than three figures on the Morgan Leaf. The curious headgear of this prophet in Schnebbelie's drawing is clearly the result of a slight miscopying of the type of brimmed hat common in late 12th-century painting — and of which two essentially similar, though more rounded, examples can be seen in the Holy Sepulchre Chapel east wall paintings (Pl. XIV). The overall colouring of the prophet figures and their frames was similar to that of the 12th-century Chapel paintings, with green and red dominant. It can even be inferred with confidence, from Milner's account, that these paintings were in the same fresco technique as the 12th-century paintings in the Chapel. Milner relates that they were much fresher and more perfect than the layer of painting which covered them, and he explains this not only by the fact that they

had been protected by the later layer, but also writes: 'Their superior freshness is easily accounted for by their having been originally executed in a stronger style of colouring, while those of a later date carry proof of a more delicate and improved pencil'.[127] This was, of course, exactly the situation in the Holy Sepulchre Chapel itself. For all these reasons it seems extremely probable that the prophets were painted at the same time as the first scheme in the Holy Sepulchre Chapel. The question arises whether they were merely an isolated pair of figures on the north wall of the transept — the wall furthest from the Chapel — or whether there was more painting of this date elsewhere in the transept, intervening between and linking them to the painting in the Chapel. The suggestion made by Richard Gough, that they originally formed part of a longer series of prophets,[128] might well be correct; in this way they would have had much more meaning than as just two isolated figures, and such series of prophets are commonly found in Romanesque and later wall painting.[129] An important series, not far from Winchester, is mentioned in this connection by Gough: the twenty-four prophets, painted with the Majesty and other figures on the choir vault of Salisbury Cathedral in the mid 13th century.[130] These Salisbury paintings were recorded by Schnebbelie in 1789 — the year after his work at Winchester — and in 1790 were whitewashed over; the paintings now seen are copies made in 1870. The Salisbury figures, who were represented seated, were each shown holding an inscribed scroll, but unfortunately none of the inscriptions corresponds to those of the two known Winchester figures.

As well as the very close stylistic parallels to the Winchester figures of prophets provided by other Winchester painting, only slightly less close comparisons can be made with contemporary wall painting at Durham. This has implications which will shortly be mentioned. The painting at Durham is in the northern recess in the east wall of the Galilee Chapel, and comprises a standing figure on each jamb of the recess — probably St Cuthbert and St Oswald (Pl. XVId) — and also simulated draperies on the back wall, and foliate borders.[131] The similarities between the Durham pair of figures and the two prophets are striking. They are similarly set within round-headed frames, and one of them is shown frontally while the other is in three-quarters view. The Durham figures have panelled backgrounds, like those of the paintings in the Holy Sepulchre Chapel. The 'St Oswald' holds a scroll in his left hand, and in the same way as the Winchester prophets; and his other hand — which is now destroyed — was clearly similarly raised, and may well have been pointing upwards. The folds in his cloak are similar to those in the cloak of the right-hand prophet, and the lozenge pattern on his buskins is also close to that on the robe of this prophet. The vair lining of his cloak is paralleled by that of four of the figures in the east wall paintings of the Holy Sepulchre Chapel. The Galilee Chapel itself is dated to $c.$ 1175,[132] and the style of the draperies in the wall painting would appear to indicate that this painting is slightly earlier than the Durham *Life of St Cuthbert* with which it is sometimes compared, and which is of $c.$ 1200.[133] Therefore, the wall painting would seem most likely to date from $c.$ 1175–85, which provides additional confirmation of this dating of the Winchester wall paintings.

One other instance of contemporary wall paintings providing stylistic parallels for the Winchester prophets may be briefly mentioned. Comparisons can be made with the fine scheme of painting, of which only a few fragments are now extant, in the chancel of Barfreston Church, Kent.[134] In particular, the figure of a prophet on a window splay on the north side of the chancel was very similar.[135] It was shown in three-quarters view, like the left hand Winchester prophet; and with one hand holding a scroll in the same manner, and the other hand similarly pointing upwards. These paintings at Barfreston were clearly coeval with the church itself, and its famous sculpture— that is, once again, $c.$ 1180.[136] And,

presumably, just as the sculpture shows influences from nearby Canterbury,[137] so also were the wall paintings closely related to contemporary work at Canterbury.[138]

These non-Winchester wall painting parallels — from as far away as Durham — for the north transept prophets, and first scheme of paintings in the Holy Sepulchre Chapel, add further confirmation to a view that has been argued earlier, and which, in conclusion, is worth emphasising. This is that it is not now feasible, on the basis of stylistic comparisons, to attribute the wall paintings to particular artists whose work is found elsewhere — for example, in the illumination of the Winchester Bible. At this period artists in different media and at different centres were working in too much the same style for it to be really possible to isolate the work of one individual in this manner (especially when it is remembered that the vast majority of the painting of this time — which would all have been in the same general style — is unknown). The Durham wall paintings are extremely close stylistically to those at Winchester, but there is virtually no possibility that they were executed by an artist from the latter centre (and, similarly, the possibility is very remote that the Winchester paintings are by an artist from Durham). This all has very important implications for the Sigena chapterhouse paintings, which unfortunately it has not been possible to discuss in any detail in the present article. Although there can now be no real doubt of their English authorship, they are by no means certainly attributable — as has been argued on the basis of comparison with Winchester wall paintings and illumination — to artists specifically from Winchester, let alone to particular Masters such as the Morgan Master. As Caviness has rightly remarked about the style of the Sigena paintings: 'Whether it belongs to Winchester or Canterbury is perhaps a question one should not ask in a period when local styles were rapidly disappearing'.[139]

ACKNOWLEDGEMENTS

I am grateful to Mr Len Furbank, of the Royal Commission on Historical Monuments (England), for taking the photographs of the Holy Sepulchre Chapel paintings. The Cathedral officials could not have been more co-operative during this operation. I am also indebted, for various kinds of help, to Mrs Eve Baker, Miss Margaret Freel, Mr Christopher Norton, Mr Neil Stratford, and the Hon. Editors.

REFERENCES

SHORTENED TITLES USED

LEE (1975) — M. Lee, *Paintings in the Holy Sepulchre Chapel, Winchester* (unpublished M.A. report, University of London 1975).

OAKESHOTT (1972) — W. Oakeshott, *Sigena: Romanesque Paintings in Spain and the Winchester Bible Artists* (London 1972).

——— (1981a) — W. Oakeshott, *The Two Winchester Bibles* (Oxford 1981).

——— (1981b) — W. Oakeshott, 'The Paintings of the Holy Sepulchre Chapel', *WCR*, 50 (1981), 10–14.

TRISTRAM (1944) — E. W. Tristram, *English Medieval Wall Painting: The Twelfth Century* (Oxford 1944).

——— (1950) — E. W. Tristram, *English Medieval Wall Painting: The Thirteenth Century* (Oxford 1950).

NOTES

1. For details of the previous condition of the paintings, and of the conservation work undertaken on them, see the articles by Eve Baker in the *WCR*, 33 (1964), 10–12; no. 34 (1965), 17–20; and no. 39 (1970), 29–31; and by Eve and Robert Baker in no. 36 (1967), 21–25. See also Oakeshott (1981b).

2. J. J. G. Alexander, 'The Middle Ages', in *The Genius of British Painting*, ed. D. Piper (London 1975), 31, 34. In view of their importance, the 12th-century paintings have received strangely little attention in print. The main published accounts are Oakeshott (1972), 131–36, and Oakeshott (1981b). The latter is illustrated with two colour plates of details of the east wall painting; and there is also a colour plate of the whole wall in O. Demus, *Romanesque Mural Painting* (London 1970), opposite 122. The paintings are discussed by K. Flynn, *English Romanesque Wall Paintings* (unpublished M.Litt. thesis, University of Birmingham 1980); and the most valuable account of all is provided by Lee (1975). For the 13th-century paintings, see especially Tristram (1950), 163–67, 612–15, Pls 28–42. It is intended to publish an exhaustive account of both schemes, as part of the national Survey of Medieval Wall Paintings which the present author is undertaking on behalf of the Courtauld Institute of Art, in association with the Royal Commission on Historical Monuments (England).

3. The architecture of the Chapel has unfortunately never been studied in any depth. The late Norman character of the capitals is noted by B/E *Hampshire and the Isle of Wight* (1967), 681, though the whole Chapel (i.e. including the 13th-century alterations, for which see below, pp. 38, 48, and n. 88) is here mistakenly regarded as of one build, dating from c. 1200. As observed by Lee (1975), 1, the Chapel must in any case date from after 1107, when the central tower collapsed.

4. The Sigena chapter house paintings were badly damaged by fire in 1936, and the remnants are now mostly displayed in the Museo de Arte de Cataluña, Barcelona. Their 'Englishness' was first demonstrated by O. Pächt, 'A Cycle of English Frescoes in Spain', *The Burlington Magazine*, CIII (1961), 166–75; and further examined by Oakeshott (1972). In the lecture to the British Archaeological Association Conference at Winchester in 1980 on which the present article is based, I also examined the Sigena paintings at some length, and considered them in relation to other wall paintings and illuminated manuscripts in Spain which also show English influence. A separate article is being devoted to this material.

5. The female figure on the right is wrongly identified as the Virgin by Oakeshott (1972), 133, and Oakeshott (1981b), 11; but interpreted as 'probably the Magdalene' by Lee (1975), 5.

6. See below, 50–51 and n. 110.

7. Oakeshott (1972), 135; Oakeshott (1981b), 12. The subject is correctly identified by E. and R. Baker, 'Paintings in the Chapel of the Holy Sepulchre', *WCR* (1967), 23–24; and by Lee (1975), 7.

8. See below, 42.

9. Tristram (1944), 152. Pl. 55. Suppl. Pl. 11b.

10. For information about the technique, see also E. and R. Baker, op. cit., 23, 25.

11. Cf. the late 11th-century paintings at Clayton (E. Sussex), and the other wall paintings of the 'Lewes Group' (for the technique of Clayton, see A. M. Baker, 'The Wall Paintings in the Church of St John the Baptist, Clayton', *Sussex Archaeological Collections*, CVIII (1970), 58–59; the early 12th-century wall paintings at Witley (Surrey) (see D. Park, 'The Romanesque Wall Paintings of All Saints' Church, Witley', *Surrey Archaeological Collections*, LXXIV (1982) forthcoming); the paintings of St Gabriel's Chapel and St Anselm's Chapel in Canterbury Cathedral (for the St Gabriel's Chapel paintings, see E. Baker 'St Gabriel's Chapel, Canterbury Cathedral', *Canterbury Cathedral Chronicle*, no. 63 (1968), 5; etc.

12. In the 13th-century scheme, the plaster for each section of the painting was laid in its entirety at one time, rather than in a succession of patches. The sketching out for the painting was then done on this plaster, rather than, as in the 12th-century paintings, on a lower layer (see n. 28 below). Oakeshott (1981a), 78 n. 2, and caption to Pl. 98a, describes how some of the more important outlines in the final painting were executed when the plaster was still wet, while less important parts were done when the plaster had become almost dry. He uses the term 'mezzo fresco' to characterise the technique of these paintings. According to Baker (1965), 19, the paintings in the eastern section of the vault were done while the plaster was still wet. I am very grateful to Mr David Perry for discussing the technique of both schemes of painting with me.

13. The mitred head and the sinopia, although uncovered in 1963, were only replaced in the Holy Sepulchre Chapel — on the north wall — in 1976. Of this painting, Lee (1975) was aware only of the mitred head, and, in the sinopia, the sketch for this head, and the series of architectural canopies. She interpreted the head as that of a bishop, and speculated that all this painting belonged to a great Last Judgement covering the south and west walls in the 12th-century scheme (and including the Resurrection of the Dead further to the west on the south wall); see Lee (1975), 28–30. This theory is accepted as probable, and further observations are added to it, by J. E. Ashby, *English Medieval Murals of the Doom* (unpublished M.Phil. thesis, University of York 1980), 30–32, 59–61. In fact, the sinopia shows three separate scenes: and it does not appear, from the 19th-century description we have of it, that the now destroyed west wall painting belonged to a Last Judgement (see below, 42, and n. 27). A different interpretation of the sinopia and mitred head is put forward by E. Baker, 'The Holy Sepulchre Chapel, Winchester Cathedral', *WCR*, 39 (1970), 31. The sinopia is here regarded as part of a 'lay subject'; and reference is made to the similarity of the mitred head to the 'one known head' of Bishop Henry of Blois (1129–71) — who it is proposed may have been responsible for the 12th-century scheme in the Chapel.

14. Richard of Ilchester's first seal was probably made in 1174, when he was consecrated bishop, but certainly
dates from before 1180; it is so far unpublished. His second seal was in use by 1185; it is reproduced, for
example, by Oakeshott (1981a), Pl. 187. The first English bishop to show the new type of mitre on his seal
appears to have been Bishop Hugh du Puiset, of Durham, on a seal which almost certainly dates from his
consecration in 1153. I am most grateful to Sandy Heslop for this information about seals. A very late
representation of the old, rounded type of mitre occurs in the window with scenes from the life of St Dunstan,
in the north choir aisle of Canterbury Cathedral, dating probably from the last quarter of the 12th century;
see M. H. Caviness, *The Early Stained Glass of Canterbury Cathedral* (Princeton 1977), Fig 111.

15. New York, Pierpont Morgan Library MS 619, recto. For a discussion of the style of the Morgan Leaf in
relation to the 12th-century paintings of the Holy Sepulchre Chapel, see below, 46–47. A similar mitre is also
worn by one of the figures in the scene of Moses and Aaron leading the Israelites out of Egypt, in the Sigena
chapterhouse wall paintings; see Oakeshott (1972), Ill. 39.

16. London, Victoria and Albert Museum MS 661, recto; see C. M. Kauffmann, *Romanesque Manuscripts
1066–1190*, a Survey of Manuscripts Illuminated in the British Isles (London 1975), 93–95, Ill. 179. The
mitres depicted on this leaf even have in some cases a similar roundel on each horn to those on the mitre in the
wall painting. So also do the mitres of the Jewish priests in the Passion scenes of the Bury Gospels, Cambridge
Pembroke College MS 120, of c. 1130; see E. Parker, 'A Twelfth-century Cycle of New Testament Drawings
from Bury St Edmunds Abbey', *Proceedings of the Suffolk Institute of Archaeology*, xxxi (1969),
Pls XXXVII–XXXVIII. The motifs enclosed by the roundels in the Winchester painting are not crosses, such
as are often found on bishops' mitres, but simple, rounded quatrefoils.

17. This scene on the leaf has not previously been interpreted specifically as Christ before Annas, but simply as
Christ between 'two mitred figures' and other men (M. R. James, 'Four Leaves of an English Psalter . . .',
Walpole Society, xxv (1936–37), 12), and as 'A man hits Christ', by Kauffmann, op. cit., 94. However, it is
clear that the scenes on the leaf follow the account in John's Gospel, of separate hearings before Annas and
Caiaphas, since in the next scene to the right Christ is shown bound and being led before Caiaphas, as
described by John 18, 24 (this scene is interpreted by Kauffmann, 94, as 'Christ before Pilate', but the figure
Christ is led before is mitred, like the other priests, whereas the representations of Pilate on the leaf show him
wearing a Phrygian cap). A similar arrangement of these scenes is found in a Book of Hours illuminated by W.
de Brailes, c. 1230–60, where the scene of Christ being struck before Annas is followed by a scene to the right
of Christ led before Caiaphas, the high priest in each case identified by an inscription: London, British Library
MS Additional 49999, f. 32; see S. C. Cockerell, *The Work of W. de Brailes*, Roxburghe Club (Cambridge
1930), Pl. XIXa.

18. See below, n. 19.

19. As, for example, on the detached Psalter leaf; Kauffmann, op. cit., Ill. 179. An abbreviated version of the
Mocking with a figure about to strike Christ with his fist, and with Caiaphas enthroned on the right, occurs on
the tympanum of the central west portal of Strasbourg Cathedral, of c. 1280; see G. Schiller, *Iconography of
Christian Art*, ii (London 1972), 58, Fig. 15. The 'victim' figure in the sinopia scene, with its beardless face
and wavy hair, looks almost female; but there is no episode in the Passion of Christ in which a female figure
appears before a high priest, or is struck. As well as the appearance of this figure, a number of other objections
could be raised to the tentative interpretation of this scene as Christ before a high priest, which has here been
proposed. For instance, there seems to be no other version of the scene of Christ before Annas which shows
the officer with a crutch; and, whereas the gospel account states that the officer struck Christ with the palm of
his hand, and this is how he is shown in other representations, the figure in the sinopia scene seems to have his
raised right hand clenched. It is, perhaps, even possible that he is holding a weapon in this hand, though it is
difficult to see how this could fit into the available space behind his head. One other possible interpretation of
the sinopia subject-matter should perhaps be mooted. In the western recess of the south wall of the Chapel are
several small scenes of the martyrdom of St Catherine of Alexandria, forming part of the 13th-century
scheme. One of these scenes, the Beheading of St Catherine, is somewhat similar in format to the central
sinopia scene, in that it shows a seated figure looking on from the left, the executioner in the centre (with
caricatured, evil face), and the (decapitated) figure of the saint at right (with, above, her soul being borne up
by an angel) (see below, 43; and Tristram (1950), 615, Pl. 39). Could, therefore, the sinopia scene be of St
Catherine, particularly in view of the somewhat female appearance of the victim figure? If this were the case,
the St Catherine subject-matter would simply have been shifted westwards in the 13th-century scheme. An
additional factor which makes this question worth raising is that philosopher figures are sometimes
represented in Romanesque art wearing horned headdresses, somewhat similar to that which appears in the
final painting above the sinopia (though I know of no examples which are precisely similar, and, in particular,
no examples with lappets like those of the Winchester mitre); and philosophers appear in the legend of St
Catherine. A scene often represented in St Catherine cycles is the saint disputing with the philosophers of
Alexandria, whom she converted to Christianity by her arguments, and who were then themselves martyred
by the Emperor Maxentius. In the scene of the Dispute in the wall paintings of Montmorillion (Vienne), of

*c.*1200, one of the philosophers is shown wearing a horned headdress (see Demus, *Romanesque Mural Painting*, Pl. 180). In spite of these points, however, it seems most improbable that the sinopia shows St Catherine. The figure at left of the Beheading scene in the 13th-century paintings at Winchester is not a philosopher, but the Emperor Maxentius, who ordered her execution. In fact, the central sinopia scene does not seem to be identifiable as any known St Catherine subject. In addition, it would not seem possible to interpret either the left-hand or right-hand scenes in the sinopia (for which, see below, 41) as part of a St Catherine cycle. On balance, therefore, the most satisfactory interpretation of the sinopia subject-matter is as part of a cycle of the Passion of Christ, leading up to the scenes on the adjacent east wall of the Chapel. And if this is so, it is difficult to see what other subject the central sinopia scene could represent except Christ before one of the high priests.

20. Lee (1975), caption to Pl. IV.
21. For the use of dados for grotesqueries in wall paintings, see Demus, op. cit., 21: '. . . the dado is the only area in mural painting where free rein is given to the grotesque, fantastic and profane elements'. Strange beasts were also represented in the peripheral areas of the Sigena chapterhouse scheme — in this case, in the spandrels of the transverse arches. See Oakeshott (1972), Ills 18–19, 28, 36–39, 42, 45, 50; and Pächt, op. cit., 169: 'Displayed side by side with the great Biblical narrative we find a different type of imagery, lower in rank and drawn on a smaller scale. . . . In this marginal sphere the medieval artist naturally had more scope for direct self-expression'.
22. Demus, op. cit., 310, Pl. 85.
23. Ibid., 311, Pl. 92.
24. Ibid., 307–8, Pl. 78.
25. See Demus, op. cit., 21.
26. Tristram (1944), 45, Pls 67–68. Tristram dates the Stowell paintings to the late 12th century, but Demus, op. cit., 512, prefers a date in the second or third decade of the 13th century. There is, of course, in this dado scene, a direct reference to the nature of the subject-matter above.
27. J. G. Waller, 'Observations on the Paintings in Winchester Cathedral', *Transactions of the British Archaeological Association . . .* (London 1846), 268. Waller's suggested interpretations of the subject-matter can probably be discounted; for instance, figures on horseback do not appear in representations of the Crucifixion until the later Middle Ages. The recent suggestion that the west wall painting formed part of a huge Last Judgement covering the whole of the south and west walls in the 12th-century scheme can also be rejected; as we have seen (39–41, and n. 13 above) Last Judgement subject-matter did not cover the whole of the south wall; and, once again, 'figures on horseback' are improbable elements of a 12th-century Doom. (Although it is true that in the late 11th-century Doom at Clayton (E. Sussex), with its to some extent unique iconography, remains of two horses occur on the north wall, there are no traces of any riders here; while the single mounted figure on the south wall is a half-naked devil. See A. M. Baker, op. cit., 63, 64, 69–70, Pl. IX.
28. For a detailed description, and many illustrations, see Tristram (1950), 612–15, Pls 28–42.
29. When this painting was detached from the wall and undergoing conservation treatment in the 1960s, a detail of the original sketching out for it on the same layer of plaster was noticed: the sun and the moon, drawn in above the horizontal arm of the cross. I am much indebted to David Perry for this information. The sun and moon, which were not included in the final painting, are more usually associated with the Crucifixion.
30. It is not known what painting was on the vault of the western bay of the Chapel, since this vault was destroyed in the 19th century when a private stairway was constructed for Samuel Sebastian Wesley to the organ above (see E. Baker, 'Wallpaintings in the Holy Sepulchre Chapel', *WCR*, no. 33 (1964), 10; and B. Matthews, *The Organs and Organists of Winchester Cathedral*, 2nd ed. (Winchester 1975), 26). The present reconstruction of the vaulting ribs in wood dates from the 1960s, from the same time that the artificial wall was made at the west end of the Chapel for the detached 13th-century east wall paintings. The stone boss carved with stiff-leaf, set at the intersection of the ribs, is probably not original to the Chapel; its exact provenance within the cathedral is unknown. I am very grateful to Mrs Corinne Bennett for this and other information about the vault. It might be mentioned here that the weight and vibration of the organ directly above have contributed to the fragility of paintings within the Chapel (see Baker, op. cit., 11; and idem., 'The Holy Sepulchre Chapel, Winchester Cathedral', *WCR*, 34 (1965), 17).
31. O. Demus, *The Mosaics of Norman Sicily* (London 1949), 11, Pl. 2.
32. Lee (1975), 9–14.
33. Hannover, Kestner-Museum; Schiller, op. cit., Fig 551. See Lee (1975), 10–11.
34. Chantilly, Musée Condé MS 9 (1695), f. 27; F. Deuchler, *Der Ingeborgpsalter* (Berlin 1967), 54–55, Pl. 31. See Lee (1975), 10 and n. 28.
35. Demus, op. cit., Pl. 72.
36. In the Monreale scene just mentioned, three Maries are in fact represented, but this may be due to reciprocal western influence

37. For the iconography of the Lamentation of Christ, see K. Weitzmann, 'The Origin of the Threnos', in *De Artibus Opuscula XL; Essays in Honour of Erwin Panofsky*, ed. M. Meiss (New York 1961), 476–90.
38. Constance, Rosgarten-Museum; ibid., 483, fig 10.
39. London, British Library MS Nero C.IV, f. 23; F. Wormald, *The Winchester Psalter* (London 1973), Ill. 26. See Lee (1975), 14.
40. Weitzmann, op. cit., 485, argues that this depiction of the hands as veiled derives from representations of angels waiting to receive the soul of the Virgin in Byzantine representations of her Death — the Koimesis. It might be noted here that the censing angel in the 12th-century Holy Sepulchre Chapel painting is not tonsured, as stated by Oakeshott (1981b), 12. Its hair is simply 'layered', in the manner often found in painting of the period; see, for example, several of the figures depicted on the Morgan Leaf (see Ayres, Pls IVA and B).
41. For the cult of the Virgin in 12th-century England, see, for example, R. W. Southern, 'The English Origins of the Miracles of the Virgin', *Medieval and Renaissance Studies*, IV (1958), 176–216; and G. Zarnecki, 'The Coronation of the Virgin on a Capital from Reading Abbey', *Journal of the Warburg and Courtauld Institutes*, XIII (1950), 1–12, especially 11–12.
42. See J. J. G. Alexander, *Norman Illumination at Mont St Michel 966–1100* (Oxford 1970), 156–57, Pl. 41C–42a for late 11th-century examples in Norman manuscripts of the Virgin shown crowned in the Assumption. In two Anglo-Saxon manuscripts, the Benedictional of St Ethelwold (971–84), London, British Library MS Additional 49598, f. 102ᵛ, and the Benedictional of Archbishop Robert (*c.* 980), Rouen, Bibliothèque Municipale MS Y.7 (369), f 54ᵛ, the Virgin is shown in the Dormition receiving a crown from the Hand of God. See E. Temple, *Anglo-Saxon Manuscripts 900–1066*, A Survey of Manuscripts Illuminated in the British Isles (London 1976), 51, 53, Ill. 87.
43. Deuchler, op. cit., Pl. XXVIII; this example is noted by Lee (1975), 32 n. 39. The Virgin is also shown crowned in the Pentecost miniature of the Shaftesbury Psalter, of *c.* 1130–40; London, British Library MS Lansdowne 383, f. 15ᵛ. See Kauffmann, op. cit., Ill. 132.
44. See especially W. Oakeshott, *The Artists of the Winchester Bible* (London 1945), 10–16; Pächt, op. cit., 171–75; E. Kitzinger, 'Norman Sicily as a Source of Byzantine Influence on Western Art in the Twelfth Century', *Byzantine Art — An European Art*, Lectures Given on the Occasion of the Ninth Exhibition of the Council of Europe (Athens 1966), 137–38; Oakeshott (1972), esp. 80 ff.; L. M. Ayres, 'The Work of the Morgan Master at Winchester and English Painting of the Early Gothic Period', *Art Bulletin*, LVI (1974), esp. 215 ff.; Kauffmann, op. cit., 27–28, 110; Oakeshott (1981a), esp. 68 ff.
45. Oakeshott, *Artists of the Winchester Bible*.
46. See Oakeshott (1981a), 43–47, Pls V, 32–42.
47. New York, Pierpont Morgan Library MS 619. For the Morgan Master, see especially Ayres, 'The Work of the Morgan Master'; and Oakeshott (1981a), 75–87, Pls II, VII, VIII, 93–96, etc.
48. Oakeshott (1981a) 71–75, Pls III, 79–83, 85–92, etc.
49. Ibid., 113; Oakeshott (1972), 98–99, 112–13.
50. See J. J. G. Alexander, Review of Oakeshott (1981a), in *Times Literary Supplement*, 21 May 1982, 563.
51. Kitzinger, loc. cit.
52. Kauffmann, op. cit., 110.
53. The illumination of another of the later generation of Winchester Bible artists, not hitherto mentioned — the Master of the Gothic Majesty — is usually regarded as working in the Transitional style. But even his illumination does not show the clear-cut, monumental forms of the *c.* 1200 works. For this Master, see Oakeshott (1981a), 82–86, Pls 29, 104, 106, 110–11, etc.
54. London, British Library MS Royal 2 A. XXII; see M. Rickert, *Painting in Britain: The Middle Ages*, 2nd edn (London 1965), 92–93, Pl. 91.
55. See Pächt, 'A Cycle of English Frescoes in Spain'; Oakeshott (1972).
56. Oxford, Bodleian Library MS Auct.E. inf. 1–2 (S.C. 2426–27). See Oakeshott (1981a), esp. 99 ff.; and J. J. G. Alexander, Review of Oakeshott (1981a), in *Times Literary Supplement*, 21 May 1982, 563.
57. See above, 38.
58. For the Genesis Master's facial types, see Oakeshott (1981a), 73, 75, and Ills 80–82, etc.
59. Ibid., 58–63.
60. These, and a number of other similarities, are pointed out by Lee (1975), 23–24.
61. Ayres, 'Morgan Master', 213; he notes that the Morgan Master's 'partiality for juxtaposing pink and vermilion is readily observed' in both the illumination and the wall paintings.
62. Oakeshott (1981b), 114. Oakeshott had earlier written of the wall paintings 'Though the quality is so fine, and though detail after detail . . . is strongly reminiscent of work by others in this group of artists, the hand is not one to which I feel at all secure in attributing any other work, either at Sigena or in the Bible. It must nevertheless belong almost exactly to the period of the later generation of Bible artists' (Oakeshott (1972), 135).

63. Oakeshott's comparison of this angel with the flying angel in the unfinished initial to Psalm 101 in the Bible (on f. 246; designed by the Leaping Figures Master, but painted by the Morgan Master), far from demonstrating their closeness, in fact exemplifies this difference in head types. See Oakeshott (1972), 135, Ill 159.

64. See Lee (1975), 25. Lee argues, from differences in the drapery styles, and other stylistic dissimilarities, against an attribution of the wall paintings to the Morgan Master.

65. Oakeshott (1972), 133: 'The dusted white high-lights on this cloak suggest a phase in which the technique was not yet as stereotyped as it became in the Genesis Master's work'. For the Genesis Master's use of highlights, see Oakeshott, *Artists of the Winchester Bible*, 13; and Oakeshott (1981a), 71.

66. Rather earlier examples are in the wall paintings of St Gabriel's Chapel and St Anselm's Chapel in Canterbury Cathedral, perhaps dating from *c.* 1120–30 and *c.* 1160 respectively. See Demus, *Romanesque Mural Painting*, Pls 234–35, and Pl. opposite 120.

67. E.g. in the last copy of the Utrecht Psalter, Paris, Bibliothèque Nationale MS lat. 8846, illuminated probably at Canterbury; see H. Omont, *Psautier illustré (XIIIe siècle): Reproduction du MS lat. 8846 de la Bibliothèque Nationale* (Paris, n.d.).

68. Oakeshott (1972), 104.

69. See above, 44.

70. For this architecture, see Oakeshott (1972), 135: 'These [roofs and turrets] are not in a hand which I recognise, either in the Bible, or at Sigena'. Oakeshott also refers to 'the rough, more homespun quality' of the Deposition, compared to the Entombment (ibid.). See also Lee (1975), 26, who contrasts the figure-painting of the wall paintings unfavourably with the Morgan Master's work, finding it less sensitive.

71. Oakeshott (1981b), 14, and see 11 and 13. See also Oakeshott (1981a), 71, 78, and captions to Pls 97 and 98a, b.

72. Ibid., caption to Pl. 97.

73. Flynn, op. cit., 181.

74. Oakeshott (1981a), 85.

75. Oakeshott (1972), 97–98. Although he is here describing the Sigena chapterhouse paintings, Oakeshott continues (98): 'These are qualities which the work of the painter of the Morgan Leaf, and of the initials in the same hand in the Winchester Bible, lead us to associate specifically with him'.

76. Ibid.

77. As already noted, the very technique of the earlier and later paintings in the Chapel is different — the earlier being in true fresco, and the later in 'mezzo fresco'. See above, 40 and n. 12.

78. Oakeshott himself described the St John figure as showing 'unmistakable anticipations of the Gothic style' (Oakeshott (1981b), 13). See also Boase's comment on the 13th-century wall paintings: 'The poses and expressions have that Gothic emotional intensity which was to be the characteristic feature of works of the mid-century'; T. S. R. Boase, *English Art 1100–1216*, 2nd edn (Oxford 1971), 277.

79. London, Society of Antiquaries MS 59; see R. Marks and N. Morgan, *The Golden Age of English Manuscript Painting 1200–1500* (London 1981), 10, 45–46, Pls 3–4.

80. Cambridge, Fitzwilliam Museum MS 12: see P. Brieger, *English Art 1216–1307* (Oxford 1957), 83–84, Pl. 26b.

81. The Robert de Lindesey Psalter has a full-page miniature of the Majesty on f. 36; see Marks and Morgan, op. cit., 46, Pl. 4. In the Peterborough Psalter, the Majesty is represented in an initial on f. 159; see Brieger, op. cit., Pl. 26b.

82. An equally close parallel is provided by the full-page Majesty on a detached psalter leaf, again of the same (?) Peterborough workshop, now London, British Library Cotton MS Vespasian A.i., f. i; see D. H. Turner, *Early Gothic Illuminated Manuscripts in England* (London 1969), 10–11, Pl. 1. This Majesty is enclosed by a plain quatrefoil frame, as is that in the Peterborough Psalter initial, and these frames provide a striking comparison for the trefoil frame around the Holy Sepulchre Chapel Pantocrator.

83. Boase, op. cit., 277: '*c.* 1220'; Tristram (1950), 166: '*c.* 1220–30'; Rickert, op. cit., 114: *c.* 1230'; Demus, op. cit., 510: '1230–50'.

84. See Marks and Morgan, op. cit., 14, 54, and esp. 57, Fig. V, Pls 8–9; and, for a general account of the Master's illumination, A. Hollaender, 'The Sarum Illuminator and his school', *Wiltshire Archaeological and Natural History Magazine*, L (1943), 230–62.

85. See Rickert, op. cit., 108–10; and, for a general discussion of Matthew Paris as artist, R. Vaughan, *Matthew Paris*, (Cambridge 1958), 205–34.

86. Cambridge, Corpus Christi College MS 26, f. vii; Rickert, op. cit., 115, Pl. 112. Rickert writes of the 13th-century wall paintings: 'Their technique still displays characteristics of Byzantine painting such as the greenish underpainting for flesh and the modelling of faces and drapery with strong high-lights. . . . The head of Christ . . . is amazingly Byzantine'.

87. P. Draper, 'The retrochoir of Winchester Cathedral', *Architectural History*, XXI (1978), 7.

88. For a discussion of Winchester stiff-leaf, see P. Wynn-Reeves, *English Stiff Leaf Sculpture* (unpublished Ph.D. Thesis, University of London 1952), 189–95. Wynn-Reeves, 194, attributes the corbel in the north-east corner of the Holy Sepulchre Chapel to the same sculptor as the inner capitals at the entrance to the Guardian Angels Chapel, and dates both the Guardian Angels Chapel and the Holy Sepulchre Chapel vault to *c.* 1220. I am grateful to Lady Wedgwood for answering my questions on the stiff-leaf.

89. See above, 46–47.

90. See, e.g. Tristram (1950), 163; and B/E, op. cit., 681, where these wall paintings are described as 'the best of about 1230 in England'.

91. The difference between the arts of wall painting and illumination in the Romanesque and earlier periods has been emphasised by C. R. Dodwell, *Painting in Europe 800–1200* (Harmondsworth 1971), 6. In relation to the treatise on the arts by the 12th-century artist 'Theophilus', which describes the use of glazes, etc. in wall painting, Dodwell writes: 'from this it is clear that the techniques of manuscript — and wall — painting were quite different. They were two separate crafts, normally practised by two different types of artist'. For Theophilus, see C. R. Dodwell, ed., *Theophilus De Diversis Artibus* (London 1961).

92. See C. M. Kauffmann, 'The Bury Bible', *Journal of the Warburg and Courtauld Institutes*, XXIX (1966), 63–64; and R. M. Thomson, 'Early Romanesque Book-Illustration in England: The Dates of the Pierpont Morgan *Vitae Sancti Edmundi* and the Bury Bible', *Viator*, II (1971), 221–23.

93. Dodwell, *Painting in Europe 800–1200*, 6.

94. For travelling wall painters, see ibid., 6, 179–80; and Demus, op. cit., 57.

95. See M. Biddle, ed., *Winchester in the Early Middle Ages: an edition and discussion of the Winton Domesday*, Winchester Studies, I (Oxford 1976), 203, 430, 432, 433, 491.

96. See Tristram (1950), 161, 445. Tristram suggests (169) that the angel busts in roundels painted on the vault of the Chapel of the Guardian Angels, which still survive, were either executed by Master William himself, or under his supervision. For these paintings, see ibid., 168–69, 616, Pls 44–50, Supp. Pl. 19; Demus, op. cit., 511, Pl. 239, Fig. 41; R. W. and E. Baker, 'An Account of the Conservation of the Painted Vault in the Chapel of the Guardian Angels, Winchester Cathedral', *Conservator*, I (1977), 17–21.

97. For a detailed discussion of Master William's career, see Tristram (1950), 445–50.

98. Ibid., 449.

99. The possibility cannot be ruled out that either or both of the schemes in the Holy Sepulchre Chapel were executed by wall painters who also worked for the king. In the case of the earlier scheme, we have seen that this dates from *c.* 1175–85. The Pipe Roll for 1182 records that in that year painting was carried out in the King's Chamber in Winchester Castle. This chamber must have been the one which Giraldus Cambrenus describes as being 'decorated with various paintings and colours', including an allegorical subject of the king being harried by his sons (though it is not clear whether this painting actually existed, or is merely an invention of Giraldus'). See G. Henderson, 'Giraldus Cambrensis' account of a painting at Winchester', *Archaeol. J.*, CXVIII (1961), 175–79; and H. M. Colvin, ed., *The History of the King's Works, II, The Middle Ages* (London 1963), 857. It is possible that the painter(s) who worked in the castle at this time also worked in the cathedral. It might be noted here that the royal accounts for Winchester Castle also provide an interesting parallel for the association in the Holy Sepulchre Chapel of architectural alterations and repainting. It is recorded that in 1233 new windows were inserted in the walls of the painted chamber in the castle, and that this chamber was repainted with 'the same pictures and stories' that it had before (see Colvin, op. cit., 861). I am grateful to Mr Paul Binski for drawing my attention to this reference.

100. J. Milner, *The History and Survey of the Antiquities of Winchester* (London 1798), 73–74; see also Lee (1975), 18.

101. For chapels of the Holy Sepulchre, and the ceremonies associated with them, see N. C. Brooks, 'The Sepulchre of Christ in Art and Liturgy with Special Reference to the Liturgical Drama', *University of Illinois Studies in Language and Literature*, VII, No. 2 (1921); D. G. Dalman, *Das Grab Christi in Deutschland*, Studien über christliche Denkmaler, XIV (Leipzig 1922); K. Young, *The Drama of the Medieval Church* (Oxford 1933), 112–410; A.-M. Schwarzweber, *Das Heilige Grab in der deutschen Bildnerei des Mittelalters* (Freiburg im Breisgau 1940).

102. For the Good Friday and Easter ceremonies at Winchester and other centres in England see J. B. L. Tolhurst, *The Monastic Breviary of Hyde Abbey, Winchester . . .* , VI (London 1942), 218–36. See also T. Symons, ed., *Regularis concordia . . .* (London 1953), 36–52; Lee (1975), 20–21.

103. A. W. Klukas, *Altaria Superiora: The Function and Significance of the Tribune-chapel in Anglo-Norman Romanesque* (Ann Arbor 1979), 378.

104. For this gift, see E. Bishop, *Liturgica Historica* (Oxford 1918), 401. For how the pyx might have been used, see Lee (1975), 19–20.

105. E. C. Parker, *The Descent from the Cross: its Relation to the Extra-liturgical Depositio Drama* (New York 1978), 126. Cf. also Parker on St Riquier: 'It will be recalled from the ordering of the altars at St Riquier that, based on the arrangement at Old St Peter's in Rome, this north transept area also carried the specific

connotations of Calvary and of the Resurrection and was thus symbolically a most meaningful part of the church' (ibid.).

106. Ibid. See also A. Heales, 'Easter Sepulchres; their Object, Nature, and History', *Archaeologia*, XLII (1869), 263–308.

107. R. Budde, *Deutsche Romanische Skulptur 1050–1150* (Munich 1979), 36–38, Pls 44–50. See also Lee (1975), 22.

108. Budde, op. cit., 30–31, Pl. 29; Lee (1975), 22.

109. Budde, op. cit., Pl. 47.

110. Oakeshott (1981b), 12; see also Oakeshott (1972), 135. Flynn, op. cit., 188, also agrees that there is a second sarcophagus in this position. Lee (1975), 6, correctly states that the angel is 'pointing to the occupied tomb of the Entombment scene, instead of an empty sepulchre'.

111. See Tristram (1950), 614. Pls 28, 33.

112. Lee (1975), 7.

113. There appear to be only two surviving Romanesque parallels for the Winchester combination of Entombment and Maries at the Sepulchre, and both of these are Spanish. One is a cloister relief at Santo Domingo de Silos, probably of *c*. 1100 (see M. Schapiro, 'From Mozarabic to Romanesque in Silos', *Art Bulletin*, XXI (1939), Fig. 28. The other is a relief in the south porch of San Andrés at Armentia (Alava), of late 12th-century date (J. Gudiol Ricart and J. A. Gaya Nuño, *Ars Hispaniae*, V (Madrid 1948), Fig. 498. In the Gerona Beatus manuscript of 975 (f. 17) there is a scene of Christ lying in the sarcophagus, with two Maries approaching, and Joseph of Arimathea seated facing them in place of the angel (See W. Neuss, *Die Katalanische Bibelillustration um die Wende des ersten Jahrtausends und die altspanische Buchmalerie* (Bonn and Leipzig 1922), Fig. 172). These examples led Cook to suggest that the combined iconography might be a native Spanish tradition (W. W. Cook, 'The Earliest Painted Panels of Catalonia', *Art Bulletin*, X (1927–28), 331). It seems unlikely, however, that there was any direct connection between them and the Winchester paintings, even allowing for the fact that English artists — perhaps from Winchester itself — were to be working on the Sigena chapterhouse paintings *c*. 1200 (the earlier Holy Sepulchre Chapel scheme of course slightly pre-dates this campaign by English artists in Spain). It has been noted by Tcherikover that on an English or north French ivory comb of the first half of the 12th-century, now in Verdun, the Entombment and Maries at the Sepulchre scenes 'share one background figure as well as the soldier and the censing angel' (A. Tcherikover, 'Two Romanesque Ivory Combs', *JBAA*, CXXXII (1979), 18). She also points out (p. 18, n. 58) that the soldiers on one of the eye-shaped sides of a similar comb in London perhaps belong to the Entombment scene on the comb, and this does indeed seem very likely. According to Tcherikover, the scenes on the Verdun comb 'should be understood as combined, although to a lesser degree than those in the Winchester wall paintings'. However, the two scenes on the comb are essentially separate, with the tomb itself being represented twice; and the placing of the soldiers on the end-teeth next to the Entombment, and of the censing angel on that above the Marys scene, is probably due more to the very limited space available on the comb, and its very awkward shape. These factors resulted in other iconographical peculiarites; e.g., on the London comb, the representation of the Magi as upright in the scene of their Dream, and the partial combination of this subject with the Adoration of the Shepherds; see D. Park, 'A New Interpretation of a Magi Scene on a Romanesque Ivory Comb', *JBAA*, CXXXIV (1981), 29–30. Perhaps the most significant parallels for the Winchester combined iconography, although they are much later in date, are provided by the sacrament houses produced in Germany in the 14th century. These life-size or smaller sculptured groups, which were used for reservation of the sacrament, often show Christ lying in the sarcophagus, the Marys standing behind, and one or two angels — either censing or pointing down at the body of Christ. See W. H. Forsyth, *The Entombment of Christ: French Sculptures of the Fifteenth and Sixteenth Centuries* (Cambridge (Mass.) 1970), 13–14; Schiller, op. cit., 183–84, Figs 641–42.

114. Ayres, op. cit., 213. See also L. M. Ayres, 'A Miniature from Jumièges and Trends in Manuscript Illumination around 1200', *Intuition und Kunstwissenschaft: Festschrift für Hanns Swarzenski . . .* (Berlin, 1973), 132.

115. See R. W. Eyton, *Court, Household, and Itinerary of King Henry II* (London 1878), 261. I am most grateful to Prof. W. L. Warren for supplying me with this reference, and with general help on this question. Ayres, 'Morgan Master', 213 and n. 41, concedes that the chronicle evidence is conflicting as to the place of the meeting, but relies mainly on the testimony of Giraldus Cambrensis who places it at Winchester.

116. The absence of any mention of the keys in a surviving list of the relics at Reading cannot therefore be treated as evidence for the meeting between Henry and Heraclius having been at Winchester, as Ayres implies (ibid.).

117. Ayres himself makes the point that 'it is well to keep in mind that chapels of the Holy Sepulchre existed well before the era of the Crusades' (ibid.).

118. See Lee (1975), 18–19.

119. For this painting, see P. Gélis-Didot and H. Lafillée, *La Peinture décorative en France du XIe au XVIe siècle* (Paris 1889), Pl. 29; V. Ruprich-Robert, *L'Architecture normand* (Paris 1884–89), 225, Pls LVIII, CLXVI; Tristram (1944), 42, 155; Tristram (1950), 162–63, 611–12, Pl. 43, Suppl. Pl. 21b.

120. According to Tristram (1944), 152, the earliest of the 'traces of painted treatments' in the transept 'appears to have been executed at the end of the 12th century'; but on p. 42 he dates the same painting to *c.* 1200. Elsewhere, he writes of the transept painting: 'considerable remains . . . of a scheme executed *c.* 1200, or early in the 13th century'; Tristram (1950), 611.

121. Ibid., 163, 612, Suppl. Pl. 31a. I am grateful to Paul Binski for his advice on the dating of this figure.

122. Ibid., 612; Milner, *History and Survey of the Antiquities of Winchester*, 74.

123. J. Milner, 'An Account of some Paintings Discovered in Winchester Cathedral', in J. Schnebbelie, *The Antiquaries Museum* . . . (London 1791), 1–3. Schnebbelie's engraving is Pl. III. I am indebted to the late Canon Bussby for drawing my attention at Winchester to Schnebbelie's copy.

124. Ibid., 2.

125. Ibid., 2–3: 'unfortunately nothing more is legible in one of [the scrolls] . . . than the letters DNS, which is the contraction for DOMINUS, with the unmeaning characters VD–NI; and in the other the letters IRTV, which probably formed part of the word VIRTUS, or one of its inflections'. I am indebted to Mr John Mitchell for confirmation of the view that these recorded remains of lettering are insufficient for certain identification of the texts, and thus of the particular prophets represented.

126. Milner did not attempt to date them; Tristram (1950), 163 and 612, mistakenly associates them with the figures in the upper and later layer, and suggests that all these figures may have belonged to the same series as the king on the east wall of the transept — which he dates to *c.* 1250, but which was probably *c.* 1300 (see above, 52).

127. Milner, op. cit., 2.

128. Ibid., n. 3.

129. For other Romanesque examples, see e.g. those in two German wall painting schemes illustrated by Demus, *Romanesque Mural Painting*: the apse paintings of Sankt Peter und Paul, Niederzell auf der Reichenau, of *c.* 1120–30 (601, Pl. 242); and the Abteikirche, Prüfening (610, Fig. 50). The Niederzell prophets stand under a series of round-headed arches.

130. For a full account of these paintings, see F. R. Horlbeck, 'The Vault Paintings of Salisbury Cathedral', *Archaeol. J.*, CXVII (1960), 116–30.

131. For this painting see Tristram (1944), 59–60, 120–21, Pls 86–87; A. Baker, 'The Frontispiece: The Wall Painting of St Cuthbert at Durham', in *The Relics of Saint Cuthbert*, ed. C. F. Battiscombe (Oxford 1956), 528–30., Col. Frontis.; M. Johnson and M. McIntyre, 'Wall Paintings in the Galilee of Durham Cathedral', *Transactions of the Architectural and Archaeological Society of Durham and Northumberland*, XI (1958–65), 278–80; M. Johnson, 'The North-East Altar in the Galilee of Durham Cathedral', ibid., 371–90. Johnson, pp. 378 ff., questions the traditional identification of the figures as St Cuthbert and St Oswald, but unconvincingly. For instance, on p. 388, she describes the 'St Oswald' as a 'knight in armour', and says 'there is no evidence that he is a king'. However, he clearly is a king, since he is holding a sceptre (not a spear or lance, as Johnson may have thought), and is not wearing armour, but rich robes and buskins.

132. See R. Halsey, 'The Galilee Chapel', *Medieval Art and Architecture at Durham Cathedral BAA CT* (1980) 62, and the works referred to in his n. 27.

133. London, British Library MS Yates Thompson 26. For a comparison of the wall painting with the miniature of St Cuthbert on f. 1ᵛ, see Baker 'Frontispiece', 529–30. The view that the drapery style indicates a somewhat earlier date for the wall painting than the manuscript is put forward by M. Baker, 'Medieval Illustrations of Bede's *Life of St Cuthbert*', *Journal of the Warburg and Courtauld Institutes*, XLI (1978), 22 n. 43. Baker here proposes a date for the wall painting of 'perhaps about 1180–90', but the very slightly earlier dating suggested above seems preferable in view of the *c.* 1175 date of the chapel itself.

134. For these paintings, of which a set of water-colour drawings made by H. Smith before 1883 is in the Library of the Society of Antiquaries, see Tristram (1944), 24, 98–99, Pl. 26, Suppl. Pl. 8.

135. Ibid., Suppl. Pl. 8.

136. For this dating of the church and its sculpture, see G. Zarnecki, *Later English Romanesque Sculpture 1140–1210* (London 1953), 40. Tristram (1940), 24, rightly points out the contemporaneity of the paintings with the church, but (p. 28) dates the latter rather too early, to *c.* 1160.

137. Zarnecki, loc. cit.

138. Painting of about the same date — showing busts of prophets in roundels, and various unidentified scenes, etc. — survives on the vault of the nave of St Gabriel's Chapel, in the crypt of Canterbury Cathedral. For this painting, which does show general stylistic similarities to the Barfreston paintings, see Tristram (1944), 19–21, 104, Pls 20–22, Suppl. Pls 2c, 3a–b. The very fine painting of St Paul and the Viper, in St Anselm's Chapel, is rather earlier — the draperies are still in the damp fold style — and may date from *c.* 1160; see U. Nilgen, 'Thomas Becket as a patron of the arts', *Art History*, III (1980), 357–74, for the suggestion that the painting was associated with Anselm's translation into the chapel in 1163.

139. Caviness, *The Early Stained Glass of Canterbury Cathedral*, 56.

A Recently Discovered Purbeck Marble Sculptured Screen of the Thirteenth Century and the Shrine of St Swithun

By Pamela Tudor-Craig and Laurence Keen

THE SHRINE OF ST SWITHUN

In 1924 J. D. Le Couteur and D. H. M. Carter offered to the Society of Antiquaries a reconstruction of the 13th-century shrine base of St Swithun (Fig. 1).[1] The essentials of that reconstruction were:

a. A band of arcading, of which two pieces, indicating a length of at least three bays, survive (Pl. XVIIA);

b. One blind panel treated with a sunken sexfoil roundel (Pl. XVIID);

c. Several portions of three and four strand cable shafting plus two capitals for the four strand shafts (Pl. XVIIB).

The width of the sexfoil panel (b) agrees with the width of one bay of the arcading (a).

In addition, they incorporated a frieze decorated with heads, of which they had found one head of a monk (Pl. XVIIc). This head is carved on both sides. They suggested it had been damaged and reused the other way up, but this interpretation was challenged at the time.[2]

The Quatrefoil base

The authors found no place in their reassembly of the shrine basement for four substantial sections of a Purbeck base, three of which fit together (Pl. XVIIE). Their decorative scheme consists of paired sunken quatrefoils within a rectangular frame, separated by two small rectangular sectioned pilasters, having between them two trefoil headed niches, one above the other. Two of the surviving quatrefoils were carved separately and then inserted into the roundels of their panel, but the remainder were carved out of the block. While these fragments may have come from a tomb chest, there are two indications that they could have formed part of the base of this shrine:

a. The unit measurement of the paired quatrefoils corresponds with that of the single sexfoil panel.

b. The small paired pilasters ought to be supporting a superstructure, of a type associated with a canopied tomb or with a shrine. They might form bases for the triangular-sectioned three strand cable shafts for which Le Couteur and Carter could find no place in their reconstruction and which they therefore delegated to the role of isolated columns supporting lights around the shrine.

Against the association of these base sections with the shrine, on the other hand, there are two factors:

a. Their relatively 'advanced' architectural detailing.

b. Their inclusion would displace the portion of arcading incorporated in the Le Couteur and Carter elevation. The dimensions between the columns of the arcade do not correspond with the vertical elements of this base.

FIG. 1. Theoretical reconstruction of St Swithin's shrine, after Le Couteur and Carter.
Courtesy of the Society of Antiquaries of London

It remains uncertain which of the two elements belonged to the shrine base itself but both probably found a place in the same complex. They are of approximately the same date as three outstanding sculptural fragments executed in freestone: a portion of window tracery, the dragon boss, and the head corbel.

The Window Tracery

This is a single stone carved with rich internal mouldings carrying the fillet (found also on the heart-tomb of Aymer de Valence (Pl. XIXB)) and relatively simple external mouldings, with a glazing groove between them. This suggests a window of exceptional quality and delicacy, but the dimensions argue a small scale.

The Dragon Boss

The boss of two dragons biting one another is well known. Again, the scale is small. These lean dragons with their ribs showing are characteristic of the mid 13th century. Neither the

dragon corbel at Wells, the Christchurch misericord, nor the Seattle copper gilt chimeras which are its nearest relations have any circumstantial dates attached to them. The search for a context for this boss and this window, which may well have been associated with one another, could turn towards the 13th-century treatment of the eastern chapel terminations.

The Head Corbel

There is a head corbel (Pl. XIXD) with wrinkled brow and whispy hair which, like the one still *in situ* at the entrance to the Lady Chapel, once probably supported a statue. Its closest parallel is with the famous Clarendon head, a royal piece from a site not too far distant in place nor perhaps in time. Both these heads have distressed expressions which were, no doubt, foils to companions of 'cheerful and joyous countenance'.[3]

In general, however, it would appear that the major structural campaign at Winchester was completed by the mid 13th century, and attention could turn to the enrichment of the standing edifice. The painting of the vault of the Guardian Angels Chapel, for instance, has been linked with a document suggesting that Master William, the king's painter, could have worked here in 1256[4] when he might well have added the naturalistic leaves.

Provenance

Le Couteur and Carter said[5] that 'in the spring of 1921 the feretory behind the high altar of Winchester Cathedral was cleared of a mass of architectural and other fragments accumulated there. The more interesting pieces were re-arranged in the north transept; the rest, including the original 14th-century statue of St Swithun, from the gable of the west front, being relegated to the crypt'. Mr Carpenter Turner told the writers that architectural fragments had been found in the core of a staircase giving access to the de Lucy extension from the south side, and that there are more to be found under the raised floor of the feretory. Others have been identified from the Paradise Wall of the Winchester Research Unit's excavations.[6]

The bulk of the great collection of Winchester statue fragments surely derives from the High Altar Screen itself and from the various chapel altar screens. Their accumulation within the feretory area is eloquent of the post-Reformation changes of focal points within the cathedral. What had been one of the most sacred parts of the structure made a conveniently central storehouse for the deposit of broken altar furnishings. The fact that all the pieces Le Couteur and Carter singled out, and very probably those to be discussed below, emerged from the feretory itself is in accord with the likelihood that they originally belonged to that place. However the undocumented reshuffling of 1921 and of more recent years has obliterated evidence of exact provenance that might have been very revealing. The archaeological approach to the movement of sculptural finds within our cathedrals is a newly discovered historical weapon that might have been very helpful had it been used in the past.

THE COLLECTION OF PURBECK FRAGMENTS FOUND IN THE SOUTH-WESTERN CRYPT

Mr Carpenter Turner, some years ago drew the attention of Pamela Tudor-Craig to a group of Purbeck marble architectural fragments lying in this area, saying that they may have been related to the shrine. Detailed examination and measurement of them undertaken by Laurence Keen[7] has revealed that they make up an important addition to our knowledge of

F

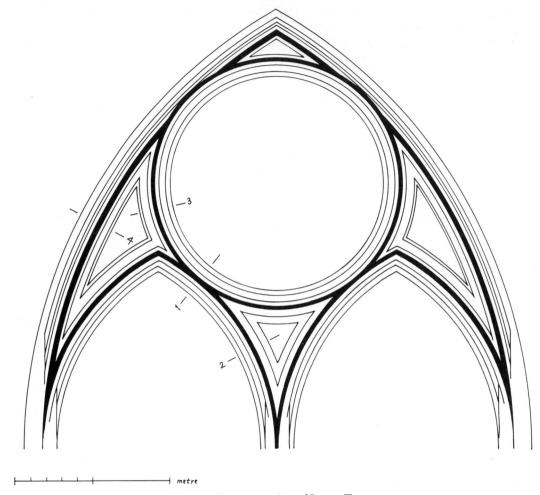

FIG. 2. Reconstruction of Screen Tracery

mid 13th-century English art. Their intimate connection with the material published by Le Couteur and Carter is established by their including two figure sculptures of the first quality, one of which constitutes the rest of the figure of the monk, of which Le Couteur and Carter mistakenly incorporated the head in their reconstruction of the shrine base. As Sir Charles Peers remarked at the time, noting that the monk's head was carved on both sides of the marble, and not favouring their suggestion that it was a reused piece, 'If placed on a screen both sides might have been rendered visible'.[8] In our opinion everything points to the correctness of Peers' view. Clearly, Le Couteur and Carter had not examined the 'less important' pieces relegated to the crypt. The completed figure shows the monk, as deacon, displaying the open Bible (Pl. XVIIIA). The reverse of the fragment of the body, like the reverse of the head unfortunately less well preserved, shows the rest of a second monk holding in both hands an open scroll (Pl. XVIIIB). The fragment carved on both sides with the two bodies has mouldings along one side. There is another sculpted and moulded

FIG. 3. Mason's mark

fragment which belongs to the same structure. Here the same mouldings survive along both sides and form an elongated triangle which contains on one side the complete figure, carved in relief, some 80 cm long, of a mitred bishop, holding a Bible in his left hand and blessing with his right (Pl. XVIIIc). The reverse of this sculpture, like the reverse of the monk unfortunately damaged, has another mitred bishop with his right hand raised in blessing and his left holding a crosier (Pl. XVIIId). Gathered together in the same part of the crypt are forty-two other pieces of moulded screenwork carrying the same profiles as the two carved spandrels. Two more related pieces are in the triforium. More may come to be identified. But it has been possible from this material to provide a reconstruction of the design of which they were a part (Fig. 2). This reconstruction is based on the average radii of the three main geometric elements calculated from detailed measurements of the curves of each individual fragment. The design is of two pointed arches supporting a large circle all contained within a larger pointed arch. All parts of the elevation are well represented except the apex of the larger pointed arch and the associated section of the roundel. It is likely that the arcade here represented rested on columns with capitals, of which no parts have as yet come to light in the crypt.[9]

The central shaft is carved in such a way that several mouldings die away into the vertical drum. The three elements of the composition spring from this central shaft. The space between the side of the pointed arches and the roundel is open. The large roundel has a groove 3 cm deep and 6 cm wide. This is clearly meant to contain a decorative element which we assume to have been made of wood.

The spandrels were treated in three ways. They were either (a) sculptured, like the two described above or (b) open, as demonstrated by section 3 and on figure 2 or (c) glazed, as indicated by a small groove, 1.5 cm wide and 1.5 cm deep.

Where the original ends of the stones survive undamaged they show shallow grooves with parallel V's and assembly holes 6 cm square and 3.5 cm deep. Only in one case does the lead tenon survive. In two cases we have found an identical mason's mark on the flat outer edge of the outer order (Fig. 3). One of these marked stones carries the adossed figures of bishops.[10]

The three ways of treating the spandrels and the three examples of the central springing demonstrate that at least three complete units once existed. We have therefore a two sided structure which was more extensive than a doorway. The most plausible deduction is that we have parts of a narrow stone screen perhaps not much thicker than the 20 cm of the decorated units. We have no means of knowing how wide the space between each bay may have been, or how the intervals were treated or how many bays beyond three there may have been. Similarly, there is no evidence for the treatment of the top of the complete composition, nor for the height of the shafts. But the two-sided sculptural enrichment and other embellishments suggest a screen, and the richness of its detailing demands that it was at ground level.

THE RELATIONSHIP OF THE SCREEN WITH THE SHRINE

The fragments which we claim to make up a screen and those associated by Le Couteur and Carter with the shrine base have more in common than their materials. The squared pilasters of the suggested shrine base can be compared with details of the canopy work over Giles de Bridport's effigy at Salisbury (Pl. XIXc) A square section is characteristic of detailing at Westminster associated with the Shrine of St Edward the Confessor (1241) onwards. The series of niches, whether foiled or blind, that form a part of the Le Couteur/ Carter reconstruction, find a parallel within Winchester in the treatment of the doorway inserted into the south aisle wall of the de Lucy extension: whether they found a place on the screen or the shrine, these foiled arches may represent a local convention. The flattened recesses between the buttresses of the quatrefoil element suggest a later date. Indeed, we may be wrong in bringing this section into the mid 13th-century orbit. But there are again parallels in the de Bridport canopy and in the tomb base of Henry III at Westminster Abbey, probably carried out before 1272.

The closest parallels for the Purbeck marble twisted shafts are those around the shrine of the Confessor (finished by 1268) and the tomb of Henry III at Westminster Abbey,[11] and those in the Winchester City Museum from Hyde Abbey.

The dating of the shrine fragments centres on the same span as the screen, linking with St Edward at Westminster (started 1241),[12] St Etheldreda at Ely (by 1254)[13] and St Edmund at Bury St Edmunds (fragments of mid 13th-century stiff leaf) which between them establish the first wave of the assertion of native cults of saints which is such a notable feature of the later 13th and earlier 14th centuries in this country.

THE HISTORY OF THE SITE OF ST SWITHUN'S SHRINE AND THE PLACE OF THIS PURBECK SCREEN IN RELATIONSHIP TO IT

Peter Draper[14] referred to an earlier structure between the Norman piers of the feretory area replaced by the 14th-century screen at the east end of the feretory. Christopher Norton suggests that the 1250–60 retrochoir floor extends about six inches below the present screen. It is possible that our Purbeck screen is the predecessor of the c.1320 screen enclosing the feretory. Like its successor it could have had its independent cornice well below the structural arches of the building. Peter Draper has debated the rival claims of the feretory and retrochoir sites for the remains of St Swithun[15] and has demonstrated that by the end of the Middle Ages they must have lain between the chantries of Cardinal Beaufort (died 1447) and William Wayneflete (died 1486). Certainly the great 15th-century reredos would have obscured the shrine, if at that date it still stood immediately behind the High Altar. Yet the ill-assorted 13th-century bases behind the reredos do indicate that the shrine should have been there in the 13th century, before the 15th-century High Altar Screen was erected. No mention has been found in the monastic records of a translation of St Swithun[16] and we know[17] that he was still housed in his ancient shrine at the end of the Middle Ages. An indication that St Swithun was failing to make his mark as a highly regarded saint by the second half of the 13th century can be found in Edward I's *Distributiones Pauperis* of 1283–84.[18] Despite Edward's ceremonial visit to the cathedral in 1276, and its proximity to the Royal Castle, St Swithun rated very low in the allocation of festal bounty.

It is perhaps the case that the new screen of 1320 reflected a change of policy. Swithun is not mentioned among the names of saints and royalty recorded upon it. Maybe at this point the monks decided to move Swithun to a site by himself in the retrochoir and to create an alternative attraction behind the High Altar by emphasising not only sainted bishops, but

the line of ancient royal burials in which Winchester alone could outdo the rival Benedictine house of Westminster.

THE SCREEN AND ITS RELATIONSHIP TO OTHER THIRTEENTH-CENTURY MATERIAL

A screen of this elaboration, incorporating glass, wood, and sculpture of the highest quality, and executed in Purbeck marble, is without parallel in surviving English 13th-century work. In compositional terms it provides a fine example of the geometric tracery form, as found in the triforium of Westminster Abbey from 1245, perhaps in the cloister at Windsor a year or two before[19] and at Binham Priory. The major groove within the large circle most probably accommodated a variety of trefoils, quatrefoils and perhaps cinquefoils, on the numerous analogies in triforia,[20] in cloisters[21] and in tomb canopies, where the Purbeck canopy of Bishop Giles de Bridport (died 1262) at Salisbury, is the most obvious comparison (Pl. XIXA). The profiles represented here (Fig. 4) are of classic mid 13th-century types. The characteristic fillet is not found in dated Winchester work before the heart tomb (Pl. XIXB) of Bishop Aymer de Valence (died 1261). Perhaps the most significant detail is the running of mouldings into the central column. This sophistication is prominent in the inner chapter house doorway at Westminster Abbey (Fig. 5) and it comes into play with growing subtlety in the design of the main arcades of Salisbury Cathedral, where it is suggested in the choir, emphasised in the transepts and evident in the nave.

FIG. 4. Sections of screen tracery mouldings

The de Bridport tomb has the cutting of figure and architectural mouldings from one block which is a feature of the spandrels of the Winchester screen. The use of leaves running along the moulded members is found in Purbeck effigy work since William Longspée (died 1226) at Salisbury, and is prominent in both the de Bridport and the de Valence effigies. But it is notable that whereas the de Bridport canopy work makes much of the naturalistic foliage convention introduced at Westminster since 1245, the de Valence tomb shows nothing of it. Nevertheless the de Valence and the de Bridport effigies have strong resemblances in their drapery conventions, their short arms, protruding ears and flattened facial features, resemblances that can be found equally in the bishop and monk figures on the Winchester screen. It appears that the ecclesiastical commissions of the mid 13th century, the effigies of Hugh de Northwold (died 1254) and Kilkenny (died 1256) both at Ely, and the founder abbot at Ramsey, among them, brought the Purbeck workshops to the peak of their achievement.

There is something unexpectedly clumsy about the large hand of the more complete bishop on the Winchester screen which has nothing of the grace of the elongated hands of

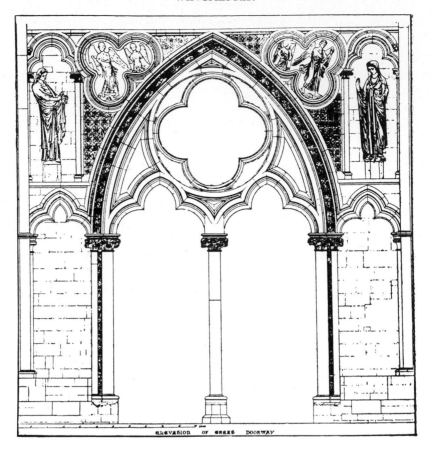

FIG. 5. Reconstruction of the inner doorway to the Chapter House, Westminster Abbey.
After W. R. Lethaby Westminster Abbey Re-examined

the previous generation of sculptures at Wells. That apart, the disposition of the two pairs of figures in their tight spandrels is highly accomplished. Their drapery would presuppose the knife-fold pleats of the Westminster Chapter House (1250) and has lost altogether the thin ribby forms of the 1240s. The two better preserved faces are in the first flight of mid-century sculpture. They have almond eyes very shallowly set in their sockets and the self conscious smile deriving from Reims, of which the English prototypes are the Westminster Chapter House Angel and transept angels, and effigies like de Bridport (Pl. XIXc).

DATE AND PATRONAGE

The Purbeck shrine base has been associated with the recorded disaster of the fall of the flabellum upon the shrine in 1241.[22] The record of the disaster declares that no harm was done to the shrine itself, so presumably the base did not suffer greatly either. We are of the view that 1241 is a decade too early for the creation of the magnificent assembly of which we have the fragments. We have associated it with a group of Purbeck tombs dated 1254–62, and with the architectural detailing of Westminster and Salisbury work of the 1245–68

span. The touchstone of these interrelationships is the heart tomb of Bishop Aymer de Valence, which cannot have been made before his death abroad in 1261. De Valence may have been no more than Bishop Elect for ten out of his eleven years of office, 1250–61, but he was not so much an absentee as other Winchester Bishops. In 1250 he gave a banquet for Henry III and his Queen, who were, as was their custom, spending Christmas here. We agree with Christopher Norton in dating the Retrochoir floor to c.1260, and see that as part of the same commission as the renewed shrine base and its accompanying screen. Mr Norton discovered a Purbeck fragment discretely gilded. The final array, with the shrine and its base seen through our sumptuous screen, could have been in direct rivalry with the feretory of Westminster Abbey, and perhaps completed, like that at Ely, before it. We would see this achievement as reflecting the patronage of a bishop as powerful and as near to the throne as Aymer de Valence, and its execution, if not during his lifetime, then in the years immediately following it. Our screen appears to be the largest single structure carried out in Purbeck marble to survive. With the shrine base within it, it must have been one of the most ambitious achievements of this brilliant period of the Purbeck marble workshops.

REFERENCES

1. J. D. Le Couteur and D. H. M. Carter, 'Notes on the Shrine of St Swithun formerly in Winchester Cathedral', *Antiquaries Journal*, IV (1924), 360–70.
2. Ibid., 365–70.
3. E. W. Tristram, *English Medieval Wall Painting: the Thirteenth Century* (Oxford 1950), 578 quoting the Liberate Roll of Henry III for 1240–45, specification for angels to flank the rood on the beam, made in 1240 in the Chapel of St John in the Tower of London.
4. Cf. ibid., 168–69. Master William of Westminster and Nigel were the King's Painters working at Winchester Castle.
5. Le Couteur and Carter, loc. cit., 360.
6. The partially 14th-century substance of the Paradise Wall could be relevant to the date of the destruction of our structure. We are grateful to Martin Biddle for showing us this material.
7. We offer our grateful thanks to Mr P. C. Brachi, B.A., B.A.(Arch.), R.I.B.A. for taking our preliminary calculations into mathematical fields beyond our competence and providing us with accurate data for this reconstruction. The reconstruction offered here differs from that shown at the Conference, the modifications having been made in the light of his revisions.
8. Le Couteur and Carter, loc. cit., 369–70.
9. The fragment among the Paradise Wall material could be a base from our structure.
10. L. F. Salzman has suggested that masons marks rarely appear on tracery or carved stones. *Building in England down to 1540: A Documentary History* (Oxford 1952), 127.
11. Cf. RCHM, *London, Westminster Abbey* (1924).
12. Cf. J. G. O'Neilly and L. E. Tanner; 'The Shrine of St Edward the Confessor', *Archaeologia*, 100 (1966), 129–54.
13. VCH *Cambridgeshire and the Isle of Ely*, IV (1953), 70. The Sacrist's account of 1349, quoted here, specifies 'Item in j pare garnet pro le Wyket versus feretrum', interpreted by the authors as referring to a hinge for the gate of the screen round the feretory. The shrine of St Etheldreda at Ely was therefore enclosed by a screen as we are suggesting at Winchester.
14. Peter Draper, 'The Retrochoir of Winchester Cathedral', *Journal of the Society of Architectural Historians*, 21 (1978), 1–17.
15. Loc. cit., 6–14.
16. Ibid., 13.
17. Ibid., 10–11 and note 39.
18. A. J. Taylor, 'Distributiones Pauperis 1283–84', '*Tribute to an Antiquary, Essays Presented to Marc Fitch*', ed. F. Emison and R. Stevens (London 1976), 93–125 esp. 99–103. After Christmas, when 500 were fed, St Edward 400, Thomas and Kenelm 200, Edmund King and Martyr, William of York, Cuthbert and George, Alban and Etheldreda, 100, Swithun and 'Getes' only fed 50. Only the seven Sleepers and Sampson, at 30, were lower on the scale.

19. W. H. St John Hope, *Windsor Castle, an Architectural History*, II (London 1913), 491-and I, 54–55 quoting a document of 1239–40 referring to a 'Grasplat' between the royal lodgings. The back wall of this enclosure with the remains of capitals close to those of Henry of Reims in the earliest stages of Westminster Abbey survives. Master Henry is recorded at Windsor. A contemporary wall painting also survives, for which cf. E. Clive Rouse, 'Two Mural Paintings in the Cloisters of St George's Chapel, Windsor', *Friends of St George's Chapel, Windsor* (1946) 16–22, illus.

20. For example, Westminster Abbey from 1245, Lincoln Angel Choir from 1255, Ely Retrochoir *c.* 1245–50 etc.

21. Most obviously Salisbury, *c.* 1260 following the east walls of Westminster Abbey 1250– and possibly the mid 13th-century design at Wells.

22. Draper, op. cit., II.

An Investigation of the Tile Pavement in the North Aisle of the Presbytery, Winchester Cathedral, in 1969

By Elizabeth Eames

In 1969, with the kind permission of the Dean and Chapter obtained through the good offices of Canon D. Maundrell, I was invited by Wilfred Carpenter Turner, then architectural adviser in charge of current work on the fabric of Winchester Cathedral, to undertake a limited excavation of the tile pavement in the north aisle of the presbytery. This pavement had been laid in the 13th century and had since been greatly disturbed and in part replaced. It had been decided that the whole of this pavement should be removed so that essential repairs to the vault of the underlying crypt could be carried out from above.

As a result of earlier discussions with the writer and others, Wilfred Carpenter Turner had already decided that before any of the pavement was removed he would record both this and the pavement of the retrochoir in as much detail as possible. His original aim was to record it as it then was, and this he did, but during the course of the recording he discovered that he could work out the original layout of the panels of the pavement and the arrangement of the tiles within the panels. The existing state of the pavement of the retrochoir had already been recorded in a series of photographs by C. J. P. Cave and these were deposited in the Library of the National Monuments Record. Seven were published in whole or in part by Dr A. B. Emden in 1948, when he used them to illustrate a paper on the medieval tile pavement of the retrochoir published in *Winchester Cathedral Record*.[1]

Carpenter Turner's work on the pavement of the retrochoir remains unpublished at the time of writing, but in 1969 he published a brief article on his work in the north presbytery aisle including two photographs of part of the pavement before it was removed.[2] The first shows the pavement as it then was, the second shows the same area with the original arrangement chalked on the tiles.[3] The stone edge visible near the top right of both plates is part of the masonry base of the existing wall of the north presbytery aisle as it was rebuilt in the second quarter of the 16th century during the time of Bishop Fox. During this rebuilding, the north part of the 13th-century tile pavement was damaged or destroyed and was replaced by a border of plain glazed 16th-century tiles, which can be seen chalked in on Carpenter Turner's Pl. 2. Further disturbance in this area was caused by the insertion of a heating pipe in 1933.[4]

The 13th-century pavement had been arranged in a series of panels running north to south across the width of the aisle, separated by decorative borders, themselves several tiles wide from east to west. Examples can be seen in the plates already referred to. Each panel seems to have been filled with tiles of one design; in some panels the tiles were set square to the axis of the building and in others they were set diagonally. This type of arrangement of tiles in panels seems to have been usual in the 13th century and may still be seen in the Chapter House of Westminster Abbey and in the retrochoir at Winchester, and was used in the Queen's chamber at Clarendon Palace[5] and in a number of other recorded or excavated pavements. The tiles used in this pavement belong to the Wessex series that was widely used in Hampshire and Wiltshire and adjacent areas during the latter part of the 13th century. The decoration was applied to the surface of the tiles by the technique known as inlaying, in which a cavity was stamped into the surface of the leather-hard tile with a wooden stamp on

which the decoration was upstanding in relief. The cavities so formed were then filled with a white clay, which was pressed in in a plastic state. Surplus clay was cut off the top of the tile and the outer edge of the decorative motifs was pared with a knife to bring up the outline sharply. In England at this period all such tiles were glazed before they were fired and were subject to one firing only. The glazes used were all lead based. In order to produce the clearest glaze available and thus to show up the inlay to the best advantage, that applied to the tiles with inlaid decoration had no other metals added intentionally, but all these medieval glazes suffered iron contamination and they therefore look yellow over the white inlay. The colour of the glazed earthenware tile body varied from rich brown to dull olive according to the oxidisation or reduction of the tile body and in the 13th century many oxidised tiles included a reduced core which appeared to a greater or lesser extent at the surface and affected the surface colour, which thus showed variations from brown at the edges to olive at the centre. Most of the tiles remaining in the area of the north presbytery aisle that was investigated were fully oxidised at the surface but very few traces of glaze remained. The decorated tiles were 125–30 mm square and 22–25 mm thick. The variations in size were due to variations in shrinkage during firing. The tiles were trimmed at the edges before they were fired and the cut was made with a downward bevel so that the surface at the top was slightly larger than that at the bottom. This is thought to have been done to allow the mortar in which the tiles were set to come up between the lower part of the tiles to hold them securely when the edges were touching at the top, but the variation in shrinkage was such that all medieval tile pavements were laid with wide mortar joints and this bevel can only have been useful when two of the largest tiles in a group were laid beside each other. In addition to the bevel the makers of these Wessex tiles scooped holes in the base of the tiles with the point of a knife. These are known as keys and undoubtedly helped to hold the tile firm on its mortar bed, but the main purpose of the keys was probably to assist the drying process. The removal of clay from the back reduced the solid bulk of the tile and exposed a larger surface to the atmosphere. This lessened the risk that the corners would dry so much more quickly than the middle that the tile warped. All but two tiles in the area investigated had four such keys scooped out of the base, and this seems usual for the tiles of 13th-century date in the cathedral.[6]

The plain glazed tiles included in the pavement of the retrochoir[7] were yellow or near black, the two most usual colours for such tiles in the 13th century. The yellow was obtained by applying the lead glaze over a thick coat of white slip on the surface of the tile. The near black glaze was obtained by applying a lead glaze, to which a proportion of about 5 per cent of copper or brass filings had been added, directly to the surface of the tile. As well as the complete square tiles, oblong halves and square quarters were also used. These were obtained by scoring the square tile on the surface through about one third or one half of its thickness before it was fired and by breaking the tile along the score after it had been fired. By this method the tiler was not faced with the problem of stacking small tiles in his oven but had only tiles of uniform size. Keys were generally omitted from tiles that were scored to be divided in this way. No plain glazed tiles were present in the small area of paving investigated in the north presbytery aisle.

The small apparently undisturbed area of medieval paving that I investigated with the assistance of James and Peggy Barfoot and Laurence Keen lay in the north part of the aisle in the second bay from the west and formed part of the third tile panel from the west end of the pavement (Pl. XXA). Its position can still be seen in the cathedral. After the completion of repairs to the vault of the crypt, the aisle was repaved with a replica of the 13th-century pavement, in which this panel measures 3.9 m from north to south by 3.6 m from east to west and is set with 840 tiles in 28 rows of 30 tiles each. One may suppose that this

represents the original size and content of this panel. The modern tiles were hand made by Professor Baker, who carried out extensive experiments on medieval examples in order to make his replicas as near as possible in fabric and technique to the originals.[8] The east part of the area investigated can be seen in the upper left part of the two plates published by Carpenter Turner. When we began work all the surface paving south of the undisturbed area had been removed.

A plan of the undisturbed tiles is shown on Fig. 1. All were decorated with the same design, a simple geometric pattern of three rows of alternating brown and yellow triangles. Examples *in situ* can be seen on Pl. XXB.[9] They were set square. Seven remained along the east edge of the panel beside the remains of its east border and eleven more tiles remained in position in the three adjacent rows to the west. West of this was a large disturbed area from which the tiles had already been removed. It is to be supposed that this area had originally been paved with eight more rows of the same tiles. West of this disturbance was another area of undisturbed tiles. A row of fifteen remained at the north edge of this patch, which continued southwards for three more rows at the east end and two at the west (see Fig. 1). An east–west line was taken 1.35 m south of the masonry base of the north wall already mentioned and all the tiles south of this line were lifted. All proved to be in their original position as had been anticipated. The ridges of mortar between the tiles and the domes of mortar that had been pressed up into the keys were undisturbed. Two tiles in the western area were without keys. The northern row of tiles and the mortar bed revealed by the removal of the tiles to the south are shown on Pl. XXB, as are also the plain tiles to the north.

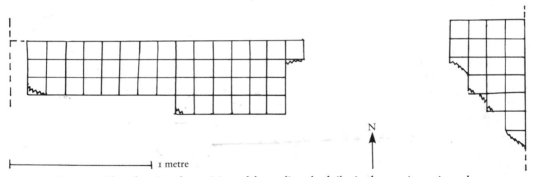

N

⊢———————————⊣ 1 metre

FIG. 1. Plan showing the position of the undisturbed tiles in the area investigated

After the tiles had been lifted a section was taken through their mortar bed and its foundation down to the filling above the vault of the crypt. This was set out along the west edge of the east patch of tiles and was then extended southwards although the surface of that area had already been disturbed. A very clear picture of the underlying levels was recovered. (Pl. XXIA.) The depressions between the highest points of the vault of the crypt were filled with lumps of chalk, chalk dust, large flints and stone dust to form a level base for the first floor of the aisle. The floor itself was identified by the mason in charge of the repairs as a mortar floor with a screed of stone dust. It may have been rather soft. It was very worn, large lumps of flint protruded through the surface, which had been repaired in places with patches of mortar that was a different colour from the stone dust screed. Several such patches were present in the area investigated. Wilfred Carpenter Turner thought that this was probably a

temporary floor laid for the use of the workmen while the building was under construction in the 1080s. Whether or not it was intended to be temporary it was certainly the earliest floor of the aisle and is likely to be of that date. This may be the first time that the Norman floor has been revealed and recorded. It is not known how long it remained in use. No artefacts were found on its surface or in the material of which the second floor was constructed.

The second floor consisted of a spread of loose aggregate rammed hard at the top. There had already been some subsidence at the south side of the aisle by the time this floor was laid and the build up of aggregate was thicker at the south to provide a level floor. It included gravel, sand and straw. A photograph of a sample of this floor is reproduced on Plate XXIb. This second floor also wore unevenly and loose pieces of straw and small bird bones were found in hollows in its surface. Perhaps owls were getting into the building and dropping the remains of their prey, or possibly small birds were nesting inside the cathedral. Again there was no indication of the length of time this floor was in use. It was superseded by the tile pavement, which was thus the third floor of the aisle, and it remained in use until the 1960s although so worn and patched and disturbed that only a shadow of the original remained.

Before the tile pavement was laid the surface was again levelled, this time with tiny pieces of stone, loose chalk and stone dust. In the area exposed the thickness varied from 6 mm to 40 mm. The mortar bed for the tiles was laid directly on top of the levelling material and was itself 30 mm to 35 mm thick. The tiles were set in the surface of the mortar.

Plate XXIa shows part of each floor exposed. At the top of the plate is the first floor with flints protruding through it on the left and one of the patches of mortar with which it was repaired on the right. At the bottom in the centre the rammed aggregate floor is exposed and on the left it is concealed by the levelling material for the mortar bed of the tile pavement, and above that is the mortar bed itself with the marks of the base of the tiles on its surface.

The sequence of the three floors is clear, first the mortar and stone screed floor with patches of different mortar where it was worn, then the rammed aggregate floor of which the surface was also worn and thirdly the decorated tile floor. It is however difficult to assign absolute dates to the three floors: there is, as far as I know, no documentary mention of any of them, and as has been mentioned no artefacts were found during the investigation. There is little doubt that the first floor was laid either during or immediately after the building of the aisle and that it dates from the 1080s. There is no information to date the second floor. The third floor, the tile pavement, dates from the 13th century, but there remains some difference of opinion about the period within the 13th century to which it should be assigned. Dr Emden suggested a date during the reign of Edward I, 1272–1307, basing this on analogies with the tile pavement in the chapter house at Salisbury, now represented by a replica laid in the 19th century.[10] Christopher Norton followed Emden in assigning these tiles to the last part of the 13th century in a paper published in 1976,[11] and discusses the matter again in his contribution to this volume. I have thought it more likely that the retrochoir was paved as soon as it was finished in about 1235 or as soon as the rest of the internal work on the building was completed, which may have been two or three years later. The paving was the last work to be undertaken after the internal scaffolding had been removed. It seems most probable that the paving of the north presbytery aisle was undertaken at the same time[12]. I do not find any closer analogies between these Winchester tiles and those from Salisbury than that both groups belong to the Wessex school and share common methods of manufacture and decoration and a common repertory of decorative designs, all of which were widely used in the Wessex area over a period of about fifty years or even longer. The fabric of the Winchester tiles seems to me to be closer and to fire to a darker red than those of the Salisbury region and to have a darker blue-grey colour when

reduced, but an archaeologist's assessment of fabric is subjective and any serious discussion of fabric must await the more informed findings of the scientists.

There seem to be three possible series of dates for these three floors: first, that the mortar and stone screed floor was soft, wore badly, had to be patched after a few years and was soon replaced by the rammed aggregate floor, which was itself replaced by the tile pavement in the late 1230s; second that the stone screed floor was replaced early by the aggregate floor, which continued in use until the tile pavement was laid in the 1260s–80s; and third that the stone screed floor was not soft but continued in use, with occasional repairs until the 1230s, that it was then replaced by the rammed aggregate floor at the same time as a temporary floor was laid in the retrochoir, and that both areas were paved in the 1260s–80s. Any of these series is possible, but it is to be hoped that future work will provide a firmer basis for the dating of the aggregate floor and the tile pavement.

REFERENCES

SHORTENED TITLES USED

CARPENTER TURNER — W. J. Carpenter Turner, 'The Retrochoir', *WCR*, 38 (1968), 57–66.

EAMES (1957–58) — Elizabeth S. Eames, 'A Tile Pavement from the Queen's Chamber, Clarendon Palace, dated 1250–52', *JBAA*, XX–XXI (1957–58), 95–106 and Pls XXXII–XXXV.

——— (1980) — Elizabeth S. Eames, *Catalogue of Medieval Lead-glazed Earthenware Tiles in the Department of Medieval and Later Antiquities, British Museum*, 2 vols (London 1980).

EMDEN — A. B. Emden, 'The Mediaeval Tile Pavement in the Retro-choir', *WCR*, 17 (1948), 6–12 and Pls IV–VII.

NORTON — E. C. Norton, 'The Medieval Paving tiles of Winchester College', *Proceedings of the Hampshire Field Club and Archaeological Society*, 31 (1976), 23–41.

NOTES

1. Emden, Pls IV–VII.
2. Carpenter Turner, 57–66 and Pls I and II.
3. Ibid., Pls I and II.
4. Ibid., 58.
5. Eames (1957–58), Pl. XXXII 2.
6. Norton, Pl. 2 centre right shows the back of a tile from Winchester College closely resembling the backs of the tiles in the north presbytery aisle.
7. Emden, Pls IV, V, VI and VII include examples of plain glazed tiles.
8. Eames (1980), 17–50 discusses methods of manufacture and decoration and refers to Professor Baker's experiments.
9. Carpenter Turner, Pls I and II. See also Eames (1980), vol. 2, design 2023, illustrating tiles 106–07 from Winchester Cathedral in the British Museum.
10. Emden, 12.
11. Norton, 26 and 39.
12. Eames (1980), 190–91.

The Medieval Tile Pavements of Winchester Cathedral

By E. C. Norton

Winchester is exceptionally rich in medieval floor tiles. Two original and two relaid floors survive at Winchester College; a considerable area of the church of St Cross is paved with mostly reused medieval tiles; a large number of loose fragments and the remains of some pavements were found at various sites in Winchester during the important excavations of the 1960s; and another sizeable collection of miscellaneous pre-War discoveries and finds from other post-War excavations is preserved in Winchester museum. And yet, important as these different remains undoubtedly are, they are individually of minor interest compared to the remarkable and very extensive areas of medieval tile paving still to be seen in Winchester Cathedral. The floor of the retrochoir still consists largely of its original tile pavement, now very worn and disturbed, but nonetheless preserving its overall layout. This is by far the most important pavement in the cathedral, but there are also other smaller areas of tiled floor which, if they are not so impressive, are no less important for the archaeologist. There are in addition numerous tile fragments from the excavations on the cathedral green, to the north of the nave, and these presumably came originally from the cathedral. For sheer numbers of tiles only perhaps Gloucester among the British cathedrals is at all comparable, while in the variety and range of surviving material Winchester is unrivalled.

It is therefore not surprising that Winchester was one of the places which attracted the attention of some of the earliest antiquaries to be interested in medieval tiles at the end of the 18th and in the early part of the 19th century. John Carter, who was the first in this country to publish illustrations of medieval floor tiles, included a number from St Cross, and he drew others in the cathedral.[1] A number of Winchester tiles, from the cathedral and from St Cross, were illustrated in the first book on the subject published in 1845 by John Gough Nichols,[2] and others were published by John Henry Parker.[3] They are however hardly represented in Henry Shaw's book.[4] There are also some unpublished drawings among the tracings collected by Lord Alwyne Compton,[5] including an important measured plan of the floor of the retrochoir and north presbytery aisle. This shows some parts of the pavement which are now lost, and it has been used for the plan in figure 2. At the end of the century many designs of tiles at St Cross and in the cathedral were published in a paper on Hampshire tiles by B. W. Greenfield.[6] Useful though they are, none of these 19th-century publications goes further than the illustration of individual patterns: there is no serious discussion of the pavements as such, and no real attempt to date the tiles properly.

Recent years have seen a revival of interest in the cathedral tiles. In 1948 Dr A. B. Emden published a paper with a sketch plan of the retrochoir floor and a discussion of its date.[7] This was followed in 1956 by an article by the Rev. G. E. C. Knapp which illustrated thirty-one designs from the cathedral.[8] In addition, over a period of some years as cathedral architect, the late Mr W. J. Carpenter-Turner devoted much time to the study and care of the medieval tiles. He had an extensive photographic record made of the retrochoir floor,[9] and he undertook the replacement of the extremely worn remains of the medieval north presbytery aisle floor with modern copies; but unfortunately only a small part of his work on the medieval tiles saw the light of day in published form.[10]

A considerable amount of work has therefore been done on the cathedral tiles, particularly in recording the surviving individual patterns. But no detailed plan of the pavements

has yet been undertaken — a daunting task — and there has hitherto been little serious attempt to sort out the different groups of tiles remaining in the cathedral, to date them, and to set them in the context of the various phases of the construction of the building and of the development of the tile industry of the area as a whole. This requires an intimate knowledge not only of all the surviving material in the cathedral, but also of the tiles at numerous other sites in Hampshire and the neighbouring counties.

It is clearly not possible in a short paper to tackle all these problems. However I have discussed at length elsewhere the identification of the different groups of tiles and the dates to which they may be assigned, taking into account the evidence from other sites. In addition, the majority of the individual designs have been or are being published, and the stylistic changes which can be discerned over the whole period have also been examined.[11] It is therefore possible in this paper to confine ourselves to an examination, on the basis of the conclusions which have been argued in detail elsewhere, of the pattern and progression of the laying of decorated floors from the mid 13th to the mid 16th century, and of their relation to the different periods of building activity in the cathedral. Winchester Cathedral provides a special opportunity to study this theme, for not only are the quantity and quality of the surviving material exceptional, but the dating evidence is also particularly good. The floors will be discussed in approximately chronological order.

Little can be said about the floors of the Norman church. The Norman building survives principally in the north and south transepts, and in the crypt. The transepts are largely paved with stone slabs of various kinds and of different dates. There is no way of knowing whether any of them in fact survive from the original Norman floor. The only real evidence for them comes from a small sounding made under part of the north presbytery aisle floor during work prior to the relaying of the floor with modern replicas. The 13th-century tiles were found to be laid on a mortar bed which was spread over an earlier, Norman floor. This had a rough and uneven surface, patched in places, and was composed apparently of stone dust rather than of mortar, with large flints sticking up through the surface.[12] This clearly showed the main advantages of tile pavements over plaster and similar floors: as well as introducing elaborate decoration, tiled floors were hard-wearing and provided a flat, even surface. However, whether of stone or of less durable materials, the Norman floors cannot have been made out of decorated tiles, as these did not appear in southern England till the 13th century.

The first major alteration to the Norman building was the construction of the retrochoir with the Lady Chapel and the two smaller flanking chapels. The building was complete by about 1230.[13] The tiled floor of the retrochoir which still survives in part as originally laid dates to later in the 13th century, c. 1260–80. However, scattered here and there through the pavement, there are some earlier 13th-century tiles which must be mentioned first.

The earliest known tiles in Winchester belong to a small group typical in technique and style of the inlaid tiles of the so-called Wessex school. They were indeed to be the starting point of the Wessex industry, which changed little in technique, in the individual designs used, or in the overall arrangement of the pavements for the best part of a century. This earliest group can be dated, from references to purchases for Winchester Castle in 1241–42, to the early 1240s (Group 1).[14] Fragments have been found in the excavations at the castle and at a few other sites in and around Winchester, and the existence of some wasters from Marwell Manor, just south of Winchester, suggests that there was a kiln there. It was probably operated by the same tilers who, a couple of years later, made the well-known circular pavement of the King's chapel at Clarendon. This was ordered in 1244 and was made at Clarendon in a kiln which has been excavated.[15] So far twenty-eight designs, many of them very fragmentary, are known from this newly-identified group at Winchester. As yet

there is no evidence of a large circular design as at Clarendon. Apart from a few inlaid mosaic tiles, all the patterned tiles are square, with fairly standard Wessex designs. In the cathedral this group is represented by a single tile set in the floor by the north-east corner of Gardiner's chantry, at the junction of the retrochoir and the north presbytery aisle (pattern 1.2, not illustrated). It is not in its original position, and it is not known which part of the cathedral was originally floored with tiles of this type. Very probably the earliest tiled floors would have been laid in some prominent position, for instance in the presbytery around the high altar or in the vicinity of the shrine of St Swithun.

Much more numerous in the retrochoir floor are some tiles which belong to a group which can be dated to within a few years of 1250 (Group 2). Tiles of this group have been found at Clarendon, principally in the Queen's chamber, where the floor dates to 1250–52.[16] Loose fragments have also been found at Winchester Castle, where they probably represent the remains of floors which were ordered for various royal apartments in 1249–52. Most of the tiles in the cathedral are of designs found at these two royal sites. These again are not in their original position. Most of them are to be found near the Lady Chapel, and a large patch of lions and griffins (laid unfortunately where they receive maximum wear from visitors) is laid just by the entrance to the chapel (Pl. XXIIA). These tiles were found some years ago under the late 15th-century stalls in the Lady Chapel,[17] and they probably once formed part of the floor of the chapel. If so, the Lady Chapel must have been paved with tiles of this type about 1250, that is, about twenty years after the chapel was completed, and a few years before the major project of paving the retrochoir was undertaken.

There is evidence for the laying of tiles of a quite different kind at about the same time as the paving of the Lady Chapel. A few very worn pieces of tile decorated with patterns identical to some of the combat scenes on roundels found at Chertsey Abbey were found by Mr Carpenter Turner in 1971 in rubble beneath the presbytery steps in the cathedral (Group 3). Another fragment turned up more recently in rubble in a trench under the choir stalls. All of the fragments are extremely worn (designs 3.1–3.4, Fig. 1). Each roundel was originally composed of four pieces. Three of the roundels can be identified from the much better preserved Chertsey roundels; one very worn fragment (design 3.4 Fig. 1) has not been identified and perhaps belongs to a hitherto unrecorded roundel. Winchester Cathedral is at the moment the only site to have produced tiles of the combat series, apart from Chertsey, where they have been dated about 1250.[18] It is perhaps significant that no fragments of roundels of the Tristram series, which is considered to be slightly later in date, have yet been found at Winchester. The appearance of these roundels in the cathedral probably results from royal connections. Winchester Castle was one of Henry III's principal residences, and one that he visited on a number of occasions at about this date. Considerable rebuilding and redecoration was carried out there by Henry III, and it is quite possible that tiles of this type, which are thought to have been made in the first instance for Westminster Palace, were laid also at Winchester Castle — though no fragments have yet been found there. At any rate, in the cathedral the tiles must be considered a special commission, particularly since there were tilers of the Wessex school readily available, and indeed working in the cathedral at about this time. It is not known where these tiles were laid. The fact that they are all extremely worn indicates that they were laid in a prominent position. The provenance of the few surviving fragments suggests that they may very well have been laid in the presbytery, most likely in front of the high altar or around the shrine of St Swithun behind it to the east. In fact this accords well with the mid 13th-century date proposed for the remains of the supposed shrine of St Swithun.[19]

The most extensive campaign of tiling, covering probably the whole of the eastern arm of the church, was undertaken about 1260–80.[20] The main surviving evidence for this is the

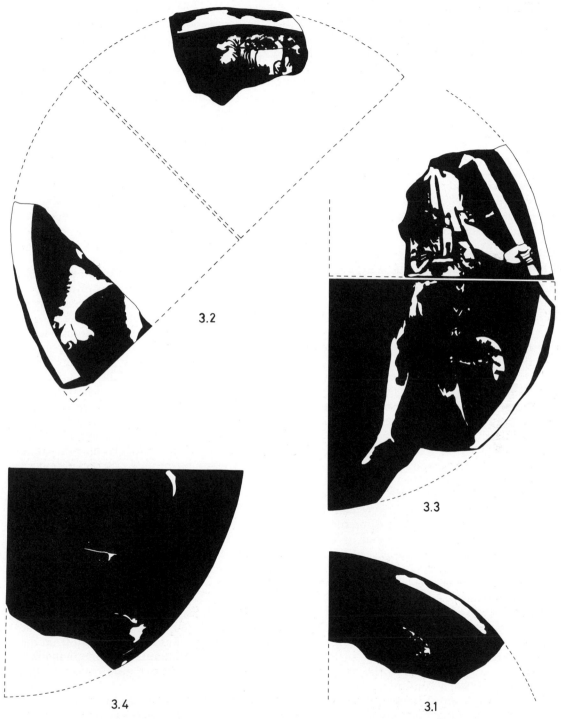

FIG. 1. Designs 3.1–3.3: fragments of Chertsey-type roundels with combat scenes, *c.* 1250.
Design 3.4: fragment of unidentified roundel.
(Scale 1:2)

G

elaborate tiled floor of the retrochoir. This did not form part of the original plan, and it was not laid till some thirty or forty years after the completion of the building. When the extension to the east end was planned about 1200, and even when it was completed about 1230, inlaid tiles had not yet appeared in Hampshire or indeed in the country as a whole. The earliest datable inlaid tiles in the country are in fact those already mentioned which belong to the early 1240s (Group 1). The whole of the retrochoir was originally paved. The basic layout partially survives and can be reconstructed in the central nave and north aisle of the retrochoir. In the south aisle the arrangement is lost, but numerous tiles are still to be seen there in total disarray. The tiles (Group 4) are very close in technique and style to the earlier Wessex tiles of the 1240s and early 1250s (Groups 1 and 2), and indeed are derived directly from them. They belong to a very large series known from numerous abbeys and churches in Hampshire, Wiltshire, Dorset and beyond. They were used for example to pave the newly-built chapter house of Salisbury Cathedral, where some of the very same designs were used. The layout of the retrochoir floor (Fig. 2) is based on a series of rectangular panels. In the central nave they were arranged in three sets of parallel panels running east–west. In the north aisle the panels run north–south, and the same arrangement was very probably adopted in the south aisle. The layout has been partially obscured by the construction in the 15th century of Waynflete's and Beaufort's chantries, but it appears that in fact the tiled floor is preserved at least in part under the chantries.[21] Within the panels the tiles are arranged in various ways: laid square or diagonally, and in groups of nine or of four, or even singly, separated by plain thin border tiles, or else in an undifferentiated mass filling the whole panel (Pls XXIIB, XXIII). Only seventeen different patterns (nos. 4.1–4.16 and 4.16a, not illustrated) can be certainly ascribed to the original floor, though some of the other patterns which survive scattered about the retrochoir may have been used in parts of the floor which are now totally lost. Nevertheless with this relatively small number of different designs considerable variety was obtained by the combination of different patterns and by different arrangements within the panels. The retrochoir floor requires a detailed study of its own, which cannot be undertaken here. But its importance as one of the finest and most extensive 13th-century tile pavements, in spite of its worn condition, is beyond question.

The north presbytery aisle, which at its east end opens on to the retrochoir, retained until very recently the remains of its medieval pavement. Its general condition was far worse than that of the retrochoir, and the tiles were all extremely worn. So the medieval tiles have been taken up and have been replaced with replicas made by Professor R. Baker.[22] The whole of the aisle was paved with tiles as far as the top of the steps leading down into the north transept. When the tiles were laid in the later 13th century the aisle was still that of the Norman church, which was internally slightly narrower than the present building. Also the floor sloped down slightly at its western end, as the original staircase into the transept (traces of which can still be seen next to the Holy Sepulchre chapel) ended at a slightly lower level.[23] Some traces of the original layout were still visible, and these have been broadly adhered to in the replica floor. Compton's plan indicates that slightly more of the original arrangement was visible in the middle of the last century. The aisle floor probably continued the basic plan of the floor of the north aisle of the retrochoir, with a series of north–south panels (probably generally rather broader than those in the retrochoir), and with the same outer border of plain tiles running probably the whole length of the north wall from the transept steps to the east end of the retrochoir (Fig. 2). In addition, the same individual patterns were used as in the retrochoir floor. The north presbytery aisle pavement was therefore clearly contemporary with that of the retrochoir.

The south presbytery aisle floor is paved with square purbeck marble slabs which very likely date from the rebuilding of the aisle in the early 16th century. There are a few

FIG. 2. Plan of the floor of the retrochoir, north presbytery aisle and presbytery step, c. 1260—80

fragmentary tiles laid against the walls, but these do not in themselves indicate anything, as there are similar fragments all over the cathedral. However it appears that the south presbytery aisle was in fact originally tiled, and it may be presumed that the floor was contemporary with those of the retrochoir and north presbytery aisle.[24]

The paving of the retrochoir and presbytery aisles was a major undertaking which very likely took several years to complete. In addition it is probable that the choir and part of the presbytery were paved at about the same time. Nothing survives in this area now, but important evidence was found under the present presbytery floor by Mr Carpenter Turner. The floor levels in this part of the cathedral are not those of the 13th century. The steps up from the choir to the presbytery were at that time further to the east. Extensive remains of a broad step, which was apparently the top step leading up from the choir to the presbytery, were found running from the north wall into the centre of the presbytery. No tiles survived on this step, but the impressions made by them in the mortar were clearly discernible over a considerable area. The size of the tiles, the form of the keys and the general arrangement indicate that they were of the standard later 13th-century type, very similar to, though slightly larger than the tiles in the retrochoir (Group 4). The approximate position and layout of the floor of this step are shown in Figure 2. If the step between the choir and presbytery was paved with tiles, it may be supposed that both choir and presbytery were also tiled. It has already been suggested that part of the presbytery may have been paved with Chertsey-type roundels (Group 3) and perhaps Wessex tiles of the early 1240s (Group 1), but at the moment there is no precise evidence as to the nature of the floor in this area. In the choir the modern floor is at the same level as the medieval floor, so no traces of the latter survive. However the recent work on the choir stalls revealed numerous fragments of 13th-century tiles of Group 4, some of which had been used as a damp-course under the early 14th-century choir stalls.[25] They are very probably the remains of the 13th-century pavement of the choir. The fragments found here are again similar to those in the retrochoir and are of the same series (Group 4), but the actual designs are different. It seems probable that the choir and presbytery would have been paved before the retrochoir and presbytery aisles, and there is some slight evidence from the analysis of the tiles themselves which were found in the choir that, though of the same large series, they may be slightly earlier than the retrochoir tiles. The paving of this area may therefore be placed about 1260, that is, shortly after the paving of the Lady Chapel about 1250, and probably a few years before the laying of the floors in the retrochoir and presbytery aisles, perhaps about 1270.

There is thus good evidence to show that by about 1280 practically the whole of the eastern arm of the church had been paved with fine decorated tiles. The paving had taken place in a number of stages, some of which have left but fragmentary traces. Nevertheless it is permissible to talk of a sustained programme of laying tile pavements over a period of thirty or forty years. The result was the paving of the Lady Chapel, the retrochoir, the north and south presbytery aisles, almost certainly the presbytery and shrine area (including probably some Chertsey-type roundels), the steps down to the choir, and the choir itself. The only places for which there is no evidence, direct or indirect, are the two chapels flanking the Lady Chapel. The Guardian Angels chapel to the north is paved with purbeck slabs, as is most of Langton's chantry to the south; the tiles on the altar-step are relaid. Although this was a period when no major structural work was in progress in the cathedral, the paving of the whole eastern arm of such a large church represents a considerable financial outlay and a notable artistic achievement.

In spite of all that had been achieved already, the end of the 13th century and the beginning of the 14th saw a continuation of the tiling programme. This is indicated by the existence of several other groups of tiles, sometimes represented by only a few fragments,

which cannot for the most part be either dated very precisely or firmly associated with any particular part of the building. They will be listed briefly. There are in the retrochoir a few worn tiles with patterns in relief (a technique which is very rare in this part of the country) which belong probably to the 13th century (Group 6).[26] A single fragment of relief tile of a quite different type, probably of somewhat later date, was found in the excavations on the cathedral green and was probably originally in the cathedral (Group 13). More important are some fragments of another series of tiles associated with Chertsey Abbey (Group 5). At Chertsey three sets of four tiles formed large rectangular panels with figures of a king, a queen and an archbishop under elaborate architectural canopies. A representation of the crucifixion appeared on a fourth, fragmentary panel.[27] A number of fragments of the panel with the archbishop (though as yet none of the others) have been recorded from the cathedral. Most recently some very worn fragments were found under the steps leading up to the presbytery. Some fragments with other contemporary designs have also been found, including a few pieces with hitherto unknown designs.[28] They are datable to the 1290s, and the large figure panels may well have been first designed for use around the tomb of Queen Eleanor at Westminster Abbey.[29] Their appearance at Winchester must again, like that of the earlier Chertsey-type tiles, result from a special commission and very likely a royal connection. It seems probable that only a small area of these tiles was laid in a position of special importance. They could perhaps be connected with the rebuilding of the feretory screen at about this time.

These relief and Chertsey-type tiles are outside the main stream of the Wessex tile industry. Three other groups of tiles from the end of the 13th or the early 14th century continue the Wessex tradition. One of these (Group 10) is represented by a few extremely worn fragments in the cathedral but is unknown from any other site. They are distinguished by being slightly larger than the earlier inlaid tiles, but the patterns are almost indecipherable. Until some better examples are found there is little that can be said about this group.[30] The next group (Group 9) is of quite small and distinctive inlaid tiles whose distribution is confined to southern Hampshire. The designs are derived from the earlier Wessex tiles. They are not very common in the cathedral, but a number of them are scattered about the retrochoir floor. They appear to be quite closely linked to another group of larger inlaid tiles (Group 8) whose designs are also derived from the earlier Wessex tradition. Although the patterns in the two groups are distinct, the distribution pattern of the two series is almost identical, and they seem to be of similar date. There is some slight evidence that the two groups may in fact have been made at the same tilery, but at the moment the relationship between them is uncertain, as is their relative dating. The Group 8 tiles are much more numerous in the cathedral. Many of them were previously to be found in the north presbytery aisle floor, though they were not in their original position. It is possible that these tiles were associated with the reconstruction of the presbytery arcades which took place at some time in the early 14th century. As neither the architectural work nor the tiles are closely dated this connection must remain hypothetical, but it would at least provide an occasion for the laying of perhaps quite substantial numbers of tiles in a part of the building which otherwise appears to have been almost completely tiled before the end of the 13th century.

However, in one place some tiles of Group 8 survive *in situ*. The eastern aisle of the north transept was altered somewhere around 1320 in order to allow the erection of three altars in the three bays. The alterations involved the insertion of three decorated windows in the Norman east wall and of another in the eastern bay of the north wall. The ogee tomb-niche below this window presumably belongs to the same period. The central bay was further enriched with a new vault and with two nodding ogee niches on the inner faces of the two

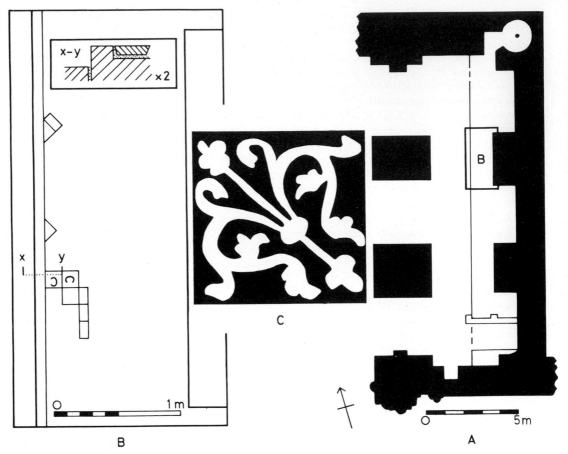

FIG. 3. A: Ground-plan of north transept eastern aisle with altar-step.
B: Detail of remains of tile pavement on altar-step, early fourteenth century.
C: Design 8.3 from the pavement (Scale 1:3)

Norman piers at the entrance to the chapel. Finally, a broad altar-step was added which runs the whole length of the transept aisle.[31] This step (Fig. 3) is only about 7 cm above the level of the north transept floor. The riser of the step is of stone, but the rest appears to have been originally tiled, and the surface of the stone risers was cut back in order to enable the tiles to be laid almost up to the edge of the step (Fig. 3B). The whole step is now in a very poor condition. No trace of the altars remains, and only a handful of tiles survives. The rest of the step is now covered by a mortar and rubble surface interspersed with a few tomb-slabs. The tiles which survive are opposite the engaged Norman column separating the northern and central bays. Only nine tiles survive. They are the very worn remains of two panels, one of tiles set diagonally with black rectangular border-tiles separating the presumably patterned tiles, the other of patterned tiles set square, again separated by thin black border-tiles. Two of the surviving patterned tiles in this latter panel can be identified

as pattern no. 8.3 (Fig. 3C). Extremely shattered though they are, these tiles are important as being the only tiles of this group known to remain *in situ* anywhere, and, being linked with the remodelling of the whole area, they do provide a rough date for the group as a whole.

These three groups of Wessex tiles mark the end of a long period of tiling in the cathedral stretching back to the early 1240s. For they are the last tiles of the Wessex school both in the cathedral and in Hampshire as a whole. After perhaps 1325 the tradition of inlaid Wessex tiles comes to an end, and the middle years of the 14th century are, as far as decorated tiles in Hampshire are concerned, remarkably barren. There is no evidence of any local industry at this period, and the few mid 14th-century tiles which do exist are almost all slip-decorated tiles of the type manufactured at Penn in Buckinghamshire. Many Penn tiles survive in the church of St Cross, but only a dozen or so are known from the cathedral.[32] None are in their original position and there is no evidence of where they were laid.

The late 14th century saw the transformation by William Edington and William of Wykeham of the Norman nave into the magnificent Perpendicular nave. There are some decorated tiles of this period, though there is no evidence that the enormous nave was ever paved with tiles. There are numerous fragments of tiles of all sorts in various places in the nave, mostly against the outer walls and by the columns, but there is nothing to suggest that they formed part of the original nave floor. It is more probable that the square purbeck slabs which survive here and there in the nave are the remains of the Perpendicular nave floor. It is however possible that tiles were used in some places, and there is one part of this great structure which does have a contemporary tiled floor, that is, Wykeham's chantry. The chantry was complete before Wykeham's death in 1404, and the tiles are undoubtedly original. They are of a type, quite different from the earlier Wessex tiles, known to have been made at this time by one William Tyelere at Otterbourne, just south of Winchester (Group 16). Wykeham's foundation, Winchester College, purchased tiles from William Tyelere for the chapel and vestry in 1395–96, and some of these very tiles have recently been discovered, including examples of the four designs used in Wykeham's chantry (designs 16.2, 16.4, 16.5, and 16.8, Fig. 5.1–4).[33] The tiles in the chantry must have been made after those at the college, as the breaks in the stamps on design 16.2 are more extensive, while the break on design 16.8 does not appear at all on the examples at the College. The tiles in the chantry can therefore be dated precisely, between 1396 and 1404. Otterbourne tiles are known at numerous sites in and around Winchester. There is also evidence that tiles of this group were being made somewhere in the Farnham area a short while before the establishment of the Otterbourne kiln, and it is quite possible that William Tyelere was brought to Winchester in the first place by William of Wykeham to provide tiles for his new buildings at the cathedral and at the college: part of the manor of Otterbourne had been acquired by Wykeham in 1386.

Otterbourne tiles do not however survive *in situ* anywhere else, so the floor of Wykeham's chantry is interesting for showing the type of layout adopted (Fig. 4). The base of the altar and the altar-step are of purbeck, as is also the base of the tomb chest, which butts up against the altar-step at a slightly lower level. It was presumably added a few years after the construction of the chantry. The body of the chapel is tiled, apart from a thin band of stone running along the west wall and in front of the doors. The tiles are laid up against the altar-step, but run under the base of the tomb chest. The floor is very worn and in many cases the tiles, whose fabric is not hardwearing, have suffered so badly that the keys on the underside show through. In places the pavement has been patched with tiles of various dates and with cement or mortar. In addition, part of the floor on the southern side of the chapel has been very recently disturbed during work on rewiring the nave. At the east end most of the original tiles have been relaid, but not in the correct order. Elsewhere for the most part other

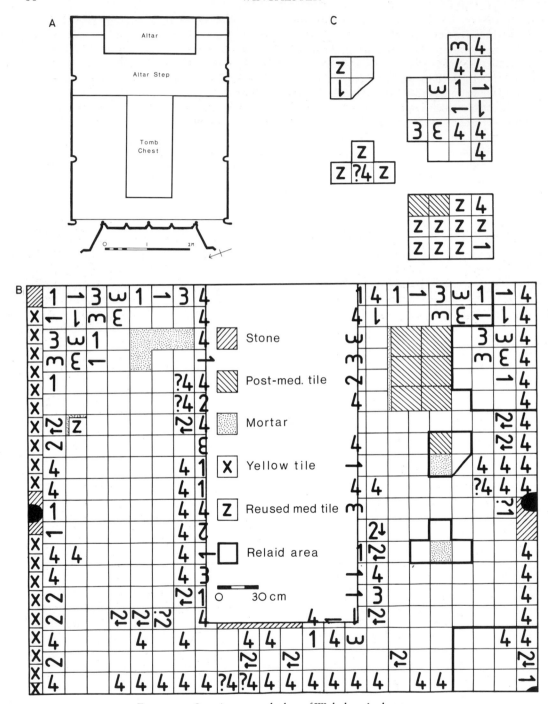

FIG. 4. A: Interior ground-plan of Wykeham's chantry.
B: Plan of tile pavement.
C: Plan of recently relaid areas

medieval tiles have been used to repair the floor. Figure 4B shows the layout before these disturbances, Figure 4C the present layout of the tiles in the patched areas.[34]

None the less, in spite of the damage caused by wear and repairs, the basic arrangement can still be worked out (Fig. 4B). In the two main panels on either side of the tomb chest the layout is based on groups of four tiles of the same pattern, and as far as can be seen the plan on the two sides is symmetrical. These sets of four tiles are flanked on either side by single rows of tiles running east–west, with another row partly obscured on either side by the tomb chest. In the centre these rows comprise specimens of all four patterns, in no special order. The outer row along the south wall is of pattern 16.8, the outer row along the north wall, where space is limited, consists of small plain yellow Netherlandish tiles which are contemporary. At the west end there are three rows of tiles running north–south across the chapel, each row being, with one exception, of a single pattern. There are no plain border

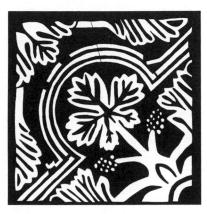

1=16.2

2=16.4

3=16.5

4=16.8

FIG. 5. Designs 16.2, 16.4, 16.5 and 16.8 (= nos 1–4 on Fig. 4): made at Otterbourne, 1396–1404. (Scale 1:3)

tiles separating the patterned tiles, as was normally the case in the 13th century (see Pls XXIIB, XXIII). Though in poor condition, this floor is an important survival from the very end of the 14th century.

Apart from this floor, there are numerous other Otterbourne tiles scattered around the cathedral, but they are all strays and it is not known what other parts of the cathedral were tiled with them. There are also a few examples of larger tiles similar in technique and style to the known Otterbourne series (Group 18). It is likely that they too are products of the Otterbourne kiln.

The floor of Wykeham's chantry is the latest tile pavement which survives *in situ* in the cathedral. But it was certainly not the last floor to be laid, for there are individual tiles surviving in various places in the cathedral which date to the 15th and early 16th centuries. Although it is again uncertain in almost every case where they were originally laid, they are none the less valuable evidence of continued tiling activity in the cathedral right up to the Reformation. The different types of tile will be summarily listed.

In the first place, there are a number of different types of plain yellow and dark green or black Netherlandish tiles, of various sizes. Such tiles were imported from the Low Countries in huge quantities from the later 14th to the early 16th century, and were probably far more common in the later Middle Ages than decorated tiles. Tiles of this type are impossible to date with any accuracy, and, apart from those just mentioned in Wykeham's chantry, none survive *in situ*.

A number of tiles survive in various parts of the cathedral belonging to the Newbury Group (Group 19). So called on account of a purchase of tiles from Newbury by Winchester College in 1411–12 (only two of which survive),[35] these slip-decorated tiles have been found in small numbers at various sites in Winchester. They have quite a wide distribution through northern Hampshire, Berkshire and Wiltshire. At the cathedral they are perhaps to be associated with work ensuing on the completion of the Perpendicular nave.

Another group of slip-decorated tiles, this time locally produced, dates to the mid 15th century. These are the large well known 'Have Mynde' tiles, which, together with a couple of other patterns, are restricted to a few sites in and around Winchester (Group 20). A few of these tiles survive along the north wall of Waynflete's chantry in the retrochoir and they are perhaps associated with it.

The latest decorated tiles in the cathedral belong to the early 16th century. A unique inlaid fragment preserved in the Victoria and Albert Museum has stylised foliage with the base of two letters (Group 24). They are clearly RF for Richard Fox, Bishop of Winchester 1500–28. The same letters with more naturalistic sculpted foliage can be seen on Fox's chantry. Finally, some large inlaid tiles with separate small roundels at the corners are perhaps also of early 16th-century date (Group 25). Until the relaying of the north presbytery aisle floor, some of these tiles were laid against the north wall of the chantry of Bishop Gardiner, who succeeded Fox. Also of this period are some large plain bright green and yellow tiles with a distinctive white fabric. During the rebuilding of the north presbytery aisle in the time of Bishop Fox the outer Norman wall was replaced by a thinner wall. The space between this new wall and the 13th-century pavement was filled with tiles of this type, some of which survived until the recent relaying of the floor. The tiles are certainly imports, and probably came from the region of Rouen.[36] These tiles mark the end of three centuries of laying of medieval tiled floors in the cathedral.[37] After this date no further major structural alterations were made to the building, and tiles decorated in the medieval techniques and styles rapidly went out of fashion.

This study has indicated something of the enormous richness of material for the study of medieval floor tiles in Winchester Cathedral. It has attempted to outline the pattern of tiling

in the cathedral from the mid 13th century. The most important period of tiling covered the years from about 1240 to about 1325, during which time almost the entire eastern arm of the church was paved with high-quality Wessex tiles. There are also some 'exotica' in the form of a few relief tiles and especially two different groups of Chertsey-type tiles which must result from special commissions. It is interesting to note that this extended campaign of tiling was not for the most part directly connected to any major structural work, but apparently continued at a fairly steady pace over many decades. From about 1325 and for the next two centuries a different pattern emerges. Small groups of tiles can be identified at various dates which seem mostly to represent fairly small additions to the cathedral's decorated pavements, and again they cannot generally be associated with major building campaigns. The rebuilding of the presbytery area in the 14th and 16th centuries and of the nave at the end of the 14th are in terms of tile pavements comparatively insignificant. There is also from about 1325 a clear change in the pattern of supply. No longer are the tiles derived from the local Wessex industry with its distinctive technique and style, but they are drawn from a number of different and unrelated sources, many of them being indeed imported from other regions or even from other countries.[38] Thus the surviving floors and individual tiles give a detailed picture of one aspect of the embellishment of Winchester Cathedral over a period of some three hundred years.

ACKNOWLEDGEMENTS

I am very grateful to Mrs Corinne Bennett, the Cathedral Architect, for much assistance in my study of the tiles, and to Mrs Elizabeth Eames for advice and support over a number of years. I should like also to record my indebtedness to the late Dr A. B. Emden and the late Mr W. J. Carpenter Turner, who both encouraged me to pursue my work on the cathedral tiles and made available unpublished notes and drawings.

REFERENCES

1. J. Carter, *Specimens of the Ancient Sculpture and Painting now remaining in this Kingdom*, 2 vols (London 1780–94), I, Pl. opp. 30. His original drawings of the St Cross tiles are in the British Library, Add. MS 29,925, f. 108[r], and of some in the cathedral, which were not published, in Add. MS 29,926, f.28[r].

2. J. G. Nichols, *Examples of Decorative Tiles, sometimes termed Encaustic* (London 1845), nos 1–2, 8–10, 15–18, 22 and 30–31.

3. J. H. Parker, *A Glossary of Terms used in Grecian, Roman, Italian and Gothic Architecture*, 5th ed., 3 vols (London 1850), Pls 198 and 207.

4. H. Shaw, *Specimens of Tile Pavements* (London 1858), Pl. XXV.

5. Volume of tracings by Lord Alwyne Compton in the Library of the Society of Antiquaries of London. Numerous tracings of individual patterns from Winchester are also to be found in many other 19th-century collections of tile tracings.

6. B. W. Greenfield, 'Encaustic tiles of the middle ages found in the south of Hampshire', *PHFCAS*, II (1892), 141–66.

7. A. B. Emden, 'The medieval tile pavement in the retrochoir', *WCR*, XVII (1948), 6–12.

8. G. E. C. Knapp, 'The medieval tiles of Winchester Cathedral', *WCR*, XXV (1956), 16–24.

9. Photographs by C. J. P. Cave preserved in the National Monuments Record.

10. W. J. Carpenter Turner, 'The retrochoir', *WCR*, XXXVIII (1969), 57–66.

11. The two main articles are E. C. Norton, 'The medieval floor tiles', in M. Biddle, ed., *Winchester Studies*, VII. 1 (Oxford forthcoming), and E. C. Norton, 'Medieval floor tiles in Winchester', in J. Collis, ed., *Winchester Excavations 1949–1960, IV, Medieval and Post-Medieval Ceramics and Glass* (forthcoming). See also n. 14. Additional illustrations of the individual patterns may be found in the sources cited in nn. 1–10.

12. E. S. Eames, *Catalogue of Medieval Lead-Glazed Earthenware Tiles in the Department of Medieval and Later Antiquities, British Museum*, 2 vols (London 1980), I, 191.

13. N. Pevsner and D. Lloyd, *BE: Hampshire and the Isle of Wight* (Harmondsworth 1967), 688–71 and P. Draper, 'The retrochoir of Winchester Cathedral', *Architectural History*, XXI (1978), 1–17, esp. 6–7.

14. This article has been prepared in conjunction with the two articles referred to in n. 11, and a single system for numbering the patterned tiles at Winchester has been adoped for all three articles. There are at the moment twenty-five known distinct groups of medieval patterned tiles at the various sites in and around Winchester. Not all are represented in the cathedral. They have been numbered in approximately chronological order, Groups 1–25. Within each Group the individual designs are numbered consecutively, preceded by the Group number. Thus the patterns of Group 1 are numbered 1.1–1.28. Some of these pattern numbers are referred to in the text. Since the articles are cross-referenced, the Group numbers of all the decorated tiles in the cathedral are given in the text, without further references in the notes. The basic discussion of almost all the tile Groups in the cathedral will be found in the article in *Winchester Studies*, viz. Groups 1–5, 8, 9, 13, 16, 18–20, 24 and 25. Additional information on Groups 1, 2, 4, 5, 8, 9, 16, and 18–20 will be found in the article in *Winchester Excavations*. For Groups 6, 10 and 15 see below, nn. 26, 30 and 32.

15. E. S. Eames, 'A thirteenth-century tiled pavement from the King's chapel, Clarendon Palace', *JBAA*, 3rd series, XXVI (1963), 40–50, and E. S. Eames, 'Further notes on a thirteenth-century tiled pavement from the King's chapel, Clarendon Palace', *JBAA*, 3rd series, XXXV (1972), 71–75. See also Eames, *Catalogue . . .*, I, 134–38.

16. E. S. Eames, 'A tile pavement from the Queen's chamber, Clarendon Palace, dated 1250–2', *JBAA*, 3rd series, XX-XXI (1957–58), 95–106, and Eames, *Catalogue . . .*, I, 187–90.

17. I owe this information to Mr Carpenter Turner.

18. See J. S. Gardner and E. S. Eames, 'A tile kiln at Chertsey Abbey', *JBAA*, 3rd series, XVII (1954), 24–42, and especially Eames, *Catalogue . . .*, I, 141–71, particularly 157 and 167. The identifiable fragments are parts of designs 468, 472 and 474.

19. See J. D. le Couteur and D. H. M. Carter, 'Notes on the shrine of St Swithun', *PHFCAS*, IX (1920–24), 370–84. The erection of a new shrine might have been necessary after the fall of the '*flabellum*' which fell and damaged the shrine in 1241. Direct royal patronage is certainly possible. In 1240 Master William, the King's painter, was given the office of painter to the priory by the King (see *Close Rolls of the Reign of Henry III, A.D. 1237–1242* (London 1911), 185). The position of the shrine of St Swithun is disputed, see n. 21 and 68.

20. This is slightly earlier than the date previously suggested by Emden, op. cit., 12 and adopted by myself in an earlier article (see n. 33).

21. During the laying of electricity cables in 1973 Mr Carpenter Turner found a part of the 13th-century floor still in position under the west end of Beaufort's chantry. This is shown on Fig. 2. It may be added that there is no evidence from the layout or condition of the floor for the existence at any date of the shrine of St Swithun in the middle of the retrochoir between the two chantries, as has sometimes been claimed (e.g. le Couteur and Carter, op. cit., 380). The general layout does not seem to indicate anything special in this area, and although the floor here is much disturbed, it is in no worse condition than some other parts of the pavement. Much of the disturbance is at any rate relatively recent. Quite apart from the relaying beneath the present 'shrine', it is known that the floor in this area was taken up in the late eighteenth century in order to see if there were any remains beneath it — which there were not (see J. Milner, *The History and Survey of the Antiquities of Winchester* (Winchester 1798), 67, n. 2). Shortly afterwards a medieval tomb-chest was placed here, later to be removed, and this very likely resulted in further disturbance of the floor (see J. Britton, *The History and Antiquities of the See and Conventual Church of Winchester* (London 1817), Pl. XIII). Had the shrine been here, I would expect the floor to be considerably more worn than it actually is. Nor can the rough flint solids in the crypt below which supported the vault between the two chantries be used in evidence, as having supported some extra weight immediately above it (see Milner, loc. cit.): there was another such support in the next bay to the west, immediately in front of the Holy Hole, where there was no special weight to be borne.

22. At the time of writing, the original tiles from the north presbytery aisle are stored in the north transept triforium.

23. This was observed by Mr Carpenter Turner during the relaying of the aisle floor.

24. Mr Carpenter Turner found either tiles or the impressions of tiles in mortar under the purbeck slabs somewhere in the south presbytery aisle during work in that area. It is not clear why this aisle should have needed repaving in the early 16th century, while the north presbytery aisle did not. Perhaps the floor was badly damaged during the rebuilding. Perhaps being on the side of the claustral buildings it had suffered continual wear from the monks entering and leaving the choir.

25. See C. G. Wilson, 'The medieval quire', *WCR*, XLV (1976), 16–18.

26. Illustrated by Knapp, op. cit., nos 23 and 24.

27. See the references cited in n. 18. The large panels are illustrated by Eames, *Catalogue*, designs 1306–18.

28. Unlike the fragments of the earlier Chertsey-type tiles (Group 3), these have all been fully discussed and illustrated elsewhere (see references in n. 11), and so are not illustrated here.

29. See E. C. Norton, 'The British Museum collection of medieval tiles', *JBAA*, CXXXIV (1981), 107–19, esp. 111–12.

30. This group is hitherto unpublished. The tiles are *c.* 165 mm square.

31. It is not clear what connection there is, if any, between this work in the north transept, the reconstruction of the Norman apse and presbytery arcades, and the erection of the choir stalls, all of which seem to be roughly contemporary. On the window tracery, see below, 94 ff.

32. One is illustrated by Knapp, op. cit., no. 21, another is in the Victoria and Albert Museum. For Penn tiles in general, see C. Hohler, 'Medieval paving tiles in Buckinghamshire', *Records of Buckinghamshire*, XIV (1942), 1–49, 99–132, and Eames, *Catalogue . . .* , I, 221–26.

33. E. C. Norton, 'The medieval paving tiles of Winchester College', *PHFC AS*, XXXI (1974), 23–42, especially 28–32 and nos 29–34.

34. In Figs 4B and 4C the orientation of each individual tile is indicated by the direction in which the number faces, except in the case of design 16.8 = no. 4, which is all but identical whichever way up it is laid. With design 16.4 = no. 2 it is very often only possible on account of the wear to determine whether the tiles were laid on a north–south or an east–west axis, but not precisely which way up they are. In this case the tiles are marked with an arrow beside the number 2. The reused medieval tile on the north side of the chapel is of design 4.38. All the other reused medieval tiles are in the newly patched areas. Most of these tiles in fact come from the church of St Martin, Winnall. A number of medieval tiles were salvaged from this church at its demolition by Mr Carpenter Turner, and placed by him in the north transept triforium. Some of these have now been relaid in the chantry, including one design (4.47) which is not known from the cathedral. The Winnall tiles are 4.42 × 1, 4.47 × 3, 4. worn flat/plain × 1, 8.6 × 1, 8.7 × 1. The remaining Winnall tiles have now been transferred to Winchester Museum and are published in the article in *Winchester Excavations*. The other medieval tiles relaid in the chantry are presumably loose tiles from elsewhere in the cathedral (of which there are large numbers). They are of designs 4.30 × 1, 4. worn flat/plain × 1, 8.2 × 1, 16.2 × 2, and a plain white-fabric tile probably imported from Rouen in the early sixteenth century (see below). There were formerly four examples of design 16.2 = no. 1 in the recently disturbed areas, now there are six. It may be presumed that one example which shows none of the breaks visible on all the other specimens in the chantry is an intruder.

35. Norton, op. cit., 34–38 and nos 16–17. See also Eames, *Catalogue . . .* , I, 218.

36. This group of tiles has only recently been identified (see references cited in n. 11) and has now been found at a number of sites along the south and east coasts. Tiles of a very similar fabric and glaze, though smaller in size, have recently been acquired by the Musée des Antiquités, Rouen, following the demolition of an early 16th-century house.

37. The only other floor of which I have any knowledge is a pavement of which traces were found, according to Mr Carpenter Turner, somewhere under the floor of the west aisle of the south transept by T. D. Atkinson before the last war. Nothing more is known of this pavement.

38. A similar pattern of laying decorated tile pavements may be found, on a smaller scale, at Christchurch Priory, see E. C. Norton, 'The medieval floor tiles of Christchurch Priory', *Proceedings of the Dorset Natural History and Archaeological Society*, CII (1980), 49–64.

Decorated Tracery in Winchester Cathedral

By Georgina Russell

At first sight, Winchester seems to be in the unusual position of being a cathedral without a major work of Decorated architecture, a position shared by Canterbury alone out of all the sixteen pre-Reformation cathedrals. Winchester does in fact possess Decorated fabric, in the shape of the central vessel of the presbytery, as Willis noted.[1] It is not immediately evident, due to remodellings in the 16th century under Bishop Fox (1500–28). Willis considered that only the arcading round the 'apse' dated from *c.* 1320; his correct identification of Bishop Edington's work in the tracery of the presbytery clerestory led him erroneously to date the arcading of the straight bays to *c.* 1350, but he does not seem to have noticed that the rere-arches of the clerestory windows have capitals decorated with hummocky 'seaweed' foliage that will only accord with a much earlier date than *c.* 1350.[2] The complete absence of vault responds on the inner face of the arcades suggests that a vault did not feature in the original design for the presbytery, and that when the present (wooden) vault was introduced it necessitated a remodelling of the clerestory windows to north and south. With the insertion of Bishop Fox's new glass and tracery in the big east window and the two windows that flank it, the last remains of what must have been an important set of window tracery were destroyed. A Purbeck marble screen (see above, Tudor Craig and Keen) was also destroyed, fragments of which were found in the crypt.

Other Decorated features, however, survive at Winchester. Below the two bays of arcading which close the east end of the presbytery is a wall bearing blind arcading known as the 'feretory screen'. The nodding ogees on the gables are similar enough to those on the *pulpitum* of Exeter cathedral (dated to 1317 from the Accounts) for a similar (if slightly earlier) date to be proposed; it is in fact an integral part of the presbytery arcading, with the result that its date is more important than might be supposed. A second feature is the set of elaborate choir stalls under the crossing, in the traditional position for the monks' choir.[3] This accords well with the text of the document usually quoted to date the stalls to 1308, since William Lyngwode's 'quoddam opus sue artis' is being carried out 'in choro ecclesie nostrae cathedralis'.[4] The location of the choir stalls under the crossing, however, rules out any attempt to date the presbytery by means of the stalls.

A third feature is the tomb effigy and chest (now separated) of a knight in armour, now recognized as Sir Arnold de Gaveston, whose funeral took place at Winchester in 1302.[5] The assumption is that the sepulture dates probably from *c.* 1308, when Arnold's son Piers was at the height of his favour, and at any rate from before Piers's death in 1312. Sir Arnold however seems to have led a chequered post mortem existence, since every author describing the tomb (previously identified as William de Foix) places him in a different position in the church. It is impossible to establish the original site of the tomb with any degree of certainty. Surprisingly, Arnold's monument appears to be the only one in the cathedral to date from the first half of the 14th-century.[6] A lack of documentation precludes the knowledge even of where bishops of the period were buried.

Finally, there is a group of Decorated architectural features in the transepts. This includes a rib vault of early 14th-century date over one of the Romanesque eastern chapels (North II) which is 'supported' by angel atlantes. This chapel was also embellished with ogee tabernacles on the sides of the piers facing across the entrance to the chapel. In the chapel to the north of this (North III) an ogee tomb recess has been inserted in the north wall. The vault of this chapel has also been reconstructed, and has been given a foliate boss. In the

south transept, chapel South II has a stone screen of pure reticulated tracery, which Pevsner suggests may have been appropriated by Prior Silkstede rather than built by him.[7] Perhaps the most noticeable features are the six windows containing Decorated tracery, which are worth considering for the metaphorical light they shed on small-scale building operations. This paper does not set out to provide all the answers: it aims merely to draw attention to some interesting features.

The six windows are all at aisle level in the eastern chapels of the Romanesque transepts, even though one (North IV) faces north rather than east. The series may have been continued some twenty or so years later by the addition of an early Perpendicular window, South III. Such a date is suggested by the awkward transom at the junction of main lights and tracery head, which is never found in Perpendicular windows at this height but which is however reminiscent of the east window of Old St Paul's, London (c. 1314).[8] The fact that the central trio of tracery lights are the same width as the main lights suggests an early date; perhaps the closest parallel is the extreme top of the east window of Gloucester choir, begun probably after 1337.[9] To arrive at a more precise date for this window is however beyond the scope of this paper; nor is it necessarily a matter of significance, since the window is again a later insertion and since similar methods were followed. The six Decorated windows have the added interest of providing a group of designs that are obviously close in date but with tantalising differences. It is these windows that I propose to look at in greater detail: first, at the designs themselves; secondly, at the way in which the windows fit into the pre-existing wall; and finally, at the conclusions and questions that are the result of such a study.

I propose to examine the designs in what I take to be their typological order, since there is no external evidence in support of date. The east window in the southern chapel of the north transept is of five lights, arranged $2 + 1 + 2$. The two pairs of tricusped lights have heads of the 'equilateral arch' variety (see Fig. 1); each pair is surmounted by a miniature cinque-foiled oculus beneath a superarch. These two pairs of lights are separated by a central cinquefoiled light which appears to be more acutely pointed than its neighbours, in order to bring its apex higher than the other four lights. In actual fact this result is gained in part by stilting the arch, in part by increasing the width of the central light from c. 0.56 m to c. 0.75 m, measured from the centre of each mullion. Over the central light is a mandorla formed, as it were, of two lancet-heads base to base, similar in size to the heads of the paired lancets below (see Fig. 2). This mandorla separates two curved triangles which lie 'on their sides' (i.e., they are rotated through 90° so that the apices point outwards horizontally); meanwhile, a third triangle, balanced on the upper corners of the other two triangles and of the mandorla, occupies the top of the window. Windows of four or more lights are in themselves unusual, and it is almost impossible to find exact duplications of any design; nevertheless, given these strictures, the design of North I is a fairly orthodox though uncommon one. There are however some small anomalies: the top cusp of the central main light is mid-way between the slightly Curvilinear 'petal' cusping of Wells chapterhouse windows (Pl. XXVIB), where the curve of each foil is given a small point, and a fully-blown ogee. This is repeated within the angles of the curved triangles and the mandorla. (This exaggerated 'petal' effect also finds a parallel in the central motif of each bay of the 'feretory' screen, mentioned above.) Finally, there are mouchettes in the interstices between the two superarches and the single central main light.

The mouldings of North I, apparently complex, follow a logical pattern (Pl. XXVc). If one begins at the intermediate plane of the minor mullions (1 and 4), one finds that there is a roll moulding which runs up these mullions and continues round the heads of the individual lights and the small oculi above them, and that it is also present on the major mullions at an intermediate level to represent their dual function. The roll moulding surmounts a cham-

FIG. 1. The equilateral arch (D is any point on
the arc being struck from point C)

FIG. 2. The mandorla (the arc AB, struck
from C, is continued down to E, likewise AC is
continued to E)

fered thickness of stone, out of which the cusps and foils are carved. (Neither the cusps nor the foils are pierced, but all are hollowed out chamfer-wise.) On the outermost plane of tracery the major mullions (2 and 3) have an additional small filleted roll which follows the bigger roll on which it is mounted, up and over the two superarches and also round the triangles and mandorla.

North IV, the north-facing window of the northern chapel of the north transept, also has both Geometrical and Curvilinear features, but there is more of a balance between the two than in the previous window (Pl. XXVA). The mullions dividing the three lights are carried up into the head to form intersecting arch tracery; the radius of these arcs is (as is usual) equal to the width of two lights rather than all three. (The formula appears to be: radius = $nw-w$ where n is equal to the number of main lights in the window, and w is the width of an individual light, measured from the centre of the mullions on either side.) Within each main light there is an ogee trefoil impaled on a cinquefoiled ogee lancet-head. The three dagger-soufflets in the tracery, however, have plain Geometrical cusping. The approach to mouldings is not so logical in this window. The mullion moulding — a large filleted roll on a slightly larger flat rectangle — is naturally carried up into the head of the window to form the arch tracery; but when a lower plane is needed for the ogee lancet-heads and soufflet-cusps, a section of the roll is 'split off', and an extra fillet is added which is not present on the mullions.

We now come to the three three-light reticulated windows, North II and III and South I (Pls XXIVA, B), whose tracery design is identical, even in such details as the way in which the topmost ogee point of the topmost soufflet is 'drawn' through the first two sections of jamb

moulding (Pl. XXVB). The mullion-section is a plain chamfer with the outermost edge shaved off to form a kind of fillet. (This is a very common type.) The cusps are on a slightly lower plane, but they do not have their own separate moulding.

Finally, there is South II, the so-called 'Isaac Walton' window, which is a compound of elements from all the designs I have described so far. In general outline it most resembles North I: a 2 + 1 + 2 arrangement, with a wider central light and three curved triangles in the head. But the pair of lights within each superarch is of reticulated tracery, and the mandorla has been replaced by an extraordinary trefoil with almost square 'shoulders', which is impaled on the central main light, which has an ogee head like its fellows on either side. The two lower triangles are slightly askew because they are made to 'rest' on the continuation of the two major mullions which are run up into the tracery head. (This feature is also the cause of the 'shoulders' of the trefoil.) It is interesting to note that the mullion-section of this window is identical to that of North IV (the three-light window of intersecting arch tracery), rather than that of North I, whose overall design it most closely resembles (Pl. XXVD). On the other hand, the rere-arch of South II is identical to that of both North IV and North I. (North II and South III have no rere-arch.) It is difficult to say whether this points to a similar date for all three windows, or whether a particular section for rere-arches was in current use over a long period; after all, it is not a particularly prestigious feature.

The proximity of North III and North IV also raises questions of chronology, which is complicated further by the presence of the ogee-capped tomb niche in the wall below North IV and the rebuilt vault over this chapel. The vault can be linked structurally with North IV since it allows room for a larger window than the Romanesque vault would have done; in fact the soffit over the window is angled up outwards in order to increase the available height still further. Beyond this, however, no one feature is linked structurally with another. All that can be said is that the tomb niche is more easily associated stylistically with North III than with North IV immediately above it.

Securely datable parallels for each tracery design are more difficult to find than it might seem. These should only be regarded as a *terminus post* (or *circa?*) *quem*, since there are good arguments for a continuing pattern book (actual or metaphorical) to which designs were added but from which few or none were discarded during the Decorated period.

North I as a whole is an exception to this in that it appears to be unique (at least in our present state of knowledge), though parallels can be found for individual elements. Curved triangles as a tracery motif (rather than a mere window-shape) seem to have appeared first in England in the choir triforium of Old St Paul's, London (1258 onwards).[10] (This building also featured main lights of unequal height, in the choir aisle windows).[11] Among the earliest examples of curved triangles to survive are those in the unglazed tracery in the doorway of Wells chapterhouse, which was probably finished by 1307,[12] though at Wells, as in Old St Paul's, only a single giant curved triangle is used in the tracery head.

The second of the two design elements in the tracery of North I, the mandorla, appears in one of the two designs which alternate in the aisle windows of the chevet of Wells; at least some of these windows had been built by the time of the dedication of the south-east transept (St Katherine's chapel), but it is likely that the designs date from some years earlier, for instance after the roofing of the central tower in 1322.[13] The original design incorporating a mandorla, however, was probably a metropolitan one, since several similar designs are found in the London Basin, for instance at Harefield, Middlesex, in the south aisle.[14] The stilting and widening of the central light is a practice similar to that employed by the designer of the four-light windows of the crypt of St Stephen's Chapel, Westminster Palace; this could therefore be another feature of metropolitan origin.

H

No parallels whatever can be found for South I, apart from the window's overall similarity to North I. One imagines that the design did not find favour, apart from the fact that opportunities for five-light windows are comparatively rare. North IV in contrast is a much more common design.[15] Most of these however are difficult to date accurately; and an early five-light version of intersecting arch tracery (with interesting variations which need not concern us here) occurs at St Etheldreda's, Ely Place, London as early as *c.* 1284–86. The Curvilinear elements in the Winchester window necessitate a date some thirty years later, I would suggest. The last design at Winchester, for the three three-light reticulated tracery windows, is commoner still. It is interesting to note that one of the earlier examples is the second of the two chevet aisle designs at Wells.

It will be realised from the above discussion that the persistence of tracery designs makes it very difficult to date individual examples accurately; but the group of six windows and their related architectural features give the impression of dating from the period 1310–30.

I should now like to outline the different approaches taken to solving the problem of inserting a large window into the heavily-articulated Romanesque fabric which was already pierced by round-headed windows. On the one hand we have North IV (Pl. XXVA), North I, South I (and South III), in which the Romanesque mouldings are swept entirely away except for tiny sections of string-course, and a large window is inserted to fill the available space between the buttresses. On the other hand, in the case of the three reticulated windows (for example North III), the hoodmould is retained, possibly because the stones on which it is carved act as a relieving arch and this saved a lot of construction work. But this decision together with the one to match the springing-points of the window-heads to those of the larger windows results in windows that are little wider than the original Romanesque ones (to judge from extant examples in the North Transept north façade).

Considerable variation is also found in the different depths by which the sill is dropped in order to enlarge the window area, ranging from a mere three courses below the lower Romanesque string-course for North II (if this has not been tampered with), to six for North IV and South I (and incidentally also South III, the perpendicular window), and even seven courses in the case of North I and III and South II. (I include in these all moulded sill courses.) This variation cannot be explained by structural limitations: the wall below North I was pierced by a doorway comparatively recently, and one can see that the wall is surprisingly thin. North II could have been enlarged downwards in a similar fashion. On the other hand, the designer of North IV had many more problems to solve in order to design a large window, as it would seem he had to preserve the full height of the access (from inside the building) to the Romanesque staircase in the north-east corner of the north transept. (Pl. XXVA). His solution was to slope the entire sill outwards, both inside and outside, and to carve away the interior stonework over the window into an upward slope. One can only conclude that depth of sill must have depended on the patron's willingness (or otherwise) to spend lavishly in order to enhance his project. Some approximation to the existing internal elevation must have been considered desirable, since, in spite of the newly increased height of vault in each of the chapels involved in these modernisations, even the highest window goes no higher than two courses above the level of the Romanesque hoodmould. That such large windows could have resulted in spite of such limitations is due to the colossal scale of the Romanesque fabric.

Now to conclusions, and to questions still unanswered. The first conclusion is that we have such a diverse group of windows that they must have been paid for by individual sponsors whose taste and pocket may have influenced the results of their generosity. The second is that it must be more than coincidental that both the numerous miscellaneous embellishments and the six Decorated windows are to be found together in the transept

chapels. The third is that the windows (and their related embellishments) were supplied at different times, to judge from the variation of approach of the builder/designer. This is in contrast to the cases where a variety of donors were sought to provide stained glass as part of a single project, for instance in the nave aisles of York Minster, where there is no variation in either tracery design or the execution of the windows. The same is true for Chartres, a century earlier. No evidence for donors of glass can be gained for Exeter Cathedral, where a variety of tracery designs is a feature of the building, but even here the method of execution of the tracery is uniform throughout each section of the building. At Winchester, donors cannot have been sought in such an organised way as at York or Chartres; but there may instead have been a policy to encourage potential donors, who had come forward of their own accord, to sponsor work in the transepts, especially if (as is likely) it was at this period that the transept chapel roofs were lowered to harmonise with the new work in the presbytery. The fourth conclusion to be drawn is that absolute symmetry in the transept elevations was not considered necessary by the Dean and Chapter, who must have had some power of veto over designs of which they did not approve.

Next some speculation, beginning with the purpose of the windows. Presumably they were made to take stained glass (as opposed to plain quarry-glass), since they were not part of a rebuilding campaign, and since they do not greatly add to the illumination of the transepts.[16] No glass of the early 14th century has survived from the cathedral, but I am tempted to suggest that the nineteen trays of splendid stained glass that were found without any associated leading among 17th-century demolition layers in the gatehouse of Wolvesey Palace, Winchester, might have come from the windows in the transepts.[17] The windows of Wolvesey Palace chapel would seem on archaeological evidence to have dated from the 15th century, and this agrees with the one recorded reference to the chapel glass.[18] In contrast to this, the styles of the painted pieces of glass suggest dates from c. 1310 to c. 1330, which is entirely correct for the cathedral transept windows. Similarly, the size of many of the border-pieces (which are still intact) imply windows on the scale of those we have been examining in the cathedral; they are much too large for a domestic chapel or parish church. The quality of the glass also matches that of the Decorated tracery windows and decorative stone carving, such as the angel-atlantes in chapel North II. Sadly, evidence that is normally available from the notes of 18th-century antiquarians is lacking at Winchester, due to the comprehensive destruction of glass and monuments by the Cromwellian soldiery.[19]

A final question remains. It is not at all certain whether we are dealing with the work of six different nearly-contemporary designers (or perhaps four, if all the reticulated windows are by one man), or whether on the other hand there was a resident mason who supervised day-to-day repairs in much the same way as a modern cathedral architect, and who could produce a design for a window on request. (Such a design might or might not be adapted from a 'pattern-book' and could be tailored in many ways to the tastes — and the means — of the donor.) It should not be forgotten that the two five-light windows (North I and South II) are 'one-off' designs of a degree of sophistication on a different level to standard three-light designs such as reticulated and intersecting arch tracery.

One can see from these conclusions and speculations that any discussion of the Decorated tracery windows at Winchester involves such perennial questions as design authorship and the involvement of the donor. It is to be hoped that further evidence will come to light as a result of continuing research and restoration work on the cathedral.

REFERENCES

1. Willis (1846), 45–48, noted 'the total absence of any documents' relating to the Decorated fabric.
2. Details can change part-way through a building project, e.g. Exeter Cathedral presbytery before and after the demolition of the apse.
3. Willis (1846), 49. It may be correct to associate the fragments of Purbeck marble screen with these stalls.
4. Cf. A. W. Goodman, 'The Choir Stalls at Winchester', *Archaeol. J.*, LXXXIV (1927), 125–26. See also Pevsner's strictures concerning the lack of precision in this document B/E *Hampshire* (1967), 608. Their reference however is incorrect.
5. 'W.S.W.', 'Remarks on an Effigy of a Knight in Winchester Cathedral', *Archaeol. J.*, XV (1858), 125 ff.
6. B/E *Hampshire*, 675–85.
7. B/E *Hampshire*, 682. Silkstede was prior from 1498 to 1524.
8. W. Dugdale (ill. W. Hollar), *The History of St Paul's Cathedral in London* (1658), 166.
9. B/E *Gloucestershire, The Vale and the Forest of Dean* (1970), 208. This window is one of the earliest Perpendicular ones to incorporate transoms. In this case, the transom near the level of the springing-point of the head of the window is 'justified' by the two extra tiers of 'main light' panels above it and below the notional 'tracery head'.
10. Included by Wren in his 'All Souls' drawing (reprod. by R. Branner, *St Louis and the Court Style* (1963), Pl. 123). See H. Bock, *Der Decorated Style* (1962), 26, n. 44, for documentary sources for Old St Paul's.
11. Dugdale, loc. cit.
12. L. S. Colchester and J. H. Harvey, 'Wells Cathedral', *Archaeol. J.*, CXXXI (1974), 205.
13. Colchester and Harvey, op. cit., 207 and 208 respectively.
14. G. A. Russell, *Decorated Tracery in the London Basin* (University of London, Courtauld Institute, MA Report 1972), 33.
15. Russell, op. cit., 29–30.
16. Plain glass could be used in prestigious places, e.g. the east end of Salisbury Cathedral (1220 to *c.* 1244?). The nave clerestory of York Minster (1291 onwards) contains small panels of 12th-century glass reset in 14th-century grisaille.
17. Ed. S. Keene and M. Biddle, *Winchester Studies*, Finds volume (forthcoming), paper contributed by G. A. Russell.
18. I am indebted to Martin and Birthe Biddle for this evidence and information, to be published in *Winchester Studies*.
19. C. Woodforde, *English Stained and Painted Glass* (1954), 45.

Carpentry in the Cathedral and Close at Winchester

By Julian Munby and John Fletcher

PART I: THE CATHEDRAL

Introduction

The timber roofs over the nave, choir and transepts of Winchester Cathedral pose unusual archaeological problems that have not been satisfactorily resolved in previous studies. Willis's paper to the Archaeological Institute in 1845, while clarifying the main sequence of events, was primarily concerned with stonework.[1] A publication dealing only with the nave roof was brought out after the restoration of the 1890s by Colson, whose drawings and photographs provide valuable evidence for the earlier state of that roof.[2] Several roofs were illustrated by Ostendorf in his pioneering work of 1908 *Die Geschichte des Dachwerks*, but it was not until Cecil Hewett's *Cathedral Carpentry* (1974) that all the roofs were drawn and described, while Jervis's *Woodwork of Winchester Cathedral* (1976) includes much of interest about them.

The object of this study is to extend previous work, and to make a further attempt to establish the phases and dates during which the construction of the high roofs occurred. We have used the methods employed in our studies of the roofs at Ely, Peterborough, Gloucester and Chichester, namely to combine an investigation of the structural context and form of the roofs with detailed observations on the size, finish, joints and assembly-marks of individual timbers.[3]

Nave and South Transept (Fig. 1)

Contrary to the opinion sometimes expressed, it is our view that virtually no parts of the roof remain *in situ* from the primary construction period (1079–93). Doubtless the first roofs were of Romanesque form of which examples are known in northern France and Hainault, with a tie beam to each truss, and a variety of bracing members attached by notch-lap joints.[4] Mortices of this sort seen on one of the nave rafters suggest reuse of a few of the members in the later work. On the face of the tower inside the present roof can be seen the coping of the Norman roof, its pitch of 50° comparing with the present pitch of 53°. In the nave the capitals of the Norman shafts which would have helped to support the roof still survive above the vault.[5] One of these still has the end of a beam embedded in the wall just above it: it is either a Norman tie beam or one of Wykeham's scaffolds.[6] In the south wall of the south transept is a short timber post with a cushion capital, standing on a stone corbel: it probably gave additional support to the tie beam next the gable wall. One further possible survival from the first roof is the wallplate in the south transept, with mortices for ashlar pieces unrelated to the present ones.

We propose that the replacement of the Romanesque roofs occurred *c.* 1400, when the nave was vaulted as part of the transformation initiated by William of Wykeham in 1394. The roofs of the nave and south transept survive from this period: they were of similar construction, but that above the nave has been extensively re-worked and added to. The phases may be summarised as follows (see also Fig. 1):

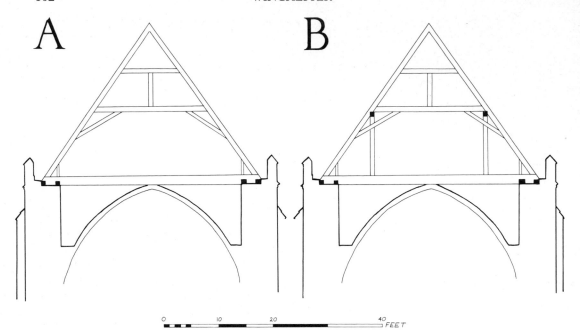

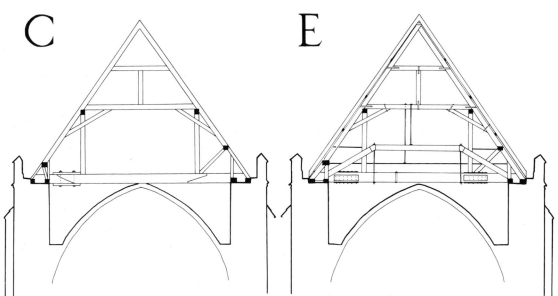

Fig. 1. Winchester Cathedral: Nave roof

A. Probable original appearance

B. Probable first phase of alterations

C. Appearance prior to 1896. (after Colson)

E. Appearance after restoration of 1896–98. (after Colson)

A. Rafter roof: each truss with two collars and a crown strut, and soulaces to the collars giving a seven-cant profile. Mortice-and-tenon joints throughout. Tie beams perhaps all present.

B. Purlins added: queen posts placed on tie beams to support side-purlins (some tie beams perhaps added at this time).

C. Base triangles repaired: rafter feet sawn off and replaced by plates supported on a variety of struts; ties beams scarfed.

D. West end of roof replaced after fire of 1698.

E. Restoration of 1896–98: lifting trusses built round each tie beam, and outer roof of softwood added.

The problem is the dating of these phases. Colson believed that A was the Norman roof, and that Wykeham was responsible for B and C when the nave was reconstructed and vaulted in c. 1400. Acceptance of this view primarily depends on the interpretation of his testimony as to the state of the roof before his work began (see Fig. 1C): 'The tie beams undoubtedly existed prior to the vaulting, as the former were bedded into the latter, the vaulting having been built up around them, and therefore point to an earlier period than Wykeham.'[7] Hewett now dates A to the time of Edington, c. 1360, and B to Wykeham's time or later.[8] We suggest that A is Wykeham's work and that all other phases are later. Whilst it is quite likely that some Norman timber survives in the present roof, and although Colson's proposal that all the Norman rafters were reused is ingenious, we find it quite inconceivable that Wykeham's rebuilding would have been capped with such a makeshift roof construction as that of phase C. Moreover, it is only to be expected that the raising of the roof would precede that of the vault, so that the masons could work under cover and have additional scaffold for hoisting. That the roof must be part of the vaulting campaign rather than an earlier one might be argued from the additional courses added to the top of the nave walls above the capitals of the Norman shafts (as happened at Chichester).

TABLE I

Nave roof in Phase A (over eastern 9½ bays of nave vault)

Width between walls:	34 ft 7½ in (10.55 m)
Pitch:	53°
Spacing:	Tie beam at each ½-bay; 8 trusses per bay, c. 2 ft (62 cm) apart
Tie beams:	14 in × 18 in (36 × 51 cm)
Rafters:	10 in × 10 in (25 cm)
Collars:	8 in × 8 in (20 cm)
Soulaces:	8¾ in × 8¾ in (22 cm)

Wykeham's roof (Fig. 1A) is noteworthy for the use of straight timber of heavy scantling (see Table I). Whereas in the Midlands, and even as close as Salisbury,[9] the use of curved beams was becoming commonplace by the end of the 13th century, Wykeham's master carpenter had no need to economise on timber since there were woodlands on dozens of manors within easy reach. The size and spacing of the rafters is such that some 30% of the overhead area was covered by them. Similar usage of massive straight timber occurred in Wykeham's work from 1380 to 1400 at New College, Oxford, for example in the *necessarium* (the Long Room).[10]

The truss with a seven-cant internal profile had been employed in the 13th century to span widths of *c.* 6 m (20 ft) across the nave or choir of many churches.[11] The additional cross-bracing needed by the wider Winchester nave and transept was achieved, as for other wide spans, by a second collar (cf. the nave of Wells, *c.* 1200, but using notch-lap joints)[12] and a crown-strut between the collars (cf. Harmondsworth Barn, *c.* 1435).[13]

The form of the roofs erected *c.* 1400 in Winchester can now be best appreciated in the south transepts.[14] The only additional feature here is the pairs of tall queen posts between the tie and collar (yet without purlins). The roof was open until the painted ceiling was added in 1819.[15]

Alterations to the Nave Roof

The nave roof, in contrast with that of the south transept, has been very severely rebuilt, and despite the conservative nature of the 1890s work, the archaeological value of the nave roof has been enormously reduced. Few if any of the timbers remain in their primary positions, and the haphazard juxtaposition of medieval-type assembly-marks with post 16th-century ones indicates a major disassembly and reconstruction. It is thus difficult to assign a date to the first large-scale alterations to the roof design (phase *B*), when the queen posts and side-purlins were added (see Fig. 1B). That they are secondary is clear from the way that their braces cut through the soulaces of the adjacent trusses as they rise from the post to the purlin. The queen posts are all of large scantling (see Table II), and the braces to the purlins are also substantial, of 'plank' section, and of curved profile.

TABLE II

Nave roof in Phase *B*

Queen posts:	11½ in × 7¾ in (29 × 19.5 cm)
Purlins:	7½ in × 6½ in (19 × 17 cm)
Braces:	11½ in × 4 in (29 × 10 cm); these braces from posts to purlins only occur at every second tie beam, i.e. those at the vault apices.

Most of the purlins were replaced in phase *E*, which casts doubt on the antiquity of the scarfs used there.[16] The posts and braces all have short, chiselled assembly-marks, that would normally be indicative of a post-medieval date (they too, could of course be of phase *E*). The purpose of these additions was to give the roof added longitudinal support, a requirement that might have been felt necessary at any time (especially if the roof was being re-leaded), and might even be contemporary with the phase *D* work at the west end of the roof, *c.* 1698. However, judging from the appearance of the timberwork, both its size and the use of curved braces, it could be assigned to the 15th or 16th century.

A most extraordinary attempt to repair the roof economically was made in phase *C*. Doubtless the need for the work was the decay of the rafter feet and tie beam ends (probably caused by inefficient dispersal of water from the parapet walks). The remedy employed was to cut off the feet of the rafters and support the truncated ends with a plate, held a few feet above the actual wallplates by numerous struts. The appearance of this work can best be seen in Colson's photographs of the roof before its reconstruction,[17] and his drawing (Fig. 1C). From these it would appear very likely that the scarfed additions to the tie beams were made at the same time. The scarfs are through-splayed (sometimes with under-squinted butts), and strengthened with iron rods. To repeat what has been said above, it is highly improbable that this kind of work would have been produced by Wykeham's carpenters. It

is also unlikely that it is contemporary with the additions of phase *B*, being of rather a different quality of carpentry. It is not impossible that it was part of phase *D* in the late 17th century, but it is quite as likely to be later still, and might even be some of the work done in the major repairs in *c.* 1827, which has not otherwise been identified.[18]

The first well-documented work, phase *D*, involved the replacement of the west end of the nave roof following a fire of 1698 which destroyed 'part of y^e roof of the Body of y^e Cathedrall'.[19] In the same year it was noted that the Cathedral was being repaired when a plumber was required by Wren at Winchester Palace.[20] The new roof, of five principal trusses, has king posts with raking side struts, and butt purlins; it has been illustrated by Hewett.[21] This type of king post truss was known in the Middle Ages, and in England is best represented in the 13th-century roofs at Chichester; it was taken up again as a Renaissance roof type, and became common from the 17th century onwards in England.[22]

The repairs of *c.* 1827 have been mentioned above as possibly associated with phase *C*, but the final phase of work, *E*, was the great restoration of 1896–98, described and executed by J. B. Colson (see Fig. 1E). He raised the ties off the vaulting with 'lifting trusses', added numerous iron ties and surrounded the tie-beam scarfs with bolted iron plates. A second outer roof of softwood rafters was built outside the earlier roof to give an even surface for the lead covering (in all, ¾ acre of lead on about 17 miles of battens!). In the nave, some 9,000 cubic feet of oak was brought in as a replacement, and almost 15,000 cubic feet of softwood.[23] Colson's preservation of the old roof with all its curious alterations is to be commended (it 'entirely satisfied' the Society for the Protection of Ancient Buildings),[24] even though he has added to the archaeological problems.

The Crossing

A timber vault was inserted here in 1634;[25] the ringing chamber above it had windows on all sides, but those opening east and west to the roof space are now blocked. If, as seems likely, the tower was originally an open lantern then all the belfry fittings must be secondary. The belfry floor has six large ties running east–west, double-braced to wall posts that rest on corbels which are themselves built into the masonry blocking the windows of the ringing chamber.[26] The timberwork is all substantial and could have been constructed at any time in the 14th–15th centuries, but there is no reason to suppose that the carving on the chamfer-stops of the corbels is original or even medieval. The bell-frame itself is dated 1734.[27]

The Presbytery and North Transept

The roofs of these parts of the cathedral are the most remarkable ones at Winchester. They are both illustrated by Hewett,[28] are similar and must be contemporary. That in the presbytery is related to the wooden vault beneath it, and there was possibly an intention to vault the north transept also. Problems in the dating of the roofs and their associated structures will be discussed below in fuller detail; like Jervis, we assign them to the time of Bishop Fox (1501–28), largely on stylistic grounds.

The presbytery roof (Fig. 2) was designed for the vault on which it stands, as it was specially built to avoid the crown of the vault (which rises higher than the walls of the clerestory). This was achieved by raising the tie beam up as if it was a low collar beam, and supporting it on two huge arch braces of unusual form. Each brace begins as a normal tie beam, taking the rafter foot and being trenched across the wallplates, but although it appears to terminate at a wall post it continues in one piece and rises to the centre of the tie, where it meets its fellow from the other side. The 'wall-post' (which apparently has no

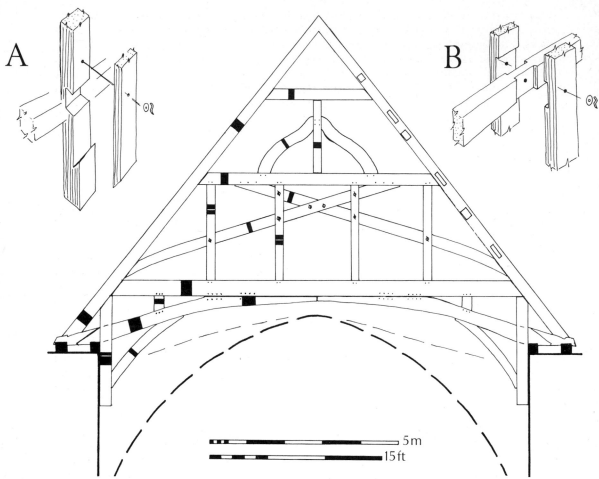

FIG. 2. Winchester Cathedral: Choir roof. Principal truss, showing (on left) dimensions of members
and (on right) mortices for purlins and wind braces
A. Detail of pendant wall-post
B. Detail of junction between scissor-brace and post

support from below) consists of two pendant members clasped round the brace, one of them
having only the thickness of a plank (Fig. 2A). Adding to the illusion of normality is a further
brace below, rising from the pendant post to the main brace. Above the tie is an elaborate
arrangement of two long scissor-braces and four upright posts rising to the collar beam;
here again the 'posts' (Fig. 2B) are actually pairs of planks clasping the scissors (and with
pairs of tenons at head and foot). All junctions are secured with forelocked bolts. Above the
collar is a plain crown strut with downward bracing.

 The roof is of eight bays, with four trusses like that shown in Figure 2, with posts
descending into the pockets of the vault; another five trusses have only a short strut rather
than a post. On each side are three butt purlins, windbraced to the principal rafters. The
purlins seem to be joined to the rafters with unrefined central tenons.

The north transept has a similar system of alternating trusses, and many features in common with the presbytery roof, with which it must be contemporary. It is not illustrated here, but has been drawn by Ostendorf and Hewett.[29] The lower trusses have a plain tie beam but are otherwise like the choir trusses; the raised tie trusses have a pair of outward turned braces rather than scissors, and only one collar above. Again, of the eight bays, four trusses are of the raised type, and five normal; this can perhaps be explained by an intention to vault. Amongst the visible joints at the end of purlins a number of diminished haunches can be seen behind the central tenons. Like the south transept, this roof was open until *c*. 1819 when the ceiling was inserted, involving the addition of some tie beams.[30]

Date and structural context of Presbytery and north transept roofs

Stylistic details suggest an early 16th-century date. The sinuous curvature of the braces in both roofs reflects the ogival revival of *c*. 1500 that influenced the tracery of so many church windows in the early 16th century. Similar ones are to be seen in the hammer-beam roof built 1516–18 by carpenters Coke and Carow for Bishop Fox in the hall of Corpus Christi College Oxford, and also in the related roof of St Mary's College that is now over Brasenose Chapel.[31] Although it is hard to find close parallels for the roof types, Hewett has recorded a roof at Fulham Palace with double queen posts which clasp scissor braces. The roof is over the hall, and probably dates to the time of Bishop FitzJames (1506–22).[32] A roof over the transept of Old St Paul's, probably built after 1561, seems to have had a similar general profile.[33]

If the presbytery roof at Winchester was built during Fox's episcopate (1501–28), then it was probably put up as part of the same campaign as the east gable wall and flying buttresses. The problem is how much else was done by him. According to Willis,[34] the east end of the presbytery was rebuilt on a polygonal plan *c*. 1320, and then gradually continued westwards by Edington from *c*. 1350, following the same elevation as the east bay, but with Perpendicular tracery (which was inserted by him into the east clerestory bay). When his attentions were diverted to the west end of the cathedral, the Norman aisles of the presbytery were still standing, and it was left for Fox to replace them with his own aisles. By this account, the vaulting of the presbytery could have been added any time after the late 14th century, though if it is seen as a continuation in timber of the nave vault, then it would have to be after *c*. 1400. On the other hand, some have claimed the clerestory of the presbytery to be the work of Fox, in which case the vault would be after 1501 and contemporary with the roof.[35] This is the most attractive hypothesis, but requires further examination of the masonry and the vault with its bosses. There are two series of bosses, the primary ones integral with the construction of the vault and having floral and foliate decoration. Subsequently these were covered with bosses bearing heraldic and emblematic designs, including the royal arms, the monogram of Henry VII, the arms of Henry Prince of Wales paired with those of Katherine of Aragon (surmounted by a crown) and the arms of Bishop Fox.[36] These should date to the period 1504–09, when the future Henry VIII was Prince of Wales, and after his betrothal to Katherine (though they appear to show her as Queen). Thus if the vault was built by Fox (after 1501) the secondary bosses would have been added not long after the vault was erected.

PART II: THE CLOSE

Several of the buildings in the Close have interesting carpentry, and one, the Pilgrim's Hall, is of outstanding importance. Apart from this, the others remain to be examined in detail, and only two are briefly noted here.

The Deanery

The Prior's Hall forms the central part of the Deanery, and although floors have been inserted into it the 15th-century roof survives complete and has in recent years been opened out and cleaned. The roof is arch-braced to the collars, the spandrels being pierced with quatrefoils; there is also a fine series of carved stone corbels.[37]

The Stables

South of the Deanery is a timber-framed stable range, recently converted into classrooms for the Pilgrim's School. It is constructed in the late-medieval tradition with a clasped-purlin roof, and with close studding and slightly curved arch braces in the side walls. One interesting feature is the double jowls on the storey posts, which occur both in the usual position at tie beam level and also at first floor level to support the principal floor joists.[38]

The Pilgrim's Hall (Fig. 3)

The origin and purpose of this building is quite unknown, the name being merely a conjecture. The open hall with its very early hammer-beam roof has long been known.[39] The structure has now been thoroughly investigated by John Crook and is the subject of a full study by him; he has shown that in addition to the three-bay hammer-beam roof, there is an adjacent two-bay roof with a base-cruck across the middle, and also one single bay at the south end.[40] The function of such a building with two open halls and what may have been a service bay is obscure. At a later stage, probably after the medieval period, the building was used as a brewery, but the masonry work of the building perhaps implies some more elevated domestic use. As the hammer-beam roof has an acknowledged part in the history of this roof type,[41] discussion is confined to that alone.

The roof is finely constructed, with large and well finished timbers. The hammer beams are tilted up slightly and gently tapered, this feature being also present in the wall posts and hammer posts where they receive downward bracing. Most of the principal members are chamfered, and the opposed hammer beams form a carefully curved trefoil arch. Above the upper plates are cornice pieces finished with a double chamfer. The collar beam is large and cambered; above it is a crown post bearing a purlin against which all the scissor braces of the common trusses rest (these continue for the entire length of the building). Joints are all mortice-and-tenon (or chase-tenons), securely pegged. The upper, or arcade plate has *trait-de-Jupiter* scarfs. One decorative feature is a series of carved faces on the end of the hammer-beams, difficult to date precisely, but possibly of early 14th-century date.[42] Clearly this roof is the self-assured design of a carpenter who knew what he was doing, and yet it is one of the earliest hammer-beam roofs known at present.

The greatest of all medieval roofs, that by Hugh Herland over Westminster Hall (1393–98), was certainly not the first hammer-beam roof, but it is a fully developed type with the added motif of a hugh arch brace running through the hammer construction.[43] An earlier roof, that at Tiptoft Farm (Wimbish, Essex) was built about the middle of the century with timbers of massive proportions.[44] Its outlines are similar to the Pilgrim's Hall, but there is added decoration in the form of cusped members. The closest parallel to Winchester is to be found in the kitchen of the Bishop's Palace at Chichester, where hammer-beam trusses are employed in two directions so that the hammer posts can support a high pyramidal roof, a tour de force of its unknown designer.[45] Many of its details are also to be found at Winchester: tilted and tapered hammer beams, the stops on the posts to receive the feet of

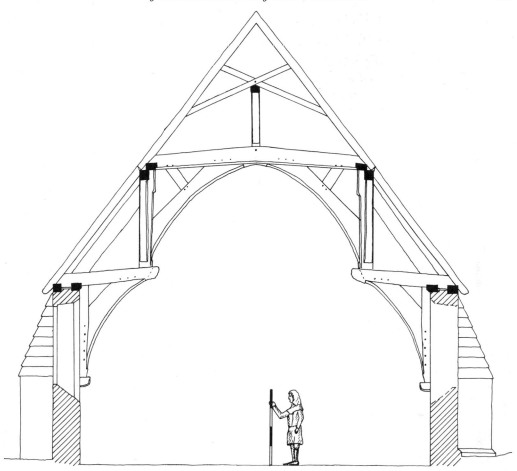

FIG. 3. The Pilgrim's Hall, Winchester: section of hammer-beam roof
(Scale: 2 m)

braces, the chamfering, proportion and arcature of the timbers. The spandrels at Chichester are filled with cross-bracing, such as can also be found in St Mary's Hospital there, a building of barn-like construction that survives much as when built, *c.* 1290.[46] The Bishop's kitchen might thus be dated to *c.* 1300, of the same generation as the Pilgrim's Hall.

A remarkable house, apparently built *c.* 1306, survives at 9 Queen Street, Salisbury.[47] Unfortunately its roof has been replaced, but there survives below the central tie beam a trefoiled arch of timber (its spandrels were filled but are now open). It is not of true hammer construction, though it has the equivalent of a hammer beam. The importance of this building is its date, and the interest that it demonstrates in the use of decorative arching across open halls at this period. This interest is evidenced elsewhere both in timber and stone buildings. Stone arches crossed the hall at Mayfield Palace, and timber arches occurred in aisled halls such as Nurstead Court, or in the form of 'base-crucks' as at Sutton Courtenay.[48] Several roofs, mostly dating to between 1300 and 1350, have similar details, in the use of cornice plates, heavy cambered ties or collars, and crown posts in their upper

stages. The display of large quantities of skilfully finished timber was a characteristic of the better class of roof at this time. What is being suggested here is that timber arches (whether of hammer-beam or base-cruck type) were not just solutions to technological problems, but were the expression of aesthetic considerations on the part of carpenters. These buildings demonstrate the highly-developed skills of their creators in the great innovative period in English carpentry in the decades around 1300.

Postscript

A number of samples from the Pilgrim's Hall have been taken for the purposes of dendrochronological analysis, and are under investigation.

CONCLUSION

The main results of our investigations are as follows:

i. The Norman roofs of the Cathedral do not survive *in situ*.
ii. The earliest roofs in the nave and south transept are those erected *c*. 1400 as part of William of Wykeham's building campaign.
iii. The roofs in the presbytery and north transept belong to Fox's episcopate (1501–28).
iv. The Pilgrim's Hall in the Close is one of the earliest hammer beam roofs, probably dating to early in the 14th century.

ACKNOWLEDGEMENTS

We should like to thank Corinne Bennett, the Cathedral Architect, Mr Holmes for his time and trouble taken in showing us the roofs and the late Wilfrid Carpenter Turner for discussions based on his extensive knowledge of the fabric; John Crook for sharing his discoveries in the Pilgrim's Hall and Pamela Tudor-Craig for discussing the date of the sculpture; John Goodall for his comments on the heraldry; Michael Coker for his photography in the roof and Alison Macaulay for her help with measuring.

REFERENCES

1. Willis (1846).
2. J. B. Colson, 'The Nave Roof, Winchester Cathedral', *Proc. Hants. Field Club*, III (1898), 283–93; also 'Winchester Cathedral A descriptive and illustrated Record of the Reparations of the Nave Roof 1896–8' (with plates), bound in G. W. Kitchin and W. R. W. Stephens *The Great Screen of Winchester Cathedral* (Winchester 3rd ed. 1899).
3. J. Fletcher, 'Medieval Timberwork at Ely', in *Medieval Art and Architecture at Ely Cathedral*, BAA CT (1979), 58–70; O. Rackham, W. J. Blair and J. T. Munby, 'The Thirteenth-century Roofs and Floor of the Blackfriars Priory at Gloucester', *Medieval Archaeology*, XXII (1978), 105–22; J. T. Munby, 'Medieval Carpentry in Chichester' in A. Down, *Chichester Excavations*, 5 (Chichester 1981), 229–53.
4. J. Fletcher and P. S. Spokes, 'The Origin and Development of Crown-Post Roofs', *Medieval Archaeology*, VIII (1964), 152–59; *Charpentes* (Paris, Centre de Recherches sur les Monuments Historiques, 1972 edn.), Vol 1: XIIᵉ siècle.
5. Willis (1846), 66, Fig. 31.
6. C. Hewett, *English Historic Carpentry* (Chichester 1980), 80.
7. Colson (1898), 285; Colson (1899), 8.

8. Hewett (1980), 157.

9. C. Hewett, *English Cathedral Carpentry* (London 1974), 150; also 22 and 37 (Wells).

10. Buckler drawings in W. Horn and E. Born, *The Plan of St Gall* (California 1979), II, 310–13; photograph in J. Buxton and P. Williams, *New College Oxford 1379–1979* (Oxford 1979), Pl. 35.

11. Fletcher and Spokes (1964) passim.

12. Hewett (1980), 69.

13. RCHM, *Middlesex* (London 1937), 61–62; R. Berger ed., *Scientific Methods in Medieval Archaeology* (California 1970), 43–46, 125, Figs 16–17: now dated dendrochonologically c.1435.

14. Illustrations in F. Ostendorf, *Die Geschichte des Dachwerks* (Leipzig and Berlin 1908), 103 and Hewett (1974), 157.

15. S. Jervis, *Woodwork of Winchester Cathedral* (Friends of Winchester Cathedral 1976), 8 and 15.

16. Hewett (1974), 157; Hewett (1980), 157.

17. Colson (1899), Pls III–V.

18. Jervis (1976), 6 and 12–13.

19. Jervis (1976), 6 (quoting diary of William Emes in Fellow's Library, Winchester College).

20. *Wren Society*, XVIII (1941), 150.

21. Hewett (1974), 159; Hewett (1980), 246; also Ostendorf (1908), 87.

22. Discussed in Munby (1981).

23. Colson (1899), table on 27.

24. Colson (1898), 292; (1899), 24.

25. Jervis (1976), 16–17 (Pl.).

26. Hewett (1974), 160, Fig. 157.

27. Jervis (1976), 16.

28. Hewett (1974), 40, 158 (where the lower tie in the nearer truss is not original) and 160; Hewett (1980), 176.

29. Ibid.; Ostendorf (1908), 86 (Figs).

30. Jervis (1976), 15.

31. RCHM, *Oxford* (London 1939), Pl. 110 and E. A. Gee 'Oxford Carpenters, 1370–1530', *Oxoniensia*, XVII/XVIII (1952–53), 131, 135 and Pl. X; J. Blair, 'Frewin Hall, Oxford: A Norman Mansion and a Monastic College', *Oxoniensia* XLIII (1978), 78–81 and RCHM, *Oxford*, 28.

32. Hewett (1980), 214.

33. *Wren Society*, I (1924), Pls VII–VIII (All Souls vol. 2, nos. 6–7); ibid. XIII (1936), 20; see also H. M. Colvin, D. R. Ransome and John Summerson, *History of the King's Works*, III, i (1975), 63–65.

34. Willis (1846), 43–49.

35. J. Harvey, *Cathedrals of England and Wales* (London 1974), 196 and 244; Jervis (1976), 23; Hewett (1980), 176.

36. Full description in C. J. P. Cave 'The Bosses on the vault of the Quire of Winchester Cathedral', *Archaeologia*, LXXVI (1927), 161–78; see also his *Roof Bosses of Winchester Cathedral* (Friends of Winchester Cathedral 1935 etc.), and *Roof Bosses in Medieval Churches* (Cambridge 1948), 217–18, Pls 239–54.

37. Turner and Parker, *Some Account of Domestic Architecture in England*, IV (1859), 323–24 and Figs; *Country Life*, 25 March 1922 (refers to oaks being felled in 1459).

38. Measured drawings by N. A. Beasley in National Monuments Record.

39. N. C. H. Nisbett 'Notes on the Roof of the Pilgrim's Hall, Winchester', *Proc. Hants. Field Club*, III (1898 — pt. i of 1895), 71–77.

40. P. M. J. Crook, 'The Pilgrim's Hall, Winchester', *PHFCAS*, 38 (1982), 85–101.

41. J. T. Smith, 'The Reliability of Typological Dating of Medieval English Roofs', in Berger (1970), 253–56.

42. Pamela Tudor-Craig kindly discussed this question with us.

43. R. A. Brown, H. M. Colvin and A. J. Taylor, *The History of the King's Works* (London 1963), I, 527–33; M. Wood, *The English Medieval House* (London 1965), 316.

44. Wood (1965), 315–16, Figs 100–01.

45. Ostendorf (1908), 184; Smith (1970), Fig. 9: Horn and Born (1979), I, 276, Fig. 224.

46. VCH, *Sussex III* (London 1935), 78–79 and Pls; Dollman and Jobbins, *An Analysis of Ancient Domestic Architecture* (1861–63) Pls; J. T. Smith, 'Medieval Roofs: A Classification', *Archaeol. J.*, 115 (1958), 115; Horn and Born (1979), II, 91–95, Figs 341–43.

47. RCHM, *Salisbury I* (London 1980), 82–83, Pl. 82.

48. Wood (1965), Pls 2, 23 and 24.

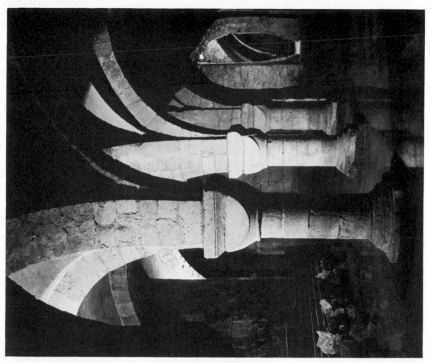

Ic. Crypt, eastern chapel
Copyright F. Woodman

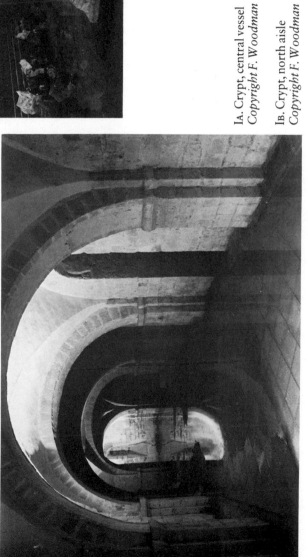

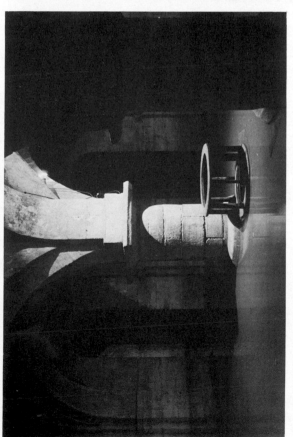

IA. Crypt, central vessel
Copyright F. Woodman

IB. Crypt, north aisle
Copyright F. Woodman

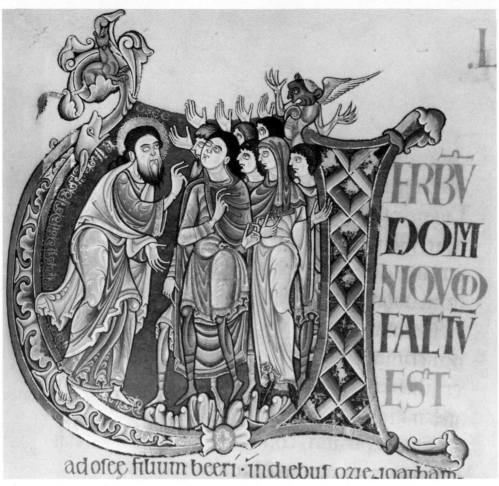

IIA. Initial at Hosea, Winchester Cathedral Library, Winchester Bible, f. 198
Courtesy Dean and Chapter, Winchester Cathedral
Photo The Warburg Institute

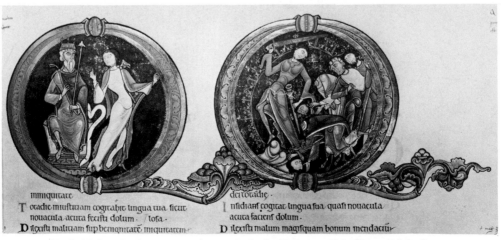

IIB. Initials at Psalm 51, Winchester Cathedral Library, Winchester Bible, f. 232
Courtesy Dean and Chapter, Winchester Cathedral
Photo The Warburg Institute

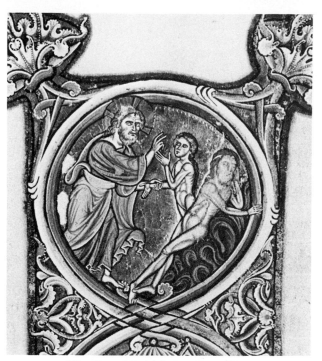

IIIA. Genesis Initial, Creation of Eve,
Winchester Cathedral Library, Winchester Bible, f. 5
Courtesy Dean and Chapter, Winchester Cathedral
Photo The Warburg Institute

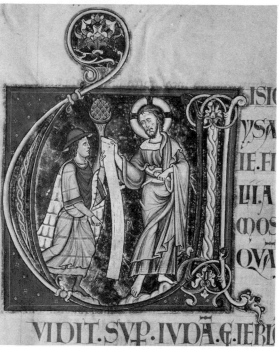

IIIB. Initial at Isaiah, Winchester Cathedral Library,
Winchester Bible, f. 131
Courtesy Dean and Chapter, Winchester Cathedral
Photo The Warburg Institute

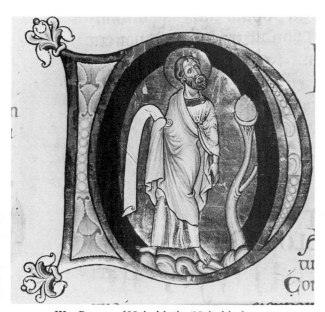

IIIc. Prayer of Habakkuk, (Habakkuk 3:2),
Winchester Cathedral Library, Winchester Bible, f. 208
Courtesy Dean and Chapter, Winchester Cathedral
Photo The Warburg Institute

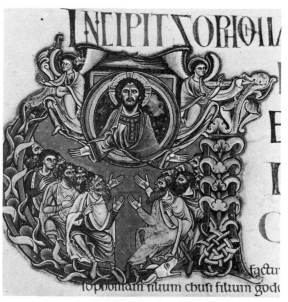

IIID. Initial at Zephaniah, Winchester Cathedral
Library, Winchester Bible, f. 209
Courtesy Dean and Chapter, Winchester Cathedral
Photo The Warburg Institute

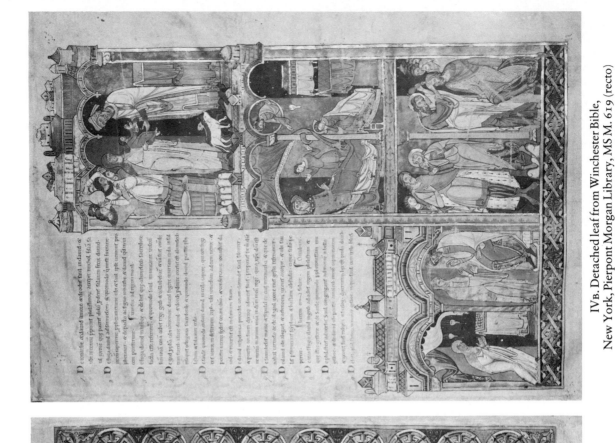

IVB. Detached leaf from Winchester Bible,
New York, Pierpont Morgan Library, MS M. 619 (recto)
Courtesy The Pierpont Morgan Library

IVA. Detached leaf from Winchester Bible,
New York, Pierpont Morgan Library, MS M. 619 (verso)
Courtesy The Pierpont Morgan Library

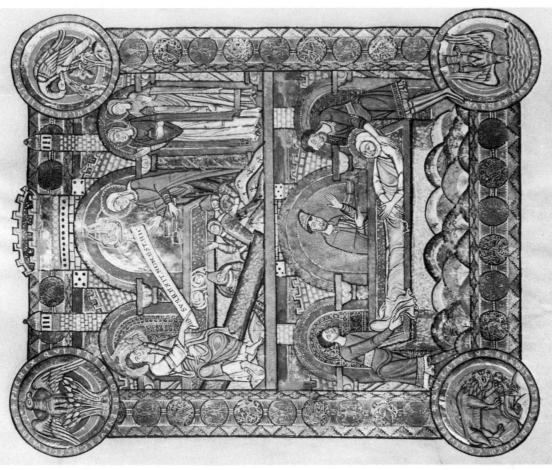

VB. Resurrection, Gospels of Henry the Lion,
formerly Gmunden, Schloss Cumberland
Photo The Warburg Institute

VA. Initial at I Kings, Stavelot Bible,
London, British Library, Additional MS 28106, f. 97
Courtesy British Library Board

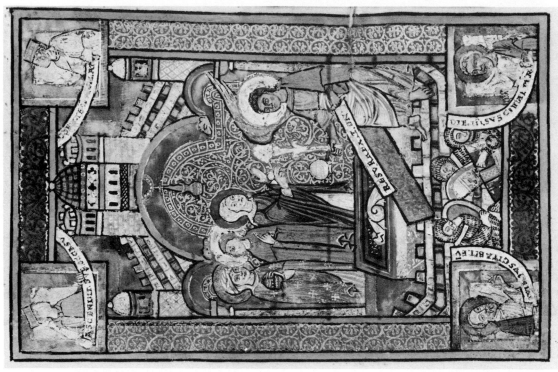

VIB. Resurrection scene from prefatory cycle of the Psalter of
Henry the Lion,
London, British Library, Lansdowne MS 381, f. 11
Courtesy British Library Board

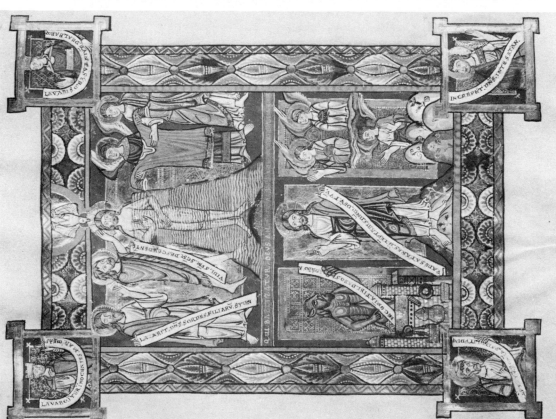

VIA. Baptism, Gospels of Henry the Lion,
formerly Gmunden, Schloss Cumberland
Photo The Warburg Institute

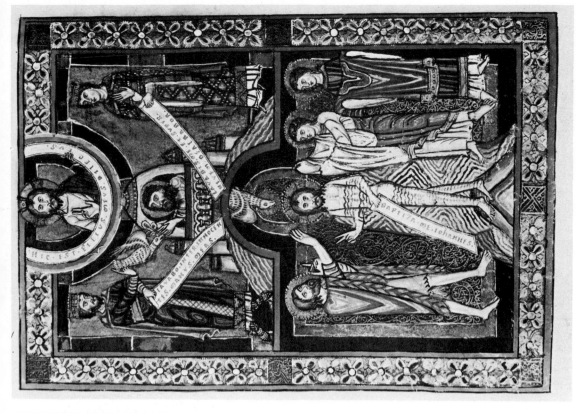

VIIB. Noah and the Dove, Baptism, Gospels from Helmarshausen,
Trier, Domschatz 67, f. 54v
Photo Bildarchiv Foto Marburg

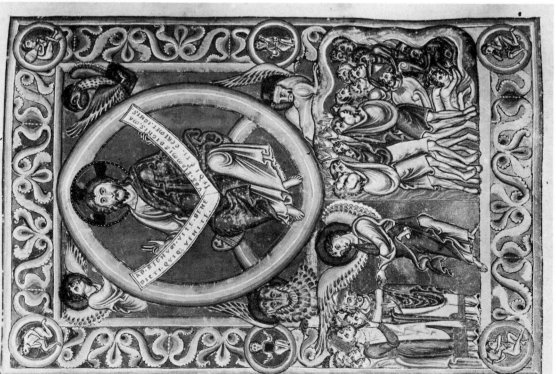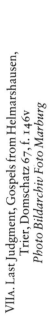

VIIA. Last Judgment, Gospels from Helmarshausen,
Trier, Domschatz 67, f. 146v
Photo Bildarchiv Foto Marburg

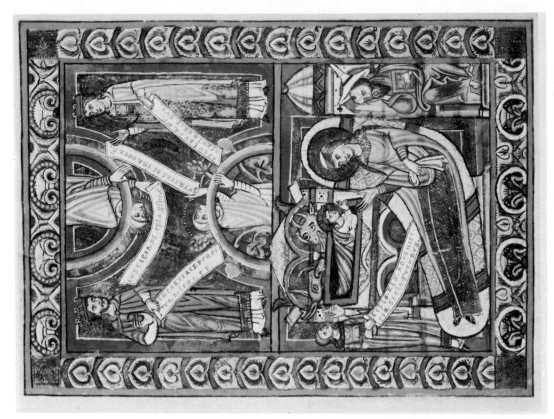

VIIIB. Nativity, Sponsus and Sponsa, Truth and Justice, detached leaf from Helmarshausen Gospels (Trier), The Cleveland Museum of Art, purchase from the J. H. Wade Fund, no. 33.445

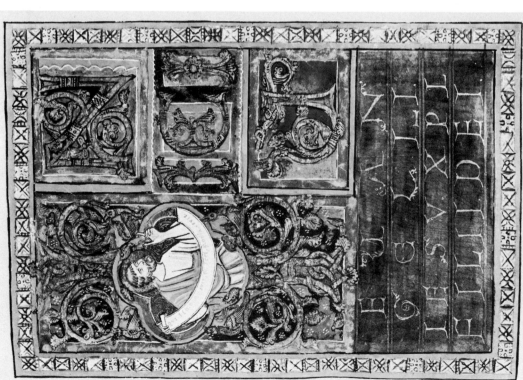

VIIIA. Ornamental text page, Gospels from Helmarshausen, Trier, Domschatz 67, f. 55
Photo Bildarchiv Foto Marburg

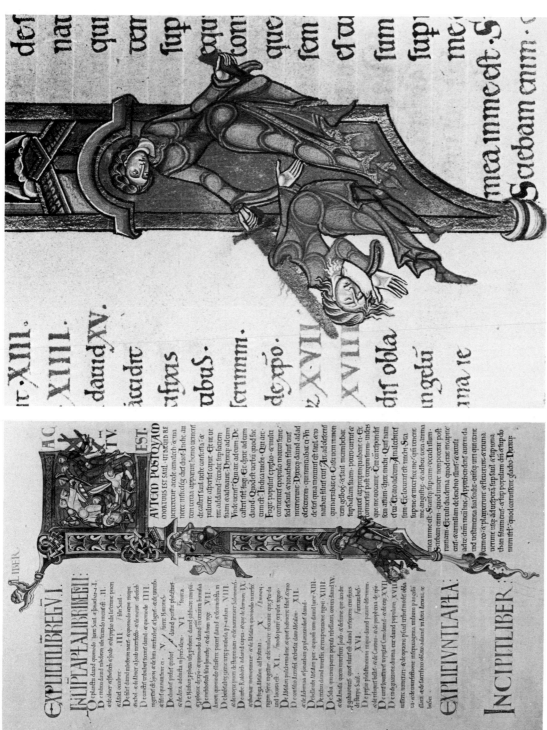

IXA. Initial at II Kings, Winchester Cathedral Library,
Winchester Bible, f. 99v
Courtesy Dean and Chapter, Winchester Cathedral
Photo The Warburg Institute

IXB. The Slaying of the Amalekite, detail of Fig. 16
Courtesy Dean and Chapter, Winchester Cathedral
Photo The Warburg Institute

X. British Museum, 'Henry of Blois plaques'

XI. Radiographs of Pl. X

XIIA
Detail of Pl. X — head of Henry of Blois

XIIB
Radiograph of Pl. XIIA

XIIC
Detail of Pl. X — head of left-hand angel

XIID
Detail of Pl. X — head of right-hand angel

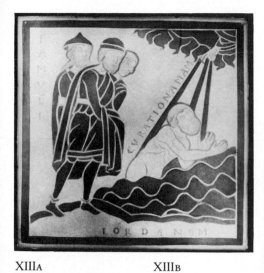

XIIIA
Radiograph of British
Museum plaque:
Naaman cured of
leprosy in the River
Jordan

XIIIB
Detail of Pl. X (top)

XIIIC
Detail of British
Museum Mosan
plaque
(MLA 56, 12–17, 1)

XIIID
Detail of Pl. XIIIA

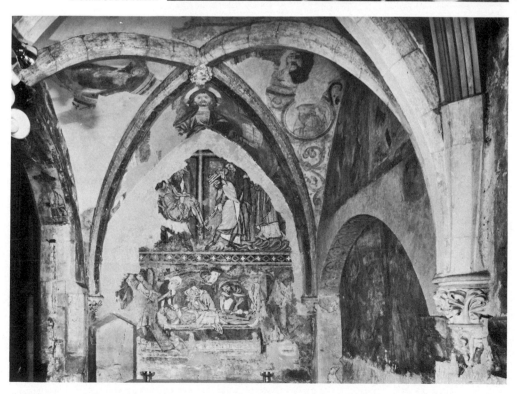

XIIIE
Chapel of the
Holy Sepulchre.
Interior,
looking E

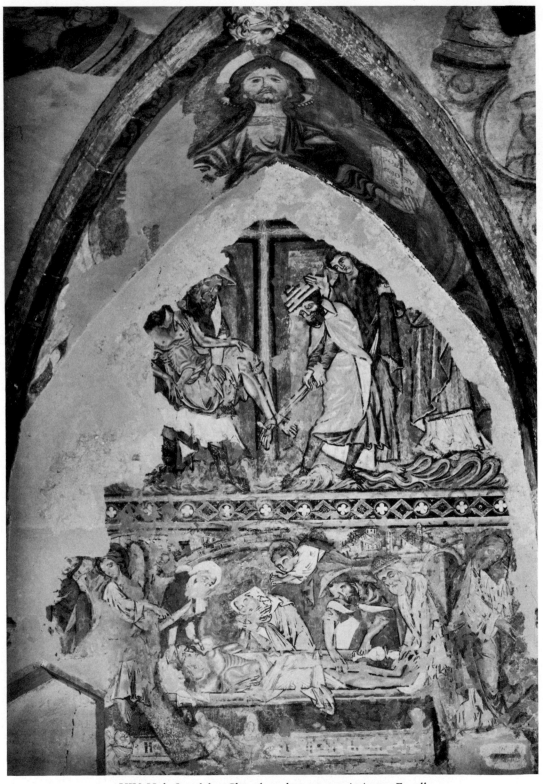

XIV. Holy Sepulchre Chapel: 12th-century painting on E wall
and 13th-century painting on vault
Photo RCHM, Crown copyright

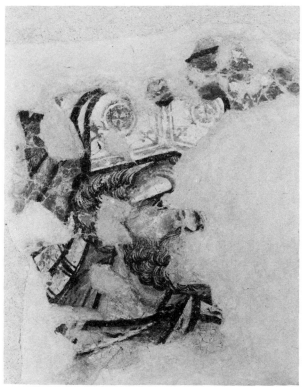

XVA. Holy Sepulchre Chapel: 12th-century head of
high priest, from S wall
Photo RCHM, Crown copyright

XVB. Holy Sepulchre Chapel: 12th-century
drawing of grotesque creature on pilaster on
S side of Chapel
Photo RCHM, Crown copyright

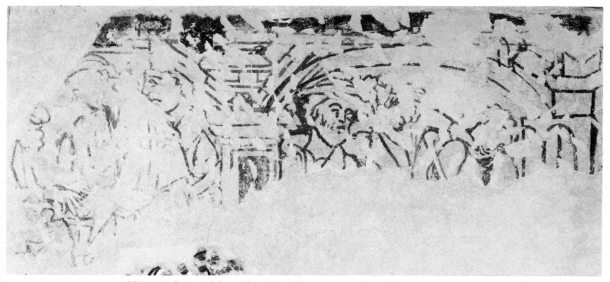

XVC. Holy Sepulchre Chapel: 12th-century sinopia from S wall, detail
Photo RCHM, Crown copyright

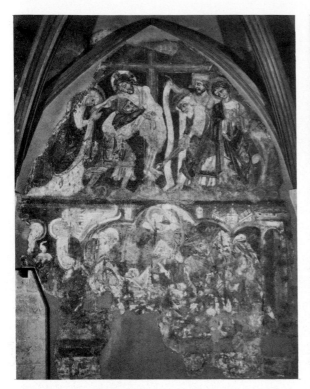

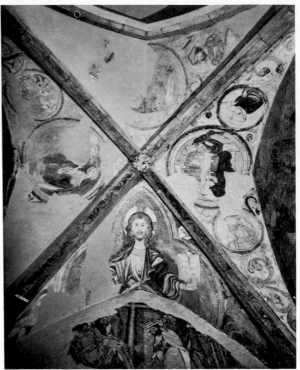

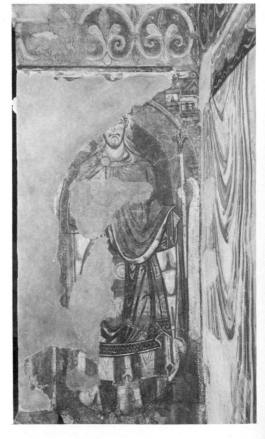

XVIA. Holy Sepulchre Chapel: 13th-century painting from
E wall, transferred to artificial wall at W end of Chapel
Photo RCHM, Crown copyright

XVIB. Holy Sepulchre Chapel: 13th-century painting on
vault of E bay
Photo RCHM, Crown copyright

XVIC. N transept: 12th-century painting of prophets.
Destroyed. From engraving by J. Schnebbelie
Photo RCHM, Crown copyright

XVID. Durham Cathedral, Galilee Chapel: detail of painting in
N recess in E wall (St Oswald?)
Photo RCHM, Crown copyright

XVIIA. Arcading, after Le Couteur and Carter

XVIIB. Twisted shafting,
after Le Couteur and Carter

XVIIc. Front and back of block with monk's head,
after Le Couteur and Carter

XVIID. Sexfoil roundel,
after Le Couteur and Carter

XVIIA–D. *Courtesy of the Society of Antiquaries of London*

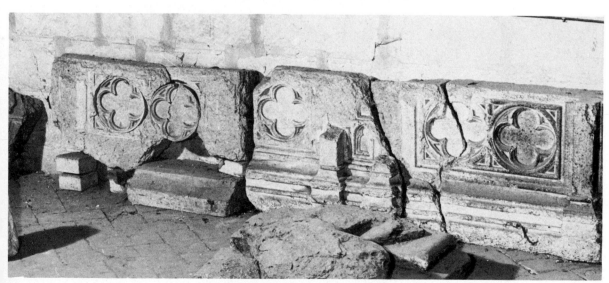

XVIIE. Purbeck base with quatrefoils
Photo courtesy Courtauld Institute of Art

XVIIIA
Figure of a monk from a cast at Winchester Cathedral
Courtesy Courtauld Institute of Art

XVIIIB
Fragmentary figure of a monk, reverse of XVIIIA

XVIIIc. Figure of a bishop

XVIIID. Damaged figure of a bishop, reverse of XVIIIc

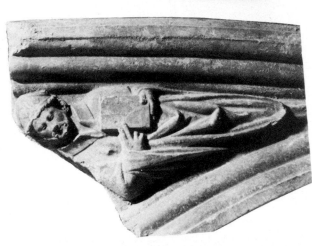

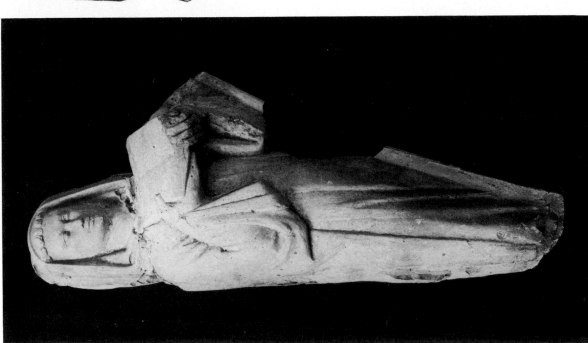

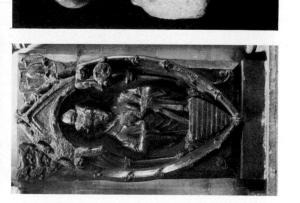

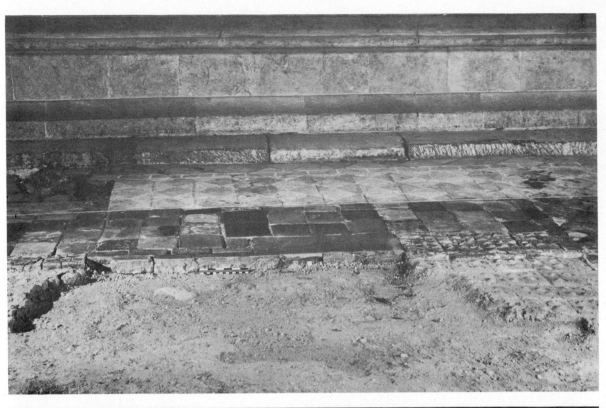

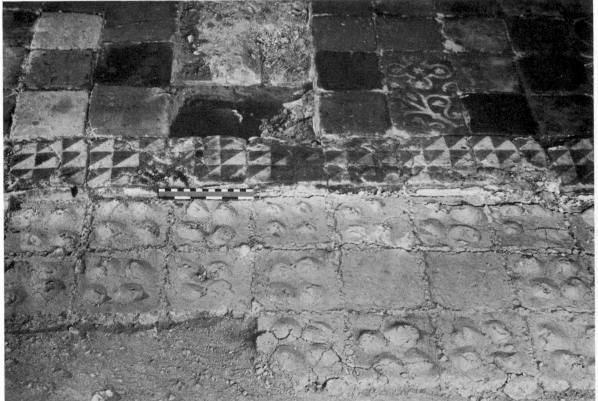

XXIA
Looking south across the
north presbytery aisle after
the tiles had been removed
and the earlier floors
revealed
Photo James Barfoot

XXIB
A sample of the rammed
aggregate floor
Photo James Barfoot

OPPOSITE
XXA
Looking north across the
north presbytery aisle at
the east end of the
excavated panel of the tile
pavement. The masonry
base of the north wall in
the background
Photo James Barfoot

XXB
Detail of the east part of
the west patch of tile
paving showing the
imprint on the mortar bed
of the tiles that had been
removed
Photo James Barfoot

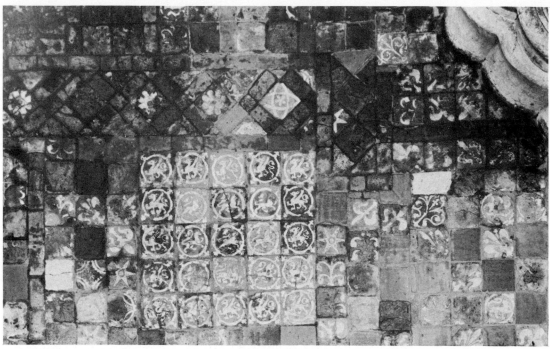

XXIIA. Retrochoir floor, in front of Lady Chapel, with fragmentary remains of original Group 4 pavement, *c.*1270, and inserted panel of lions and griffins from Lady Chapel, of Group 2, *c.*1250 (plus one griffin of Group 4)
Photo National Monuments Record, Crown copyright

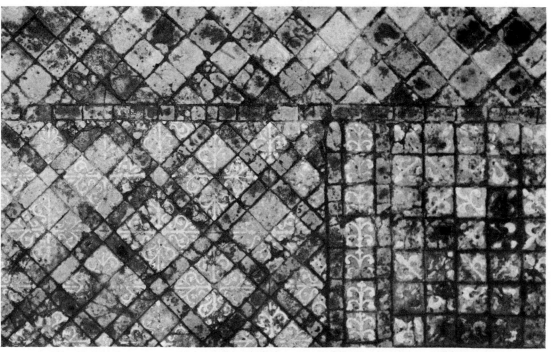

XXIIB. Retrochoir north aisle floor, to west of Waynflete's chantry: panels of original Group 4 pavement, *c.*1270
Photo National Monuments Record, Crown copyright

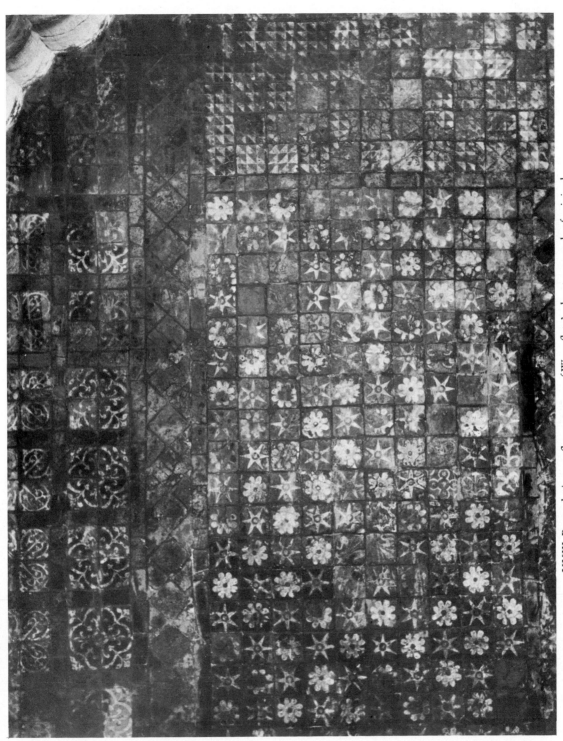

XXIII. Retrochoir nave floor, to west of Waynflete's chantry: panels of original
Group 4 pavement, c. 1270
Photo National Monuments Record, Crown copyright

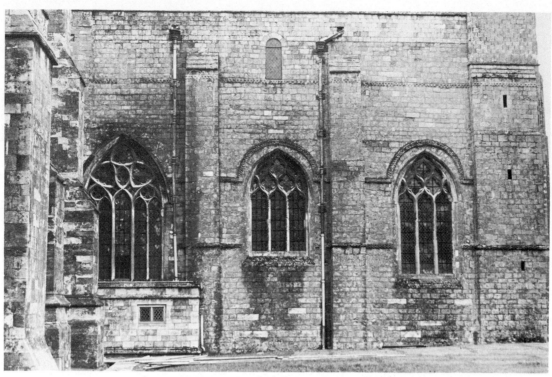

XXIVA. Winchester Cathedral, N transept (from E) showing
chapel windows North 1, 2 and 3 (left to right)

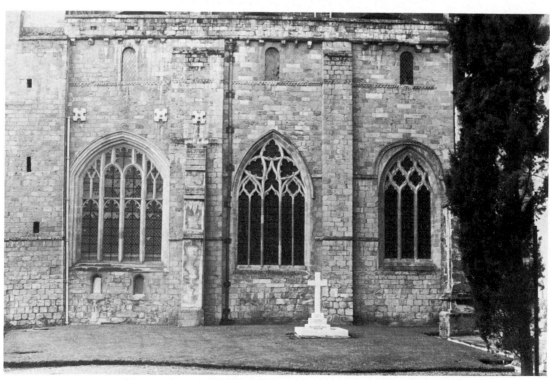

XXIVB. Winchester Cathedral, S transept (from E) showing
chapels South 3, 2 and 1 (left to right)

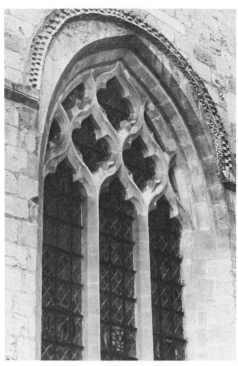

XXVa. Winchester Cathedral, N transept (from N)
chapel window North 4

XXVb. S transept,
window South 1, mouldings

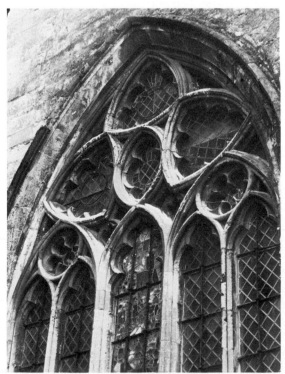

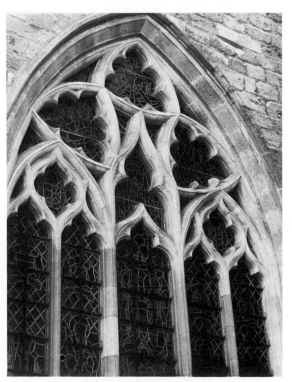

XXVc. N transept,
window North 1, mouldings

XXVd. S transept,
window South 2, mouldings

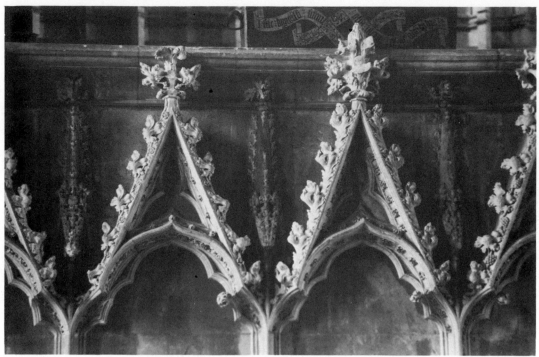

XXVIA. Feretory Screen viewed from Retrochoir (detail)

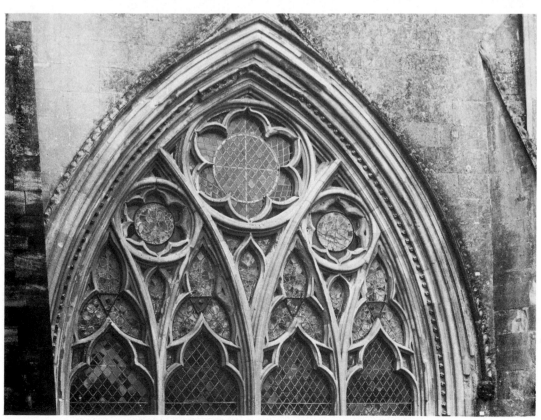

XXVIB. Wells Cathedral, Chapterhouse window (detail)